D1465256

THE COMPLETE BOOK OF DRAWING
FANTASY ART

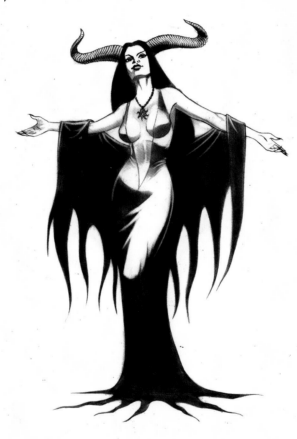

THE COMPLETE BOOK OF DRAWING
FANTASY ART

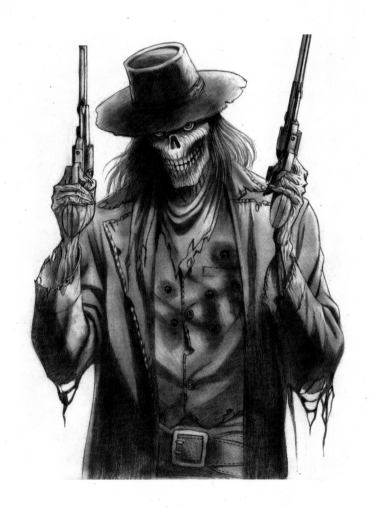

STEVE BEAUMONT

ARCTURUS

Credits

Thanks to the following artists' materials brands that appear in this book:
Copic® [Copic is a trademark of Too Corporation in Japan], Derwent,
Faber-Castell, Letraset, Staedtler, Winsor & Newton.

Picture credits: The Kobal Collection (Art Archive): 232 (Figure 6);
Shutterstock: 51, 80 (Figures 4–6), 125, 126, 134, 139 (Figures 1–5), 146
(Figure 6), 179 (Figures 2 and 3), 182 (Figures 6–8), 188 (Figures 17 and 18)
193 (Figures 3 and 4), 209, 224, 232 (Figure 5), 233, 234, 239 (Figures 7
and 8), 244.

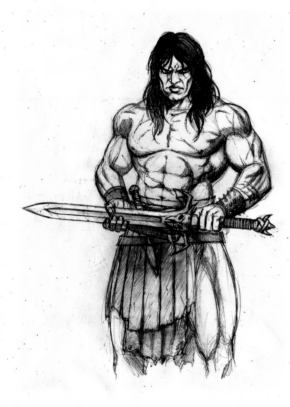

ARCTURUS

This edition published in 2015 by Arcturus Publishing Limited
26/27 Bickels Yard, 151–153 Bermondsey Street,
London SE1 3HA

Copyright © Arcturus Holdings Limited/Steve Beaumont

ISBN: 978-1-78404-859-4
AD004764UK

Printed in China

CONTENTS

PROJECTS

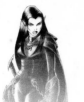

Project 1
ELF PRINCESS

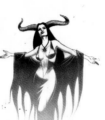

Project 2
ENCHANTRESS

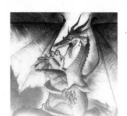

Project 3
DRAGON'S LAIR

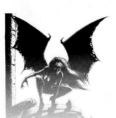

Project 4
CREATURE OF THE NIGHT

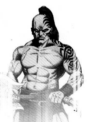

Project 5
TRIBAL WARRIOR

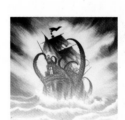

Project 6
THE KRAKEN

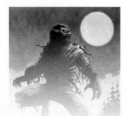

Project 7
WEREWOLF

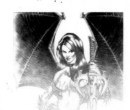

Project 8
WINGED WARRIOR

Project 9
DARK ANGEL

Contents

⸺•◦❊◦•⸺

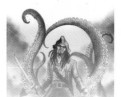
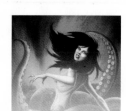
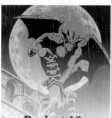
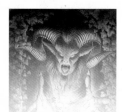

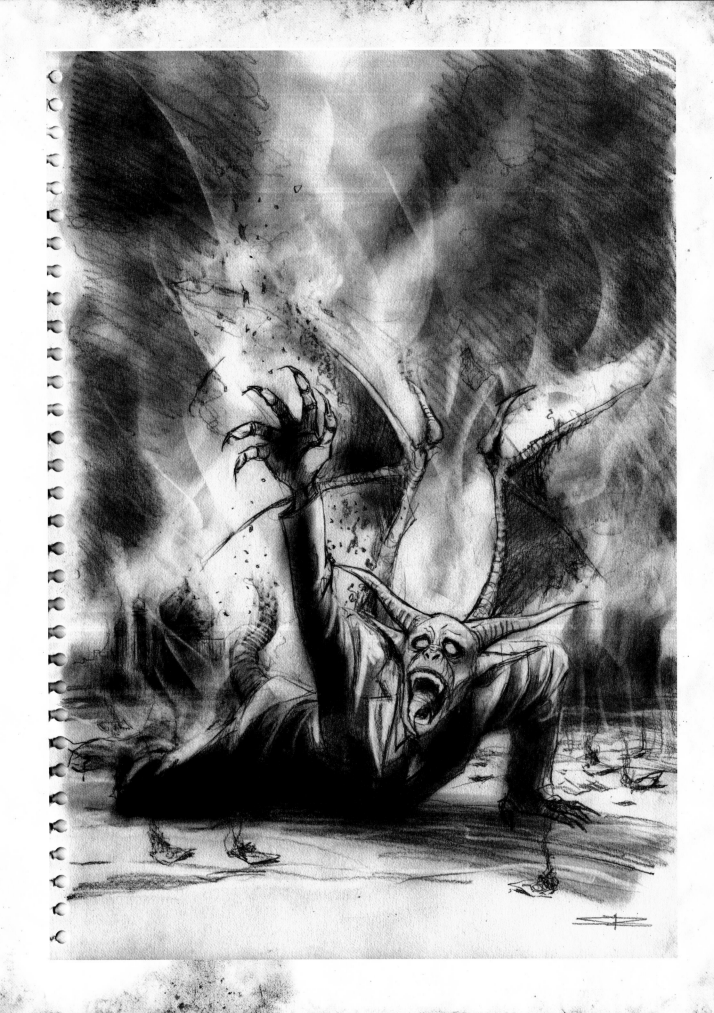

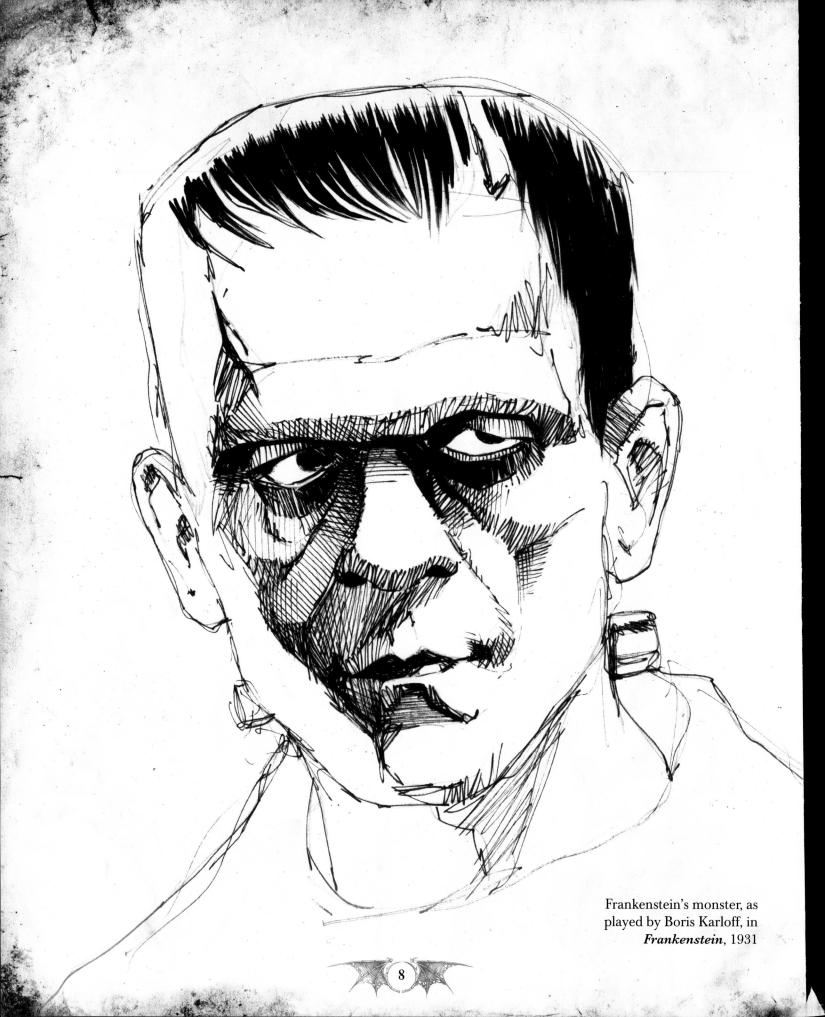

Frankenstein's monster, as
played by Boris Karloff, in
Frankenstein, 1931

INTRODUCTION

What is it about fantasy art that so many find appealing? Is it that it covers so many different genres, from horror and science fiction to swashbuckling, swords and sorcery? Is it that it offers the opportunity to engage with extraordinary characters and creatures in extraordinary worlds? Or is it because there are no barriers and anything is possible? The answer is that it is all of these things, and every individual enjoys different aspects of the genre. In this book we shall explore a small collection of some of those characters and the worlds they inhabit and in the process create some exciting fantasy art.

I have had a life-long love affair with comics, books and films dealing with themes of fantasy. As a child, I enjoyed nothing more than reading DC Comics' *Batman* series drawn by Dick Sprang, the first artist to inspire me to produce a piece of fantasy art. Later, motivation was provided by Jack Kirby's and Frank Frazetta's art. In my teenage years, Frazetta's work opened up all kinds of possibilities for fantasy drawings, based upon and inspired by my favourite TV shows and films, including *Doctor Who*, *The Outer Limits*, *The Twilight Zone*, *Frankenstein*, *The Wolfman* and *Creature from the Black Lagoon*.

I have been professionally providing illustrations, concept art, storyboards and (occasionally) comic-book art for the past 20 years or so. I have had no professional tutoring: everything I have learned has been self-taught, proving that anyone, with practice, can produce fantastic and fantastical art. What I shall be passing on to you within the pages of this book are some of the techniques and approaches I have developed, either by accident or by watching other artists at work, over my professional career.

I also teach a 'how to draw fantasy art' class and this book incorporates some of the themes and tutorials used there. It is a companion book, if you like. During the years the class has been running, I have successfully enabled a number of students to compile a portfolio of work, which they showed to talent scouts at comic conventions and eventually led to them getting commissions from Marvel Comics. What I shall be showing you in the following pages are easy-to-follow steps that will guide you through the process of producing a piece of fantasy art. I have not gone into every minute detail and this is because, as I keep telling my students, I do not want to encourage you to copy my style and exactly how I draw as if it were the only way, as we all have to find our own path forward.

This book is not aimed at the professional or semi-professional artist – it is more for those who enjoy drawing, are fans of fantasy art and are looking for some tips and ideas that will enable them to take their drawing skills a stage further. I thought it would also be helpful to document any changes that occurred to me as I went along. Unlike drawings I produce for a client, which are meticulously planned and go through various stages of development, I have approached these artworks as I would any drawing

I am producing just for myself, complete with mistakes, experiments and last-minute revisions. I have included these thoughts and alterations in the hope that they will encourage you constantly to seek to improve your work. Remember, it's vital not to worry too much about making mistakes – instead, keep the drawings you are not happy with to remind you what not to do next time.

When I was having fun drawing as a child, I mostly drew from comic books and from what I had seen on TV or at the cinema. Basically, I drew what pleased me and what I was interested in, and this is true of most fantasy artists. For instance, Frank Frazetta is a sports fan and, from what I have read, something of an athlete, and this is evident in his work. Adi Granov has a love of automobiles, aircraft and machinery and these are strong features in his drawings. Claire Wendling clearly has a love and understanding of wildlife and nature. They draw what they are passionate about and this makes them better artists, in my view.

Personally, I love horror and sci-fi movies and comics and 70 per cent of my daily work is related to these themes. I enjoy working with this subject matter and I hope you find drawing it as much fun as I do.

Steve Beaumont

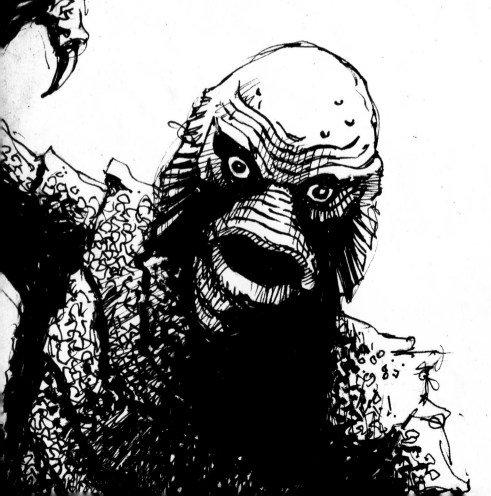

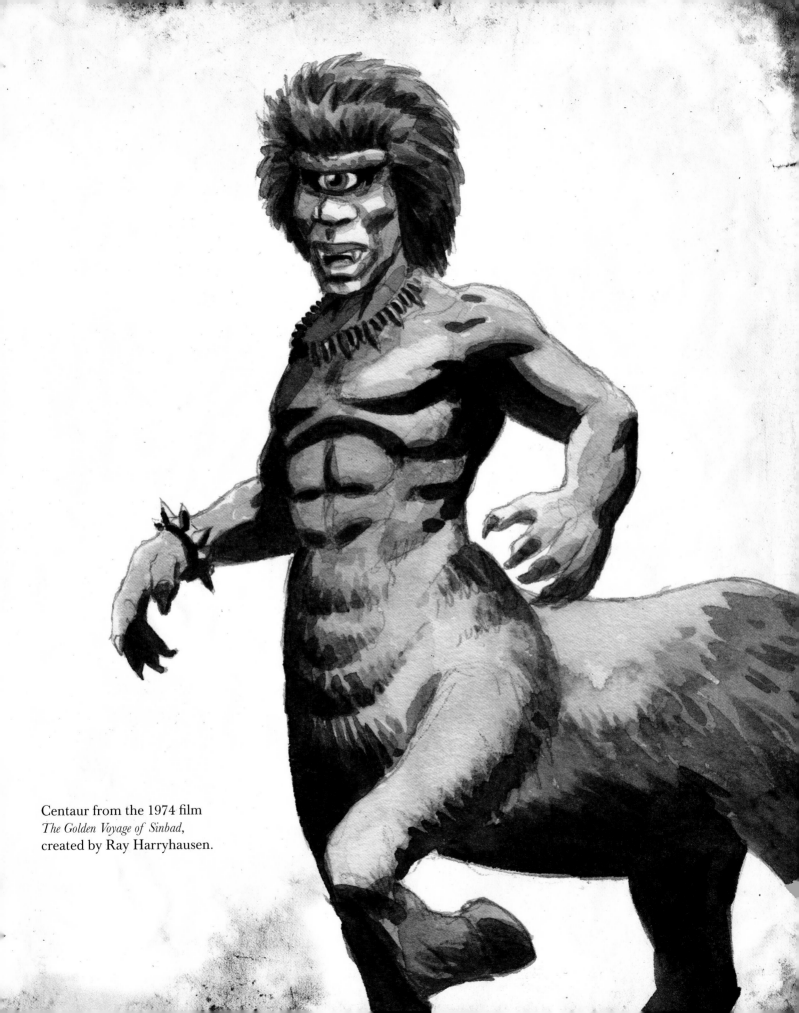

Centaur from the 1974 film
The Golden Voyage of Sinbad,
created by Ray Harryhausen.

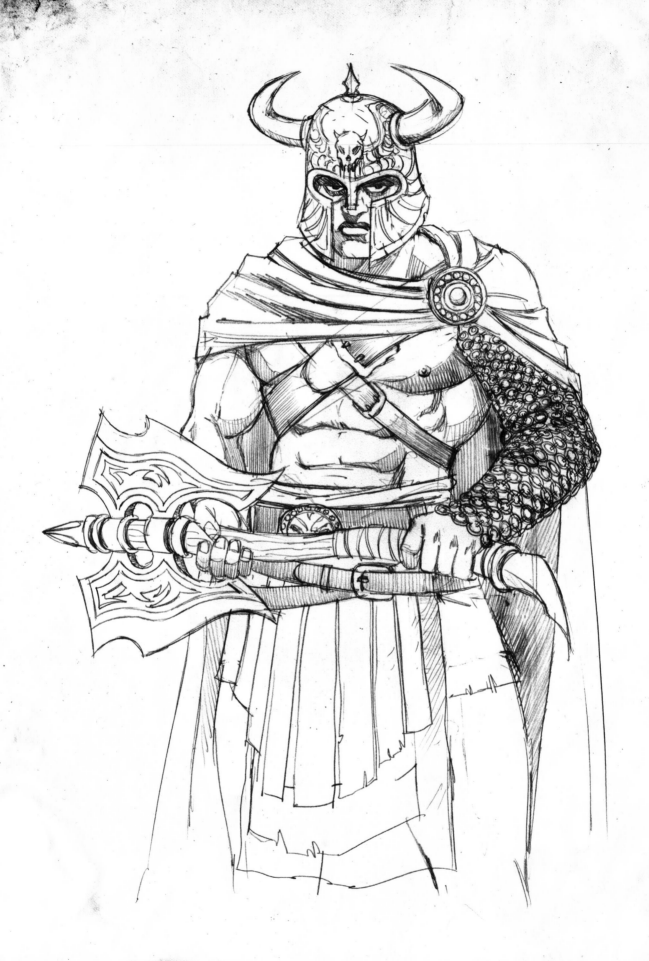

Materials and Techniques

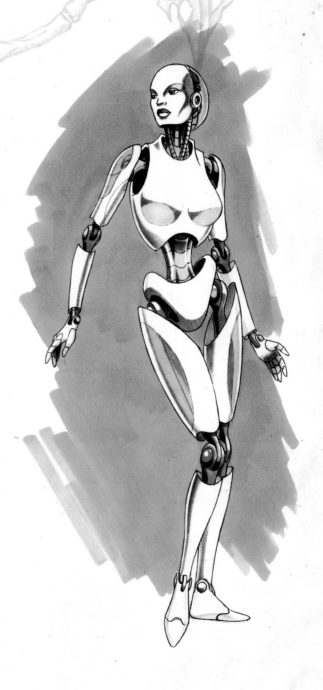

A good artist is able to use their experience and ability to draw something great with even the most basic of tools. However, for the less experienced artist to progress well and achieve the very best results, good-quality equipment is required, especially at a professional level. Cheap materials will often not only hinder your development but will also detract from the quality of your work. They are also much less pleasurable to use.

If you ever go to a comic convention and watch artists draw, you will notice that each artist has their own preferred brand of pen or pencil. I often try out new materials after watching another artist work with a tool that I am not familiar with. This new implement may push my drawing ability forward, but it's by no means always the case. Ultimately, the choice of drawing tools comes down to personal preference and budget – but it's worth experimenting widely before deciding what works best for you, so don't limit yourself too quickly.

This section covers some of my favourite tools that I have used for the drawings in this book. Good-quality, affordable and readily available, they should meet most requirements to set you on your way.

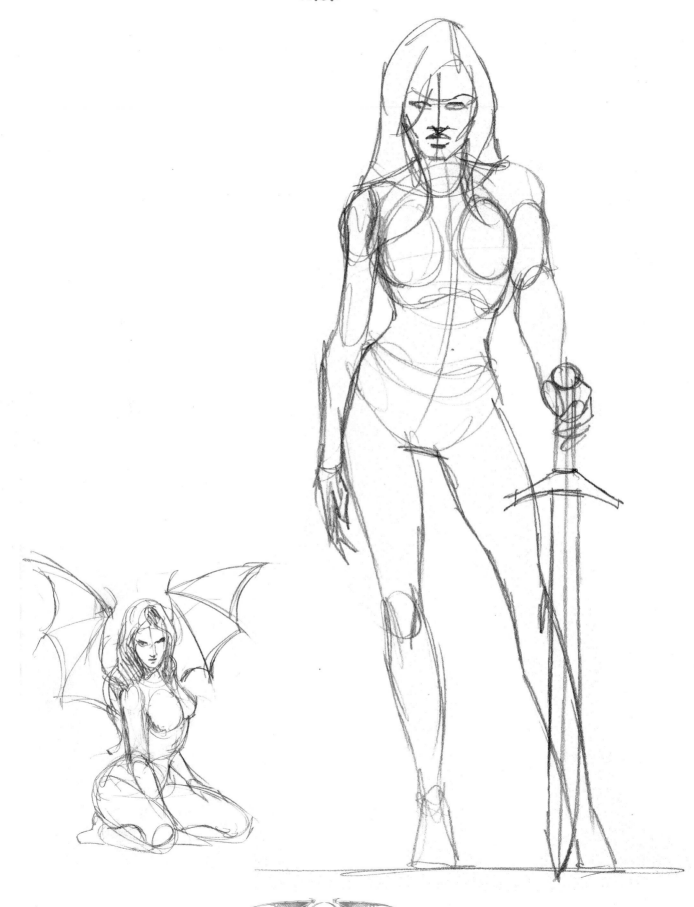

PENCILS, ERASERS, BLENDERS AND PAPER

These are the tools that form the foundation of all the fantasy art you are going to create, whether you are devising a drawing to be inked, coloured or to be rendered purely in graphite. Most of the exercises in this book were achieved using a basic pencil, an eraser and some good-quality paper.

PENCILS

There is a huge range of pencils available, and it is worth trying out a few to see which you prefer. These are a few of the most common ones:

Pentel clutch pencil: This is available in a number of lead weights and thicknesses and it uses lead refills, meaning there is no need to sharpen it. This is a great technical pen for fine detail.

Wolff's carbon: Provides the depth of tone of charcoal with the smooth finish of graphite.

Derwent watersoluble graphite: A pencil-shaped stick of pure water-soluble graphite, which can be used as a conventional pencil, broken into chunks to create broad sweeping strokes or for subtle washes.

Faber-Castell Pitt graphite: This is a very high-quality pure graphite sketching stick that gives excellent tone. It is also available as a crayon stick.

Derwent sketching pencil: This reliable pencil is available in the usual range of H–HB–B leads.

Rexel Cumberland Derwent Graphic: A good-quality, low-priced pencil that gives pleasing results on most papers.

Staedtler: This is a very reliable budget-range pencil that gives great results.

I tend to use Staedtler HB pencils for most workings out and even some finished art. Derwent pencils are another preferred choice.

PENCIL WEIGHTS

Here is a list of pencil weights and their qualities:

- H leads are hard and create a lighter mark on the paper. The range consists of H–9H, with 9H being the hardest.
- HB pencils are a good mid-range pencil, giving a wide variety of tone between the H and B leads.
- B leads are softer and leave a lot of lead on the paper, which is easily smudged. The range consists of B–9B, with 9B being the softest.

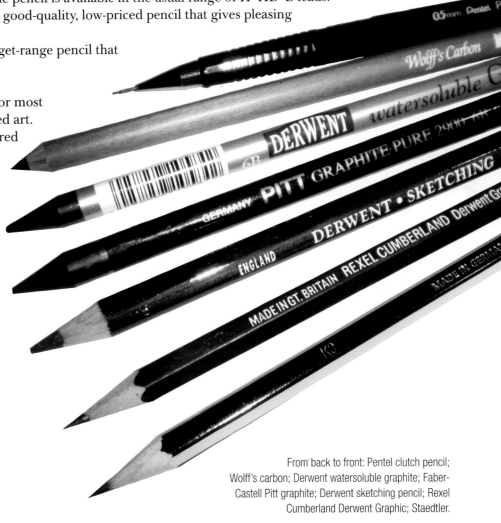

From back to front: Pentel clutch pencil; Wolff's carbon; Derwent watersoluble graphite; Faber-Castell Pitt graphite; Derwent sketching pencil; Rexel Cumberland Derwent Graphic; Staedtler.

ERASERS

There are lots of erasers on the market, but only a select few good products. Don't go for the cheapest as you will often find these are inferior. I tend to use Winsor & Newton putty rubbers (Figure 1), Staedtler plastic erasers (Figure 2), and a Derwent battery-operated eraser (Figure 3). The small eraser on the end of a Staedtler pencil is also useful for creating detailed highlights.

Figure 2

Figure 1

Figure 3

BLENDERS

A lot of pencil work involves blending pencil lead to give a smooth area of tone or to create clouds of smoke or other effects. To create these I use tissue paper wrapped around my index finger or a blending stump (Figure 4). Tissue paper can give a softer, gentler blend over a larger surface. Stumps are very good for smaller areas and detail work, although I have seen many artists use a stump for large areas too.

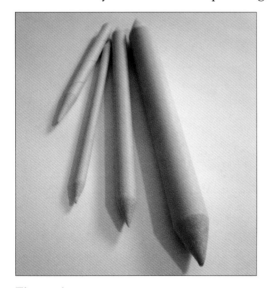

Figure 4

PAPER

With so many different surfaces and weights of paper on the market it would be difficult to mention them all here. If I am working in pencil I use a variety of weights and surfaces of cartridge paper, depending on the desired type of pencil line I am trying to achieve. I can recommend Winsor & Newton cartridge paper. I use 180gsm for general rough sketching and 300gsm for finished artwork. I turn to a medium rough-surface paper for pencil work that I want to blend, as this gives excellent effects and is also good for dry brushwork when using ink. For work requiring a precise, crisp line, I use a smooth-surface paper. Arches Aquarelle watercolour paper is also nice for pencil work, especially if you are combining an ink or watercolour wash with your drawing.

When working with paint, the type of paper required varies depending on the paint used and the finish that is wanted. In general, I like to use Langton Prestige Hot Pressed paper 300–400gsm, Saunders Waterford Hot Pressed paper 300–400gsm and Arches Aquarelle Watercolour Paper 300gsm all surfaces. These are just my preferences, however, and you should try out others. For most brands, the following abbreviations are given: HP = Hot Pressed (smooth finish); NOT/CP = Cold Pressed (slightly textured). You will also find Rough, which is as it says.

Pencil techniques

Shading

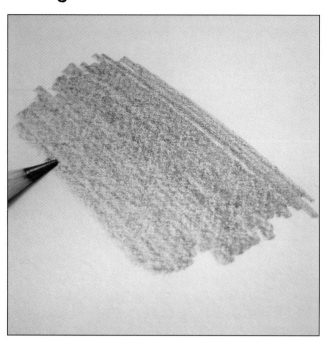

Position the pencil so that the flat edge rubs across the paper.

This gives you a wide coverage and is useful when shading a large area.

Blending 1

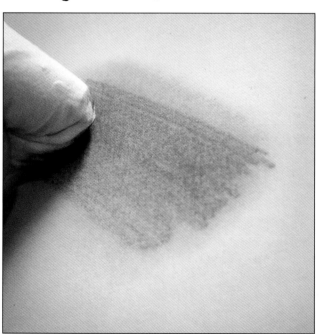

Wrap some tissue paper or soft cloth around your finger and run it across a shaded area so that the pencil strokes begin to blend together.

This action will give a smoother surface to your pencil work and is especially good for large areas.

Blending 2

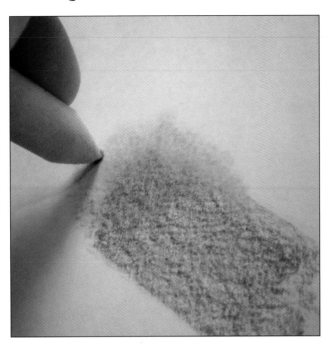

A blending stump is another good tool for blending pencil work. Hold the stump as you would a pencil and apply a little pressure.

This technique gives you a lot of control over the blending and is useful for detailed and smaller areas.

Highlights

For this technique, use either a rounded edge of a Staedtler plastic eraser or a putty rubber to create lighter areas. You need to assess from which angle the light is coming when applying highlights and ensure you are consistent when you position them. Highlights can also be used to mimic the way flames flicker and smoke swirls if you drag the eraser across the pencil work to create sinuous shapes.

Creating cloud effects

You can use a combination of blending and erasing to create cloud effects. First, shade the area and blend it with tissue paper, then give the edge of the clouds definition by chiselling away with an eraser. Finally, go over the image again with tissue paper to soften the edges.

POINTER NOTES

This image was drawn using an HB and an H pencil. The clouds were created using the blending technique. The highlights were made with a finely chiselled eraser and the fine highlights on the barbed wire were created by painting with gouache and a No. 0 round sable Winsor & Newton watercolour brush. You can follow the whole exercise on pages 138–143.

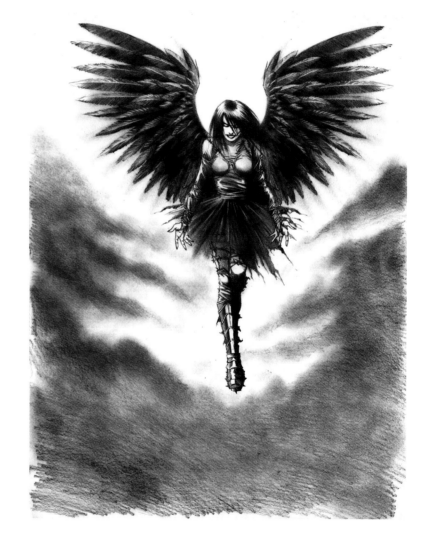

INKING

Inking requires a lot more concentration than mark-making with a pencil, as every pen/brush stroke is permanent and can only be corrected by painting in white over the top or, if you are using Bristol board, by scraping away the top surface with a surgical blade.

The powerful impact that black ink has on a drawing cannot be denied. Occasionally I use a brush for inking a drawing, but about half of my work is inked using Faber-Castell Pitt Artist Pens and Copic Multiliner pens. Both brands use waterproof Indian ink and give very pleasing results.

INK PENS

Faber-Castell Pitt Artist pens and Copic Multiliners are the brands I tend to use for inking. Although I do try out others, these are the pens that I feel most comfortable working with. They were used to create the inked drawings in this book. Of course, you do not have to go by my recommendations; I suggest that you try various brands and types of tools to find the one that is right for you.

Faber-Castell Pitt Artist pens come in a range of nib thicknesses (Figures 1, 2 and 3), indicated by the letters on the side: XS = Extra superfine, S = Superfine, F = Fine, M = Medium and B = Brush. Faber-Castell also produce a Big Brush pen that carries their heaviest nib, which is a bit like using a No. 8 brush. My personal favourite is the B nib.

The Copic Multiliner (Figure 4) is a more technical pen than the Faber-Castell and, unlike the Faber-Castell, you can refill it with ink cartridges and also replace the nibs. These pens are available in a number of nib thicknesses, ranging from 0.03–0.7 to brush. Another benefit of the Multiliner is that your line work will not smudge when it is coloured using Copic Colour Markers.

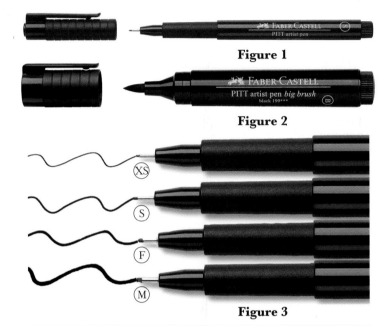

Figure 1

Figure 2

Figure 3

Figure 4

Figure 5

WATERCOLOUR BRUSHES

Watercolour brushes (Figure 5) are also great for inking, although using a brush takes more practice than a pen. The beauty of brushes, however, is that they come in a wide variety of sizes and, in the case of the much larger brushes, enable you to quickly cover broader areas with black. You can buy waterproof Indian ink in any art supplies store.

Techniques

Varying the thickness of a line

Brush nibs and brushes are very versatile as they offer a variable line thickness that is determined by the amount of pressure you apply to the paper. The harder you press, the thicker the line. Fine nibs generally give a consistent thin line, which you can thicken by adding a second layer.

Hatching

Hatching is a method of building up shading using parallel lines. You can create tapering lines by applying pressure at the beginning of the stroke and then reducing the pressure gradually, as shown here.

Cross-hatching

Having created an area of hatching, you can create cross-hatching by repeating the technique at right angles over the first set of lines. This method is used to add texture or shading.

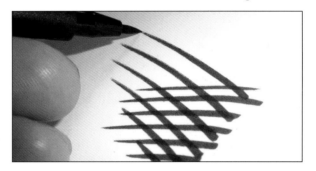

POINTER NOTES

The image in Figure 6 was inked using a Faber-Castell Pitt Artist superfine Pen and a brush Pen.

This picture (Figure 7) was inked using a brush pen.

This image (Figure 8) was inked using a superfine pen for the hatching and line work and a brush pen for the solid areas.

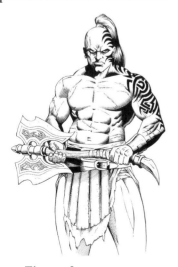

Figure 6

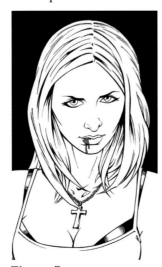

Figure 7

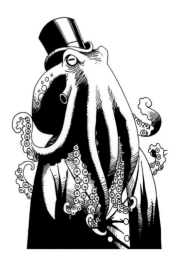

Figure 8

MARKER PENS

I use marker pens for quite a lot of my colouring as the hues are vibrant and can be manipulated by using a blender fluid. There are a number of brands of marker pen available, but by far the most popular are the Letraset Tria and the Copic Marker, of which the latter is my preference.

THREE-NIB PENS

The Letraset marker pen (Figure 1) is considered the best three-nib pen. All nibs are replaceable and the markers are also refillable.

Figure 1

TWO-NIB PENS

Although these marker pens only have two nibs, each type is available with a range of three nib choices: the Classic marker (Figure 2), which features a wide chisel and a fine nib; the Sketch (Figure 3), which has a small chisel and a brush nib; and the Ciao (Figure 4), which has a super size brush nib and a medium-broad chisel nib. All Copic markers are refillable with bottles of Copic ink and all nibs are replaceable.

Figure 2

Figure 3

Figure 4

Techniques

Using different nibs to vary line thickness

The Classic Copic marker nib range enables an artist to easily create lines of varying thickness. The top line was created with the chisel nib and the lines below were created with the fine nib.

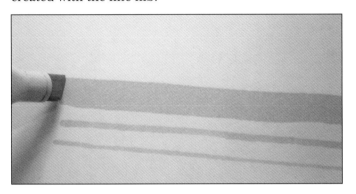

Covering a large area with tone

Drawing slightly overlapping lines with a chisel nib results in a neat area of flat tone and is a quick way to colour a large area.

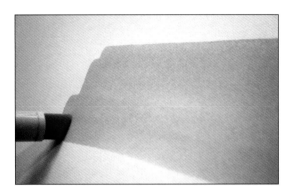

The effect of blender fluid

This image shows how ink in a coloured area reacts to Copic colourless blender fluid that has been applied randomly. Ink disperses outwards through the paper away from the area where the blender fluid is densest, creating a region of paler colour with a bounding ring of darker ink. Blender fluid is also good for creating graduated tone when carefully applied using a chisel nib of a blender marker. The fluid can also be applied using either cotton swabs or cotton buds.

Achieving different effects with the Sketch and Ciao pens

This image shows the various types of line that are achievable with the Sketch and Ciao marker pens. The top line was created with the chisel nib and the thinner lines were created with the brush nib.

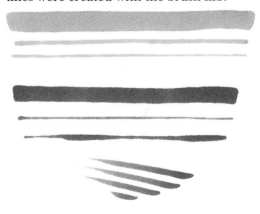

POINTER NOTES

This image (Figure 5) was coloured using Copic markers. There is a breakdown of the application on pages 94–97, so you can re-create the image yourself.

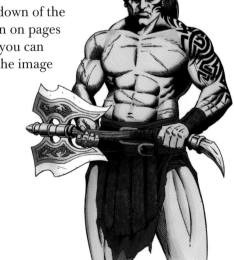

Figure 5

DIGITAL COLOUR

For the best part of my career I have been a traditional artist. By 'traditional' I mean that I usually work with pencils, inks and paint on paper, board or canvas rather than creating images digitally. About 70 per cent of my concept art and storyboard work is coloured using Copic markers and sometimes coloured pencils, but more recently I have begun using Photoshop.

This change came about by chance, when I placed an order for some materials but only a few were immediately available: the other items arrived later but not in time for me to meet a work deadline, so I decided to colour the piece digitally. At the time I used a mouse, which was a slow and clumsy device for certain parts of the colouring. However, the final piece pleased the client so much that I invested in a Wacom graphics tablet.

I have since discovered that using a tablet and computer enables me to work more quickly and saves a lot of money that I would normally spend on materials. I still consider myself a traditional artist, but today I often merge traditional and digital techniques, gaining the best of both worlds as they each offer different benefits.

I approach colouring my work digitally in the same way as I would if I were using markers or

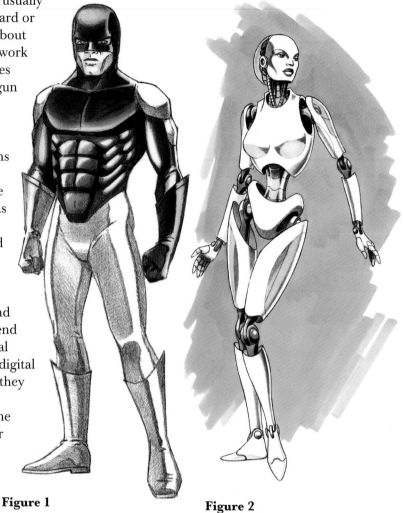

Figure 1

Figure 2

Figure 3

Figure 4

watercolours and, to some extent, acrylic or oils.

I apply a pale wash as a background for the rest of the colours to sit on, which adds depth. I build up the colours using layers, all set to Multiply. This allows colours to interact and blend with the layers. If I were working on a pure white background I could end up with bits of white showing through where the brush strokes are lighter or broken, which would create

a brighter, breezier image. This could be fine if that is the effect you want to achieve.

Figure 1 and Figure 2 are examples of traditional concept art, coloured using Copic markers. I started by laying down a single flat coat of ink with the pen (Figure 3). Figure 4 demonstrates how I built up the depth of colour by applying more layers of the same shade. You should be able to see the strength variations as the layers cross over one another.

COLOURING WITH MARKERS VS DIGITAL COLOURING

Figures 5–10 demonstrate how markers and digital colouring work in pretty much the same way. The images in the left-hand column were created using Copic markers on paper and the images in the right-hand column were created digitally.

If you closely examine the lines created by the marker, you will see that the ink creates a texture as it soaks into the fibres of the paper. This can lend a pleasing quality to illustrations and concept art in the same way that the random and uneven drying of ink or watercolour washes can. Digital colouring always tends to be cleaner and brighter than manual colouring, which can be desirable. Both methods have their own unique benefits that will enhance your art and I will be using both in this book.

COLOURING AN IMAGE USING PHOTOSHOP

Although I do not give explicit instructions regarding colouring images using Photoshop, or the exact CMYK colours I used, it is helpful to have a rough idea of how to start experimenting with this program. The best way to learn is simply to give things a go; that is the main benefit of digital images – unlike hard-copy drawings they can be replicated and saved as separate files so you can try out infinite variations.

1. Scan the finished drawing and save it as a tiff or psd file. Import this file into Photoshop.

2. Create a new layer (Layer 1), then choose the Fill option and select a shade for the base layer. Adjust the opacity until you are happy with the result. Choose the Multiply option from the drop-down menu, which will ensure the layer is transparent.

3. Add details to specific areas of the picture using one of the many brushes and the palette of colours available. It is a good idea to create a new layer, set to Multiply, for each level of detailing so that

Figure 5

Figure 6

Figure 7

Figure 8

Figure 9

Figure 10

you can amend them individually. There are many brushes available online, but I sometimes create my own marks by scanning ink spatters, pencil rubbings and cross-hatching I have produced on paper.

4. To add highlights, use a brush tool set to Normal rather than Multiply, since you don't want highlights to be transparent or to blend with the layers underneath.

LIGHTING

Understanding light and shade and where to place highlights and darkened areas can make or break a good piece of illustration. Figure 1 shows how the position of an object in relation to a light source affects the shadow cast by the object. I learned about shading in relation to light by drawing an object lit by a single light source, the position of which changed in each sketch (Figure 2). This simple technique helped me develop an understanding of how light affects a picture. Face A is lit by a soft front-on light source. Face B is lit by a light source to the side of the head, face C is lit by a low light and face D is lit from above.

Of course, lighting is a lot more complex than it appears in these examples and there is often more than one source. In addition, in a confined space a single light source can bounce off the surrounding walls to create additional light sources. This can be useful for highlighting

Figure 1

A B C D

Figure 2

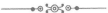

Figure 3

different areas of an object to make them stand out from the background.

Figures 3 and 4 are sketches I produced while on holiday in bright sunshine. I intensified the shadows created by the sun to a solid black. This enabled me to create bold, striking images. The use of dramatic lighting and areas of deep shadow can be used to create an eerie atmosphere in your composition, as in Figure 5.

Figure 4

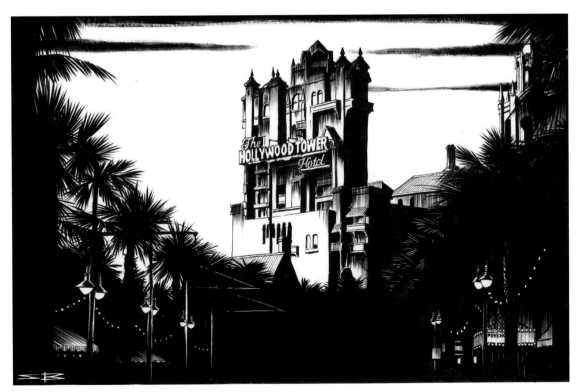

Figure 5

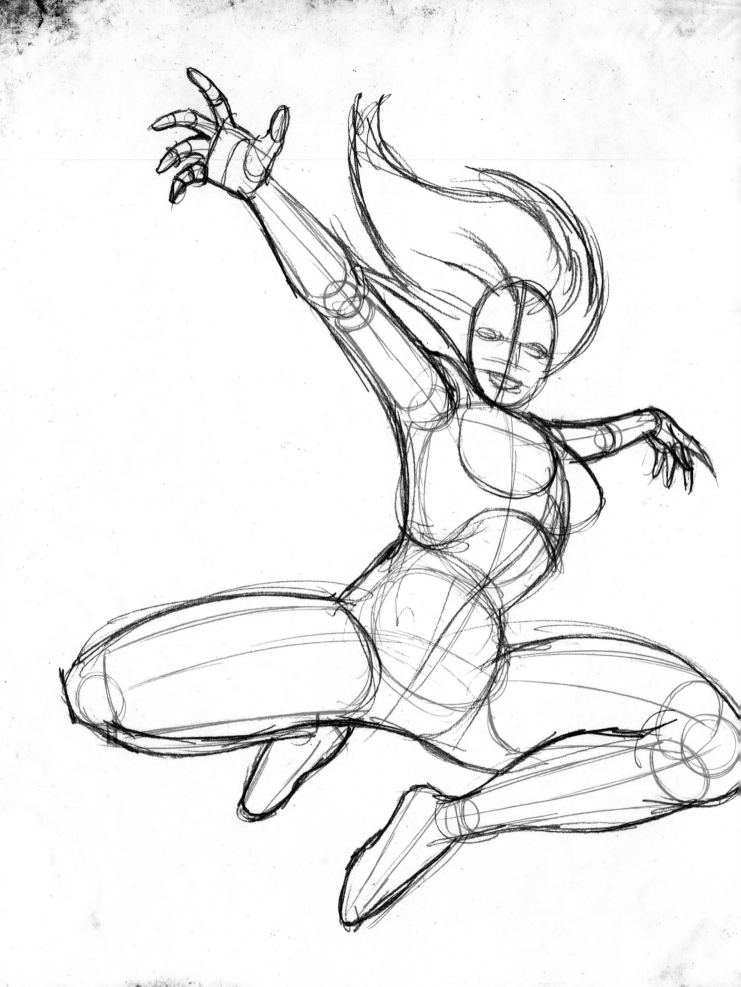

THE BASICS OF FIGURE DRAWING

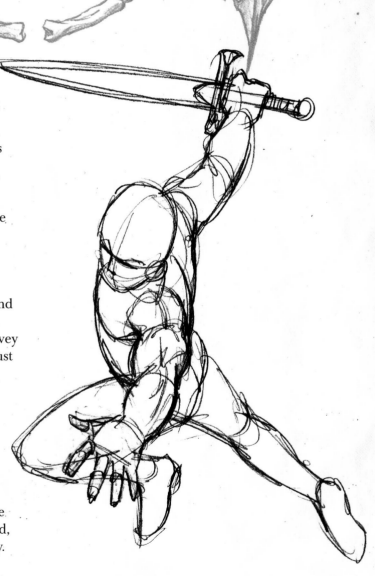

The job of a fantasy artist is to make the unreal seem real and the unbelievable, believable. Almost all fantasy art contains human or human-like figures, whether these are 'normal' or distorted beings or some kind of creature that walks on two legs. They can all be drawn with more conviction if the artist is familiar with basic anatomy.

There are books devoted to the subject of anatomy for artists and they are daunting to look at because of the fine detail they explore and the terminology they use. Fortunately, such an in-depth study is not necessary for our purposes. All you need to know is the proportions of the human figure and, most importantly, how to show figures in action and get different angles of view true to life. A strong stance is vital in fantasy art to convey power, and figures in threatening action must convince the viewer of their reality.

In this section you will discover how to simplify figures by breaking them down into shapes such as circles, cylinders and ovals and learning how those shapes relate to each other when the body moves and takes on different poses. You will soon find it second nature to match the sway of the body to the angle of the legs, or indicate the character of the figure by the tilt of the head, and your drawings will gain life and solidity.

BASIC ANATOMY

A study of the human skeleton is essential, but it is not necessary to know the name of every single bone. Nor do you have to draw a full skeleton every time you sketch a figure; by studying the structure you can simplify it and break it down into some basic shapes. The key is to get the proportions correct.

The image on the left (Figure 1) shows a human skeleton, and the image on the right (Figure 2) shows how this can be broken down into a more manageable frame, which can then be used as the basis of a figure. At this stage, the limbs can be represented by simple stick lines and the rib cage and hips as basic oval shapes.

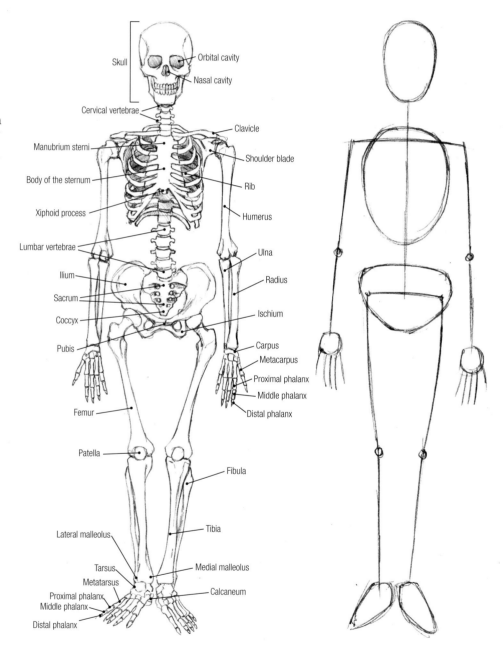

Figure 1

Figure 2

FIGURES IN ACTION

Once you are familiar with the skeleton, try drawing some rough sketches of stick figures in action. If you are drawing someone throwing a punch or swinging a sword, try to imagine the action and the direction of movement, and where the body weight is distributed. For instance, if the figure is throwing a punch it is more than likely that all the body weight will be supported by the leg that is farthest forward rather than by the rear leg.

You also need to consider the flow of movement and action. This flow can be simplified by a single stroke of a pen. This is evident when you look at the images of the upright figure with the staff in its left hand (below); one is annotated with arrows that indicate the direction of the twists and bends of the body, while in the alternative image the line of the pose has been simplified to a brush stroke.

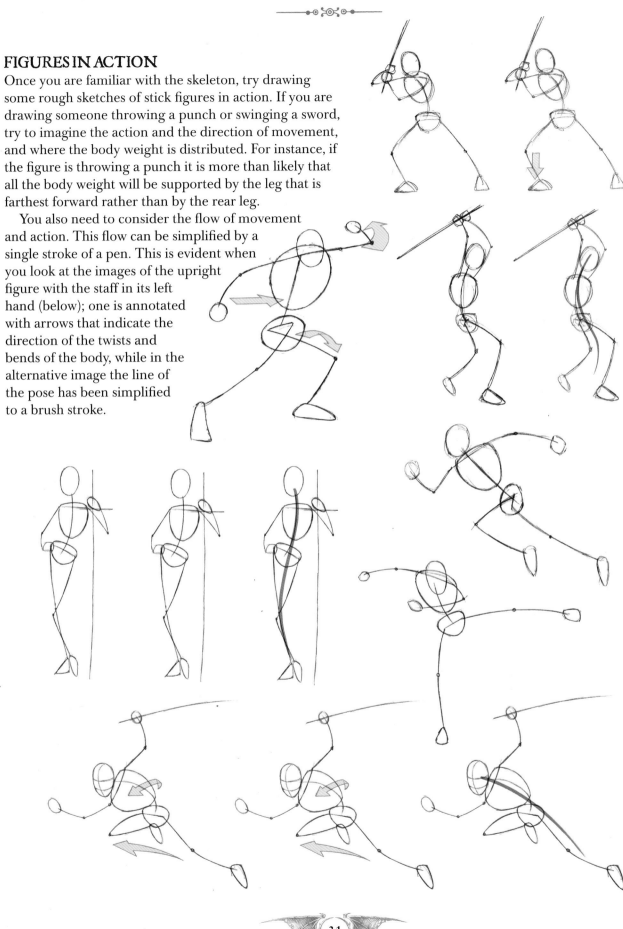

The next stage is to develop the skeletal frame into a more fully formed figure. One of the weaknesses I have noticed in the early stages of many students' work is the inability to gauge the proportions of anatomy correctly. Sometimes the head is too big or too small in proportion to the body, or perhaps the legs are too short or too long. One of the tried-and-tested ways of gauging proportions is to use the head as a unit of measurement. Generally, the body height of the average male is seven and a half heads tall. In fantasy art, however, it is common to exaggerate features, and male figures are often scaled up so their bodies measure eight and three-quarter heads tall. This results in a more athletic, heroic figure than is the norm in the real world.

Figure 1 shows a male with a body that is eight and three-quarter heads tall. The female in Figure 2 is given the same body height proportions, but notice the obvious differences between the two forms. The female's hips are much wider than those of the male in relation to the width of the shoulders. The feminine form is not as muscular – notice the width of the female arms compared to those of the male.

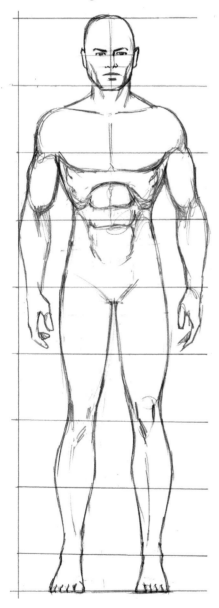

Figure 1

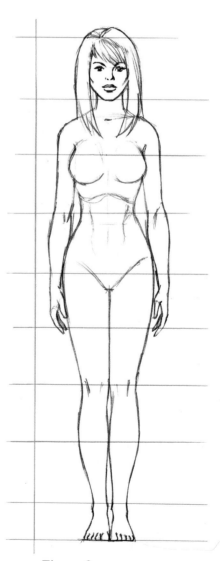

Figure 2

Figure 3 and Figure 4 show how a figure can be constructed using simple circles, ovals and cylinders. This method will enable you to successfully draw a more balanced figure from various angles. Figure 5, Figure 6 and Figure 7 show the stages of development from stick figure to fully formed figure.

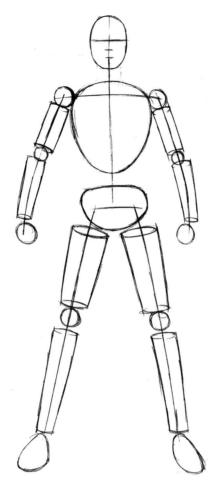

Figure 3

Figure 4

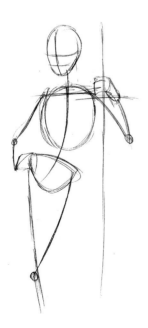

Figure 5

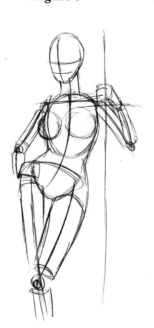

Figure 6

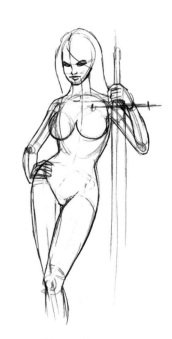

Figure 7

The construction shapes will help you to gauge the proportions of the limbs. With practice, you will probably find you develop an understanding of how the body works, enabling you to sketch out a figure with minimal use of construction shapes.

Figures 8–12 show the development of a figure using construction shapes, and how the outer shape (the skin) fits over them.

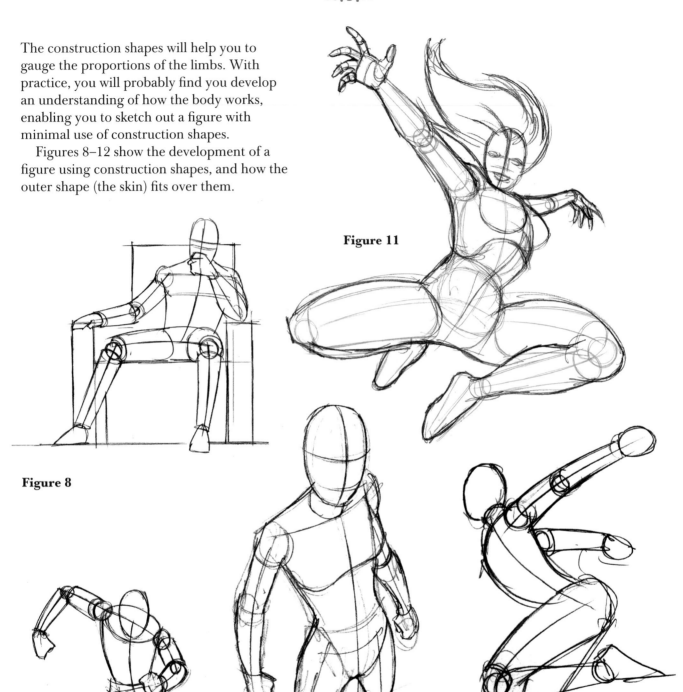

Figure 11

Figure 8

Figure 9

Figure 10

Figure 12

Figures 13–15 show some characters that were drawn in a sketchy style (sometimes referred to as scribbling). This is a technique that uses loose, scribbly lines to build up the form of a human body. The pencil rarely leaves the paper during this process and the form is produced very quickly.

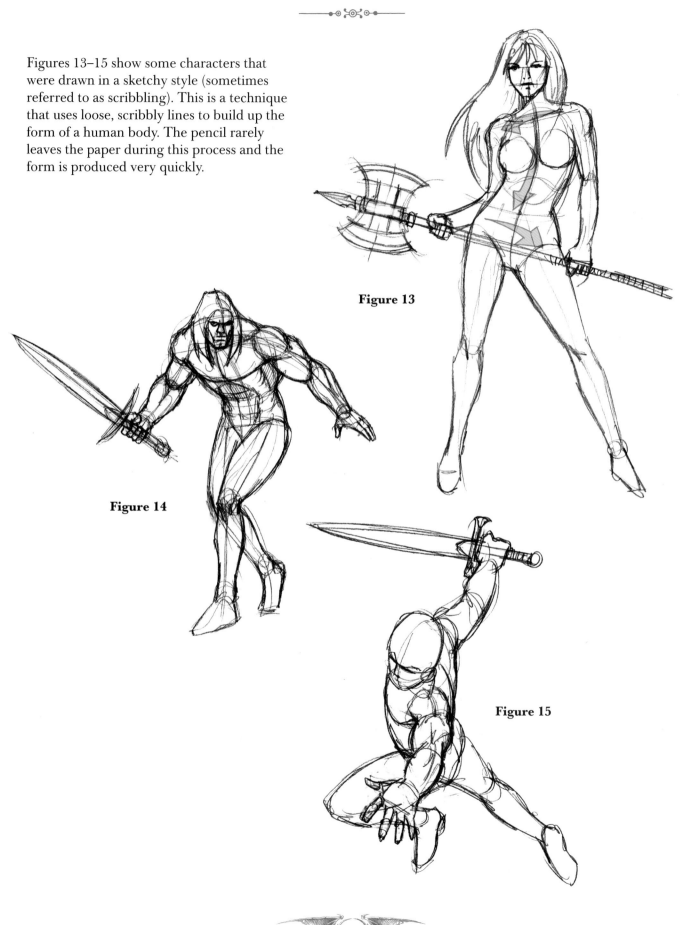

Figure 13

Figure 14

Figure 15

DRAWING MUSCLES

Once the basic framework of the figure has been established, you can go on to build the shapes of the muscles. Muscle structure is something a lot of beginners struggle with. This is usually because they have a limited understanding of the human form and how it works. Also, most of us can't precisely recall how, for instance, abdominal muscles look when a body is in a certain position. We can easily recognize various parts of the anatomy, but re-creating them accurately on paper is another matter; recognition and observation are two very different things.

Fortunately, this is easily remedied. We all have muscles (otherwise we would just collapse!), and they do not have to be well developed for you to study and observe how they work within the body. This is why I recommend studying your own form in a mirror.

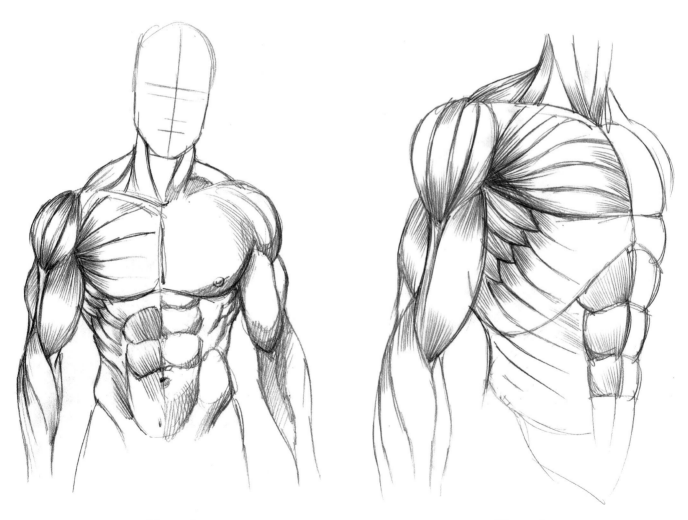

Figure 1 **Figure 2**

I appreciate that some people may be self-conscious, but once you get over your initial insecurities you will find posing in the mirror an invaluable practice. Alternatively, if you have a friend who will pose for you, then that is also a fantastic way to study the human form. Life-drawing classes could be a good idea, although you should bear in mind that some lessons are more about abstract work and lighting than the actual study of anatomy.

Figures 1 and 2 (opposite) show how the biceps, triceps, shoulder, chest and abdomen muscles are drawn as interconnecting shapes, while Figure 3 shows how the various muscles in the leg fit together. Whether large or small, the muscles all begin and end with a point which either overlaps another muscle or ends where a muscle starts. They contract and expand to create different shapes. When a biceps muscle is outstretched, for example, it appears long and thin, but when the arm is bent and the muscle is flexed it becomes short and wide.

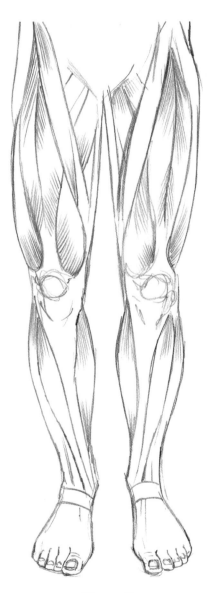

Figure 3

DRAWING THE HEAD

Learning to draw a human head is critical, as most pieces of fantasy art contain a human figure or a variation of one. The proportions of a human skull will usually fit within a square. By dividing this square into four equal sections you can determine the position of the eye line (which is situated about halfway between the top of the head and the chin) and the centre line (the vertical mid-line). These two lines will help you to correctly place the features of the face.

Figure 1 shows the head in profile. Note that the end of the nose sits roughly halfway between the centre line/eyes and the chin, and the top of the visible ear is aligned with the eye.

Figure 2 shows you how to plot the face when viewing it from the front. When drawing the eyes, divide the head across its width into five equal spaces. The eyes will sit in the second and fourth spaces. Of course, in reality the human face varies tremendously and can be many shapes and sizes, but applying these guidelines to whatever shape head you are drawing should help you create a balanced face.

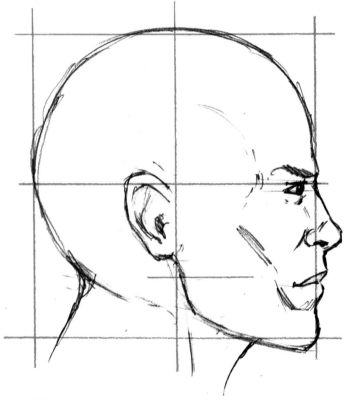

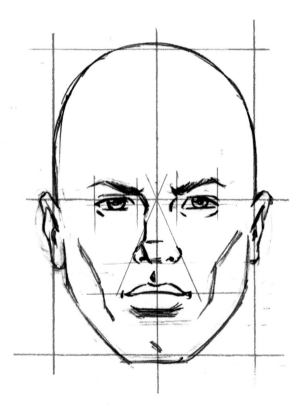

Figure 1

Figure 2

Another popular technique for drawing a head is to use a ball and cube shape. Figure 3 shows the head constructed around these forms. The same principle can be applied whatever the angle of the head, whether shown at a three-quarter view (Figure 4) or a lowered three-quarter view (Figure 5).

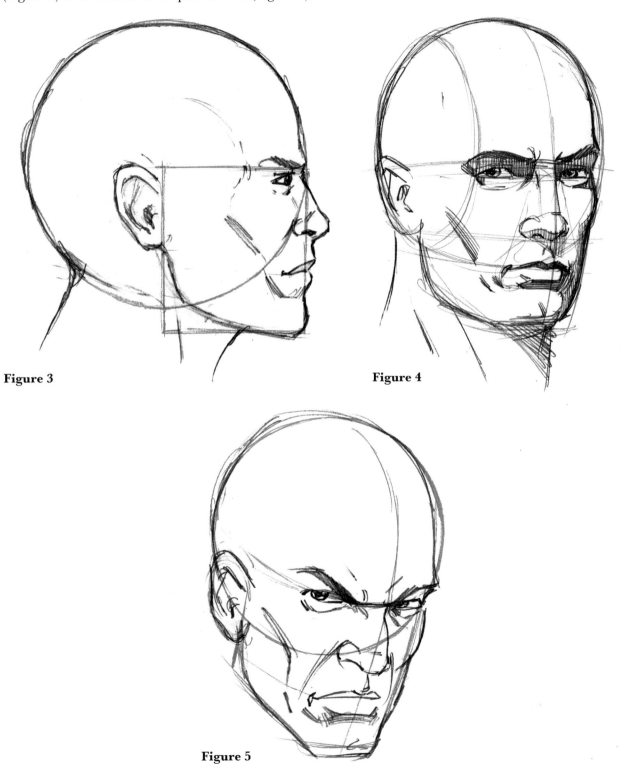

Figure 3

Figure 4

Figure 5

Here we have the female face. Figure 6 shows a round, young-looking face, while in Figure 7 you can see that by using a narrower grid to produce a thinner face the figure appears slightly older. Notice the shape of the eyes, which are larger and rounder (although essentially still oval) than those of a male, and the shape and thickness of the eyebrows. Using slightly bigger eyes on a female character will often make her appear more attractive. Also notice the shape of the female chin in Figure 8, which is narrower and more refined than that of a male, who would be likely to have a square jaw and flatter chin.

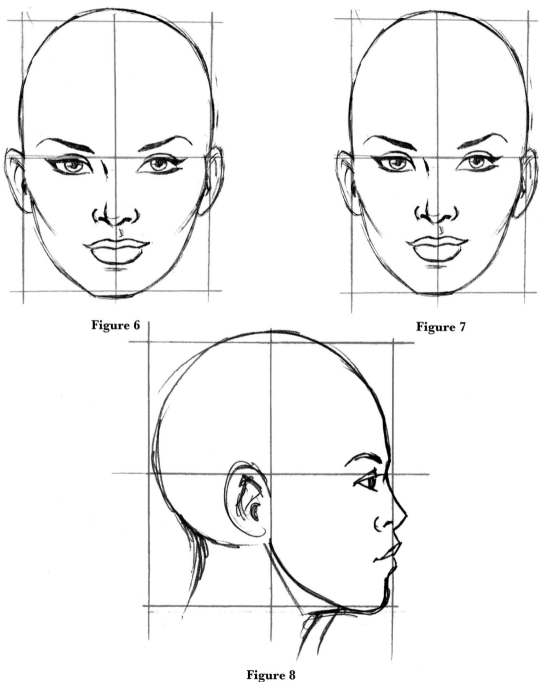

Figure 6 **Figure 7**

Figure 8

As with the male head, I have simplified the construction of the face and head to a ball and cube shape (Figure 9). Have fun drawing the head at different angles (Figures 10–12). It may help to study your own head in the mirror at different angles, noticing what is visible and what is not when the head is tilted back, or turned three-quarters to the left or right, or tilted down slightly. You can learn a lot from studying your own face in the mirror, especially when trying to capture expressions.

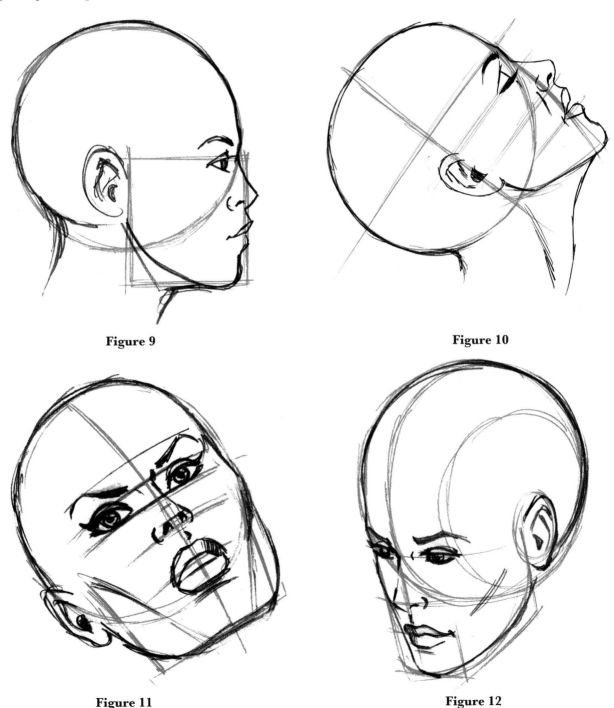

Figure 9

Figure 10

Figure 11

Figure 12

DRAWING FEET

Feet can be a difficulty for many artists but, as with other parts of the anatomy, they can be broken down and simplified. Looking at the foot from the side, think of it as a right-angled triangle and build the foot around that shape (Figure 1). The toes are a lot shorter than the fingers of the hand, so I tend to sketch rough spheres or ovals for the toe ends and to draw in stumpy cylinder shapes between the spheres and the triangle of the foot. The shape of the underside of the foot can be approximated using a top-heavy figure-of-eight (Figure 2). Study and draw your own feet in a neutral position (Figure 3) and then see how the shape varies when you walk or curl your toes (Figure 4). Try to observe carefully, absorb what you see and apply it to your drawing. This is the best way of learning to draw anything.

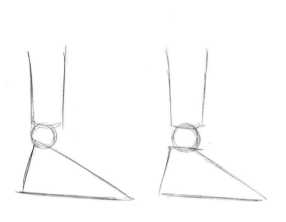

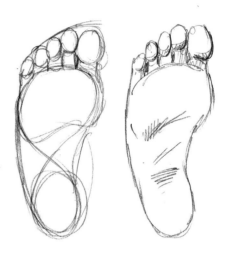

Figure 1

Figure 2

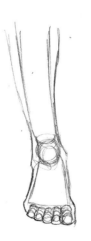

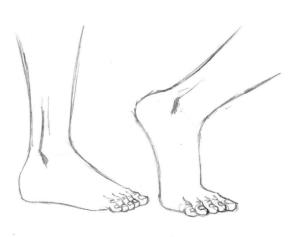

Figure 3

Figure 4

DRAWING HANDS

I learned to draw hands using a classic, tried-and-tested method and this remains one of the best ways to approach drawing these complex body parts. Using construction shapes is a very good start, especially when viewing the hand from above (Figure 5). The back of the hand is essentially a square shape. Each finger has three sections, which can be represented by cylinders. These are connected to one another by two joints along the finger, and at the knuckle, where a small sphere can be used. The thumb is shorter than the fingers and has only one joint. The area where the thumb joins the hand is represented by a triangle. This helps me to position the thumb correctly in various poses.

Once you have completed the construction shapes you can start to flesh out the drawing (Figure 6). When you are satisfied, erase the construction shapes and add the fingernails and other surface details to the hand (Figure 7).

Figures 8–14 are sketches of hands in various poses, and you can use these as a guide for practising some of the more difficult views. I drew these using my own hand for reference, either looking directly at it as I drew or at its reflection in a mirror. There is no doubt that hands are difficult to master, but if you start with simple poses and gradually progress to more complex shapes, with practice you will notice an improvement.

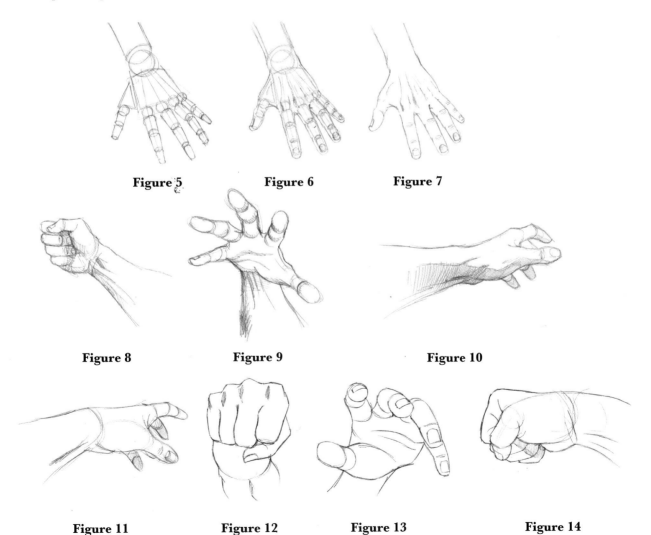

Figure 5 **Figure 6** **Figure 7**

Figure 8 **Figure 9** **Figure 10**

Figure 11 **Figure 12** **Figure 13** **Figure 14**

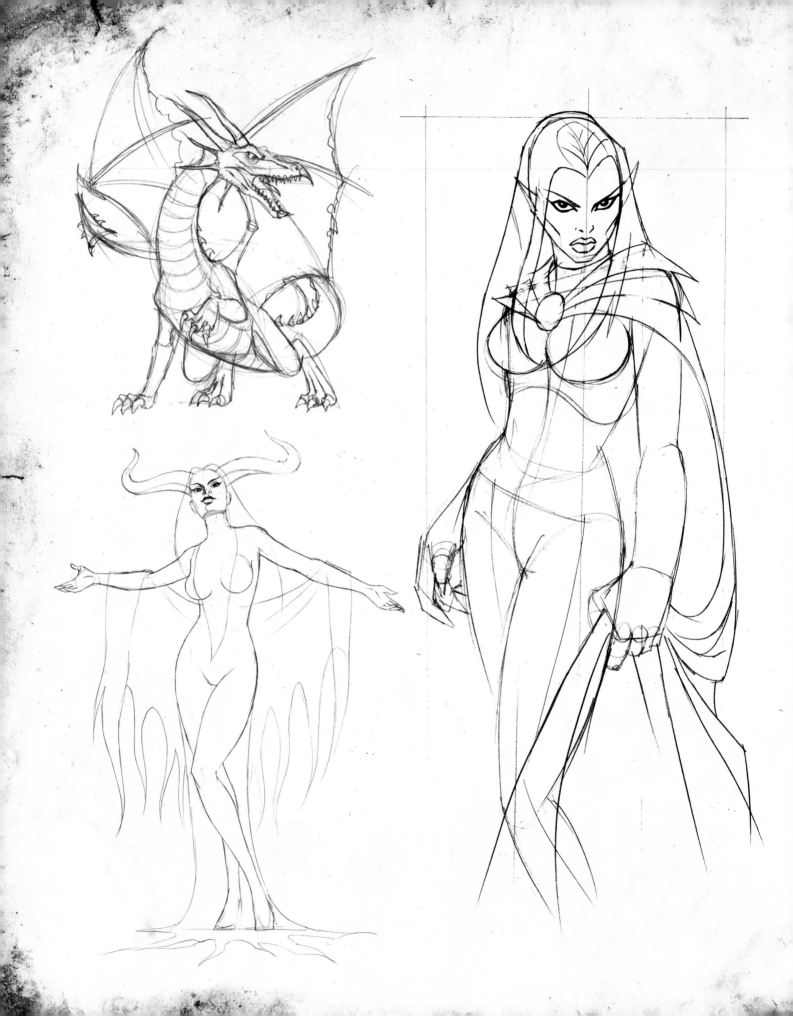

PROJECTS

Now that you have got a grasp of the necessary tools and techniques, you can move on to the really exciting bit – creating your own drawings. In this section of the book you will find a range of fantasy figures to have a go at, from a princess to a gunfighter belonging to the legions of the undead.

The first figures are intended to give you an easy start, so it's wise to draw them before you move on to the more complex images. Tackling one of the latter at the outset risks disappointment before you have hardly begun. Conversely, making a good job of the Elfin Princess, for example (pages 46–55), will give you a lot of satisfaction and confidence – and it's the confidence of the line work and handling of shading that will convince the viewer that they are looking at work by a competent artist.

As you work your way through, you will come to images that have been coloured with Photoshop. This is complex software that takes quite a time to learn in its entirety, but it is possible to use it for the projects here and get good results without having to delve too deeply into everything it offers. If you do not have a graphics tablet, it is well worth buying one for the greater ease of manoeuvring on screen it gives you – the large 'professional' tablets are costly, but there are smaller ones for non-professional use available that are much cheaper. While a tablet will be the most expensive piece of kit compared to pens and pencils, it will really liberate the way you work digitally.

So, enjoy the projects and do not be afraid of making mistakes – each one will teach you something and set you on your way to being a better artist.

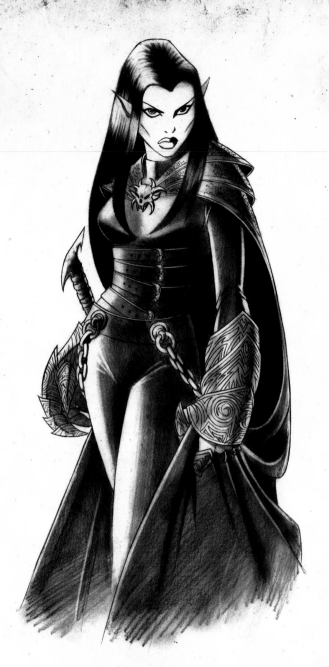

ELF PRINCESS

This first exercise is a good way to build up your confidence in figure drawing before tackling the more complex characters in the book. The main point of focus here is achieving the correct stance, as the attitude of the figure is conveyed through the pose. Drawing the character will also give you a chance to tackle clothing, armour and accessories, all of which are part of character design.

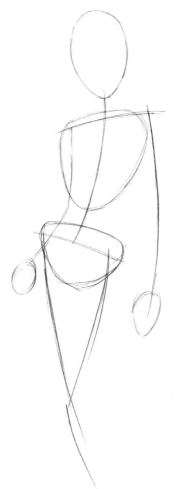

STEP 1

Begin by drawing a skeleton frame, using the techniques outlined on pages 30–31 and referring to this image as a guide. It is important to get the stance right before moving on to the next stage. If the pose is not balanced, all the shading and armour in the world will not disguise the fact that the figure's pose is weak.

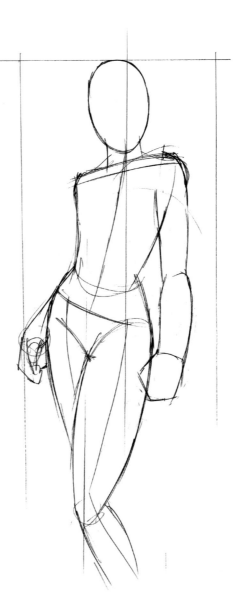

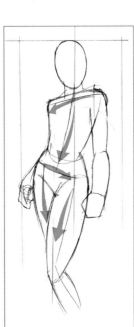

Figure 1

STEP 2

Once the skeletal figure has been drawn with the correct stance, flesh out the outer shape of the body and check the stance again, as it is easy to start over at this stage if you find it is unbalanced. The red arrows in Figure 1 clearly show the various angles of the pose. Notice that the figure is putting her body weight on her right leg (her left as we are looking at her), which is causing her hip to tilt and her left leg to bend. Her shoulders are also affected by the position of her legs – her right shoulder is lower than her left. The angle of the head is also important – notice that it turns towards us, adding another twist to the spine.

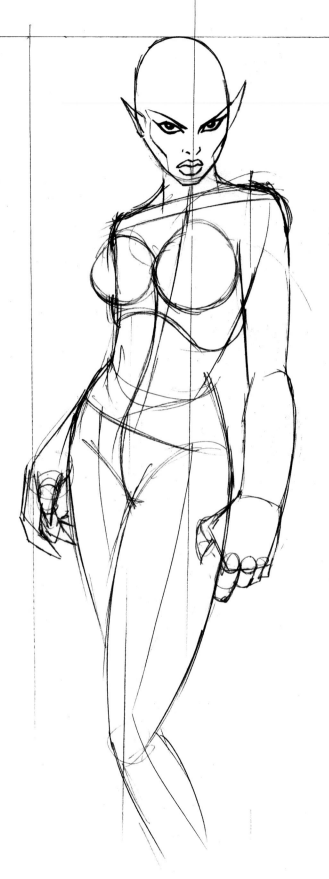

STEP 3

Once the pose has been established and you are happy with the balance of it, the rest of the body can be fleshed out. The breasts rest on the ribcage area and for now can be round or slightly oval. When drawing the face, keep the features simple. Try not to overwork it by adding too many lines. Notice I have not drawn the entire line for the nose, merely implying its position by carefully placing nostrils in the correct place. Because the head is tilting downwards, her eyes are looking slightly up towards her eyebrows (Figures 2 and 3). Once you are happy with the face, you can carefully erase the guidelines (Figure 4).

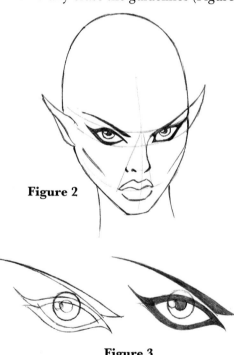

Figure 2

Figure 3

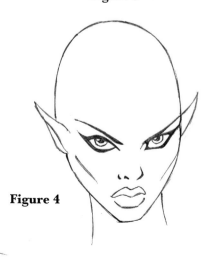

Figure 4

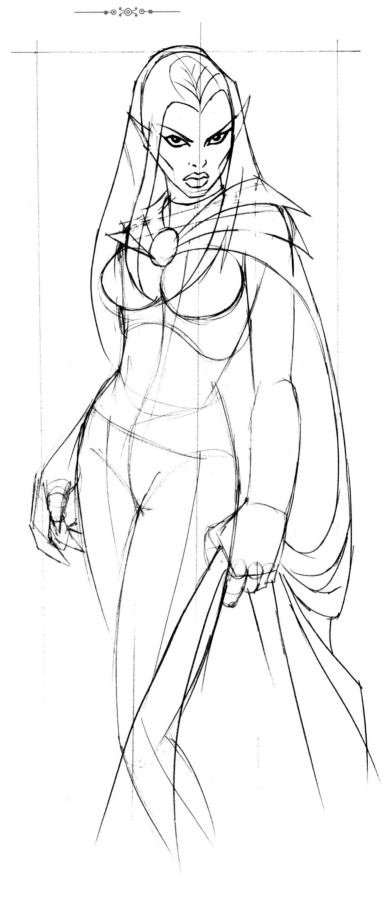

STEP 4

Now you can add details such as the hair and cape. Keep the shapes simple when drawing the hair. Go for curves that are aesthetically pleasing and try not to make things unnecessarily complicated. The same applies to the cape that hangs from her shoulders. When it comes to drawing clothing, a good point of reference is to look in the mirror and observe how garments fit and hang from your own body. For the cape, you could throw a sheet or blanket over your shoulders to see how it hangs down.

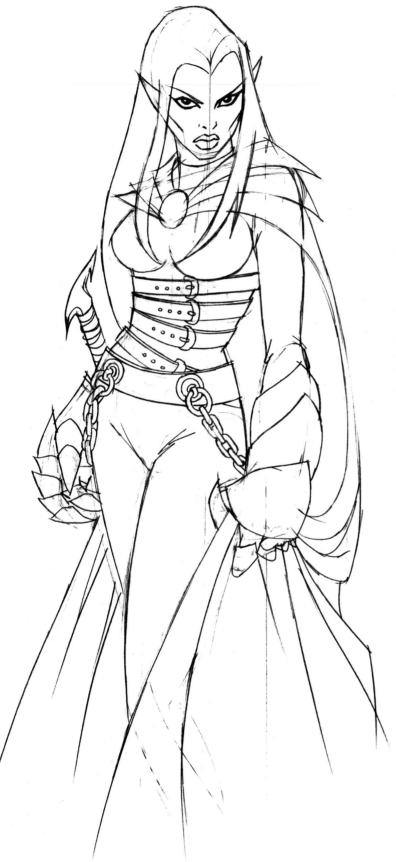

STEP 5

The clothing worn by the character now needs to be drawn. I chose a leather or rubber bodysuit that adheres to the contours of the body, and added belts, straps and chains to lend the figure extra interest. I also gave her a pair of metallic gauntlets, which make her hands appear more powerful.

This part of the design process is where the character develops, so it is important to think about what details to add and where to position them. You can gain inspiration for different looks in many places, from the high street and fashion shows to books, magazines, movies, video games or the internet. For this character I referenced photographs of medieval armour. When drawing the chains, think about the thickness of each link and how they interlock with each other (Figure 5), and try to render this accurately.

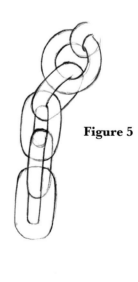

Figure 5

STEP 6

Having established the main shapes and position of the clothing and any embellishments, these can now be decorated with finer detail. When it came to drawing the detail on the gauntlet (Figure 6), I took inspiration from a book on medieval armour (Figure 7). It is essential to have a point of reference when drawing an unusual item, if you hope to represent it correctly.

Before applying the first layers of shading, I decided to alter the clasp for the cape. I felt the original shape was a bit boring, so I changed it to a more interesting demonic skull shape (Figure 8).

Figure 6

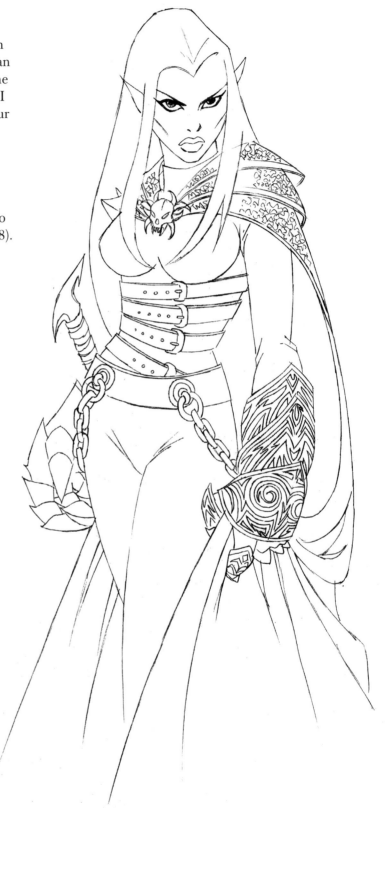

Figure 7

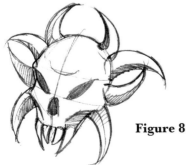

Figure 8

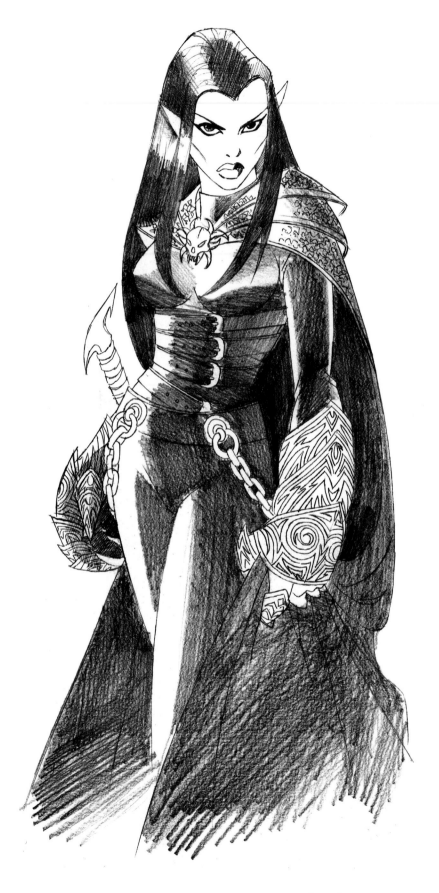

STEP 7

Once the outline drawing has been finished, areas of tone need to be blocked in. I applied an even layer of shading for the base layer. As I knew there were not going to be too many layers of tone for her clothing, I applied an overall dark tone using a B lead. Leave areas of white for the highlights on the left-hand side (as we are looking at the picture), which indicate that the main light source is to the left of the picture. This will make it easier to strengthen the highlights with an eraser later. As this drawing is not a full figure and does not include the lower legs and feet, the shading gradually fades out at the bottom of the page.

STEP 8

Once you are happy with the base layer, softly blend it with tissue paper, then apply a second layer for the darker tones on her hair (Figure 9), the underside of her breasts and the inside and folds of her cape. For blending the hair I used a No. 5 blending stump (Figure 10).

Figure 9

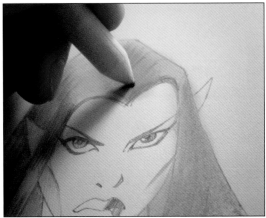

Figure 10

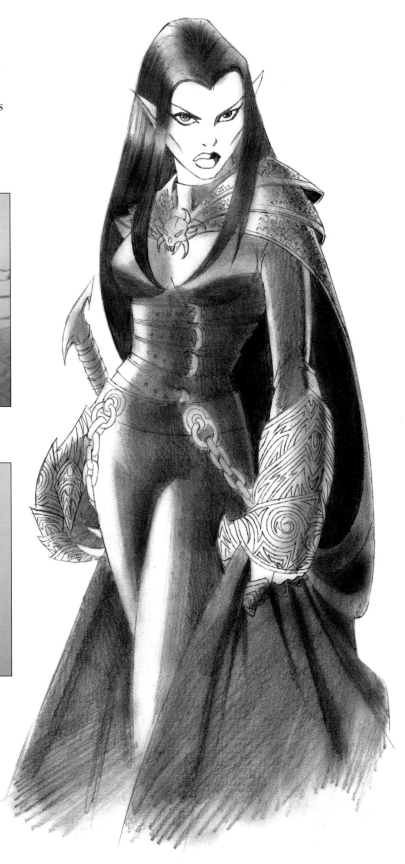

STEP 9

Once the blending is correct, apply highlights with an eraser. Use the fine edge of a plastic eraser or mould a putty rubber into a fine point to get into the more fiddly details, such as the belts and chains (Figure 11). Define the highlights by chiselling away with the sharp edge of an eraser. Think of the eraser as adding and not removing – rather as if you were painting white highlights with permanent white gouache. The light source is mostly coming from the left of the figure as we are looking at her, so the bolder highlights are on the left-hand side, with some less dominant ones to the right, indicating a weaker light source to the right.

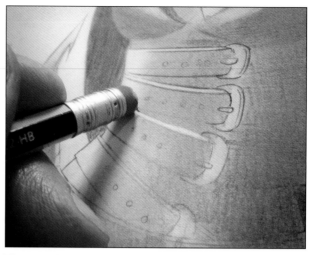

Figure 11

Having applied all the final shading and highlighting, clean up around the outside of the drawing with an eraser, being careful not to erase any of your drawing (Figure 12).

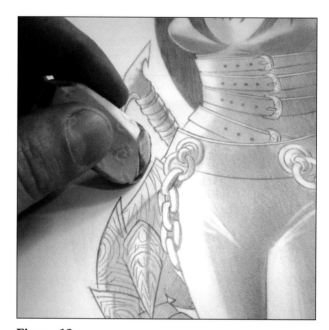

Figure 12

Finally, go around the drawing using a sharp HB pencil and add a crisp, hard line to any areas that need defining (Figure 13), such as the outline of the hair and cape and the detail of the gauntlet and belt. The finished drawing can be seen on the facing page.

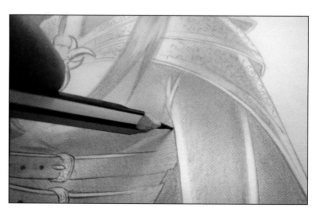

Figure 13

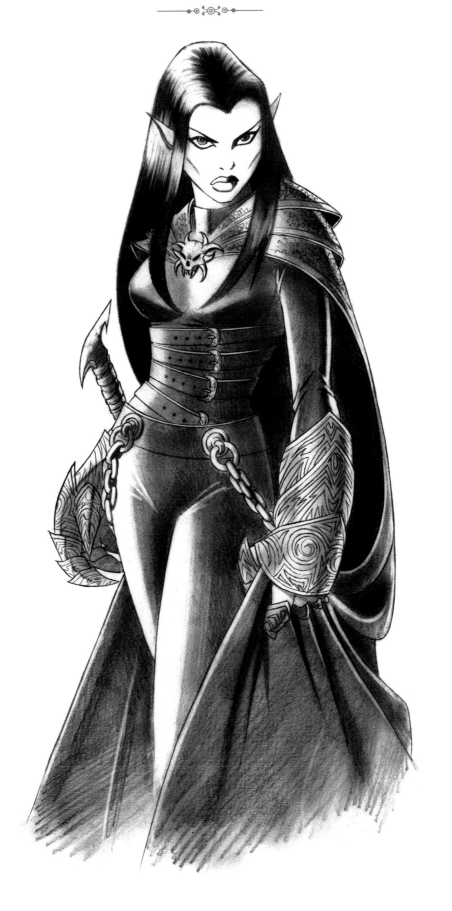

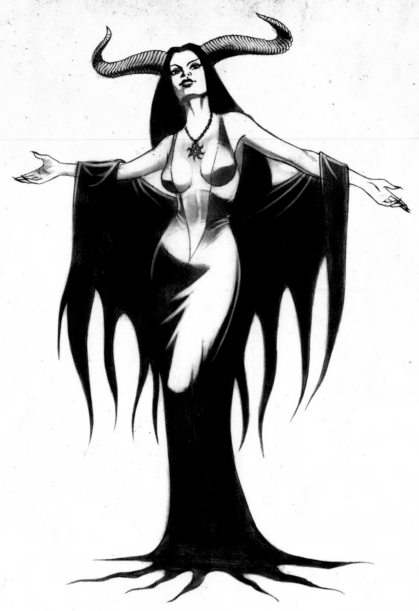

PROJECT 2

ENCHANTRESS

Here is another simple figure-drawing exercise for you to have fun with. As with the first one, this introductory tutorial is designed to help you become familiar with basic techniques and develop your confidence.

The inspiration for this drawing came from the characters Darkness (played by Tim Curry in Ridley Scott's *Legend*) and Malecifent (from Walt Disney's *Sleeping Beauty*). Darkness is a demonic figure with massive bull-like horns, and Malecifent wears a headdress/helmet with huge twisting horns, and a long black gown. Even though Malecifent is evil and not meant to be the most attractive character in the movie, there was something strangely appealing about her.

STEP 1

Start by drawing the skeletal frame. Notice that, as in the first exercise, the twist of the spine and the angle of the hips and shoulders establish the attitude of this pose. All the body weight is on the right leg, which is straight, making the left leg bend at the knee. The shoulders tilt down towards the raised hip. The head is tilted back slightly. Before moving on to the next stage, make sure you have successfully drawn a balanced pose.

STEP 2

When you are happy with the pose, flesh out the body frame with simple geometric shapes.

STEP 3

Now round out your figure with more natural curves. Be careful not to make it look masculine; this is a female body, so keep to slender shapes and pay attention to the arms and waist.

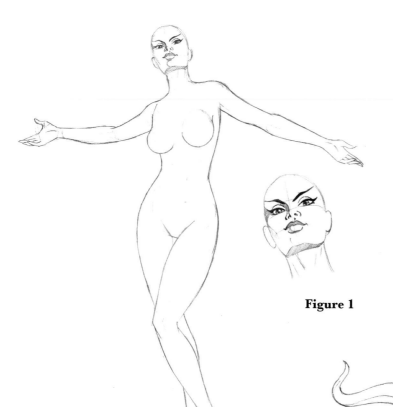

Figure 1

STEP 4

Once you are happy with the shape, erase the guidelines on the body and concentrate on adding detail to the head. Figure 1 shows a close-up of the face. This may be a little tricky to draw at first, but try a few practice attempts on scrap paper first. Notice that the head is tilted back, making the underside of the chin and nose visible. The trick is to avoid making her look as though she has a pig-like snout. I have kept to simple lines, eliminating unnecessary detail that could make her face look unattractive.

STEP 5

You can now add the horns and outerwear. I chose to keep the shawl simple, with no embellishments except for the fringing details at the bottom.

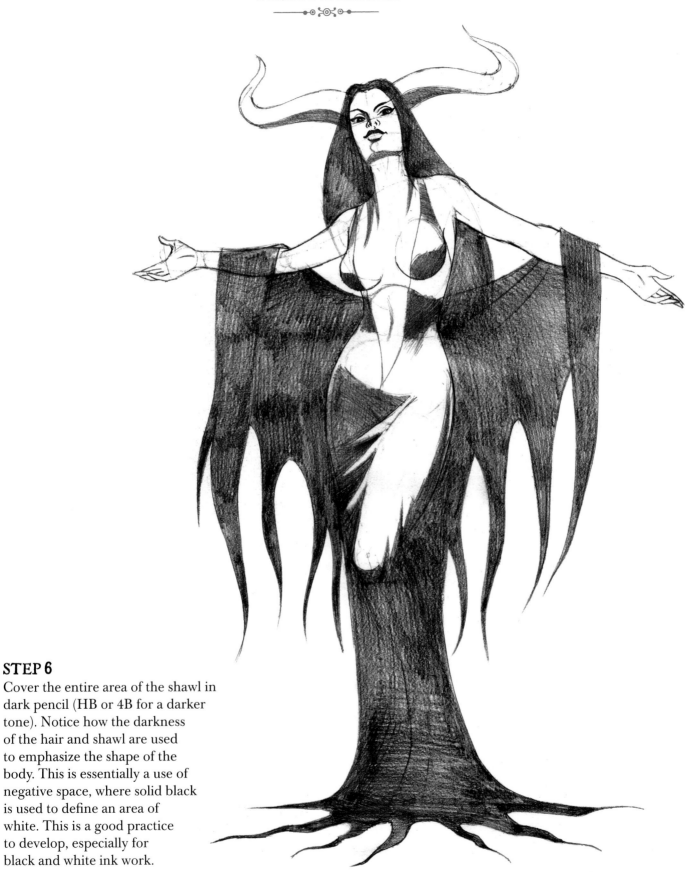

STEP 6

Cover the entire area of the shawl in dark pencil (HB or 4B for a darker tone). Notice how the darkness of the hair and shawl are used to emphasize the shape of the body. This is essentially a use of negative space, where solid black is used to define an area of white. This is a good practice to develop, especially for black and white ink work.

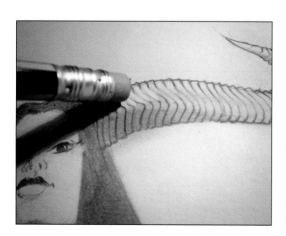

STEP 7

Using a blending stump, blend the pencil work to give a smoother finish.

STEP 8

You can now fine-tune the drawing and refine details, such as darkening and defining lines. When adding detail to the horns, make sure your pencil has a sharp point so that you can draw a large amount of ridge detail without all the line work merging.

STEP 9

Use the fine edge of an eraser to create highlights on the horns, gown and shawl. This will give extra detail to the clothing and interest to the drawing.

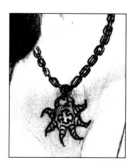

STEP 10

Now assess the picture as a whole. Does anything need adding? I felt the space created by the open cut of her dress looked a bit too bare and needed some kind of amulet or chain to create a bit more interest. Notice how the design of the amulet echoes the shapes of the dress and shawl. Always try to make all the elements of your drawing look like they belong together.

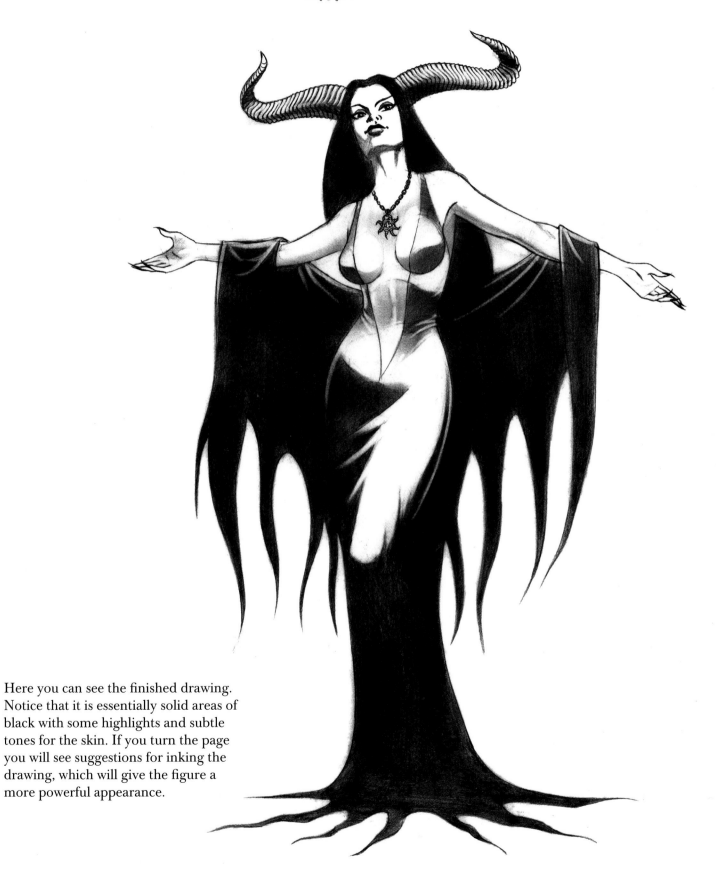

Here you can see the finished drawing. Notice that it is essentially solid areas of black with some highlights and subtle tones for the skin. If you turn the page you will see suggestions for inking the drawing, which will give the figure a more powerful appearance.

Figure 2

Having completed the drawing using pencils, you can now consider inking it for a more dramatic effect. Figure 2 was inked with a Faber-Castell brush nib, which creates different strengths of line work. Notice that the line work on the arms and figure is bolder and varies in thickness. Try to make the line work define the contours of the figure – the areas closer to the light source should be thinner and the areas furthest from the light source should be thicker.

This alternative image (Figure 3) was inked with a sable No. 2 Winsor & Newton watercolour brush, with the result that the line work is a little looser in areas, creating a softer effect.

Figure 3

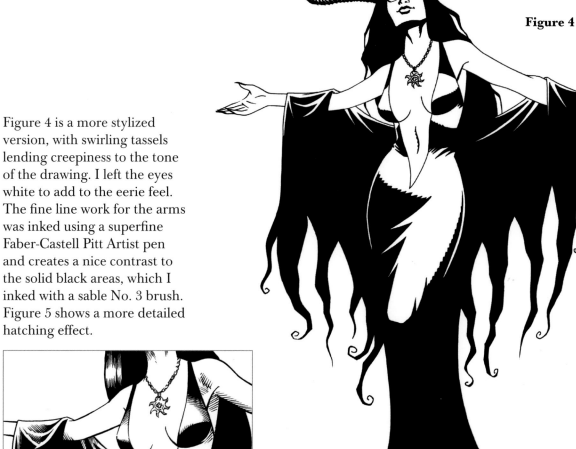

Figure 4

Figure 4 is a more stylized version, with swirling tassels lending creepiness to the tone of the drawing. I left the eyes white to add to the eerie feel. The fine line work for the arms was inked using a superfine Faber-Castell Pitt Artist pen and creates a nice contrast to the solid black areas, which I inked with a sable No. 3 brush. Figure 5 shows a more detailed hatching effect.

Figure 5

PRACTICAL TIPS

There are many things to consider when drawing, including your posture, how you hold the pen or brush and which part of the drawing to ink first.

• If you are going to spend a lot of time drawing you will need to consider how you sit and what you rest your pad or paper on while you draw. Most professional artists work at an angled drawing board. Drawing on a flat surface is not only bad for your back, it can actually affect how you draw your artwork. It certainly influences

how you view your artwork as you draw it; an angled drawing board allows you to see your work from a better perspective, whereas a flat surface can cause distortion. If a drawing board is beyond your budget, try a lap board, which you can rest against a table or on your lap.

• If possible, sit near a window that gives you as much natural light as possible. If you are working under a lamp, try using a daylight bulb.

• If you are using a brush, try holding it at a high angle, so that it is almost vertical. This will give

you more control over the brush. You may find that a low angle inhibits your movements.

• Conversely, if you are using a pen to ink work, you may find that holding the pen at a low angle is best, as a high angle often does not give enough control.

• If you are right-handed it is a good idea to start work from the left-hand side of the drawing, so that your hand moves away from your freshly laid ink and you avoid smudging. If you are left-handed, work from right to left.

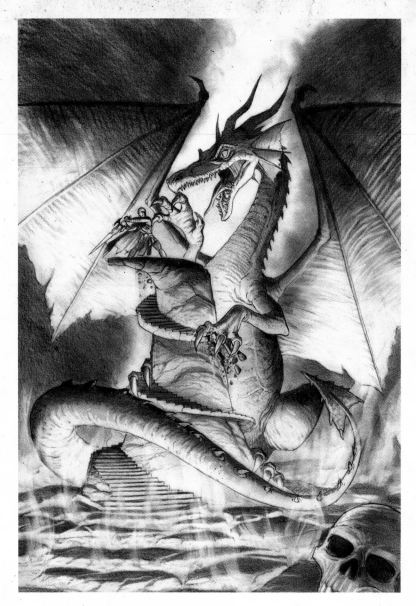

PROJECT 3

◦•◦❧◈☙◦•◦

DRAGON'S LAIR

◦•◦❧◈☙◦•◦

Featuring in the mythology of many countries – including Japan, China, the UK, France and South America – dragons are one of the most recognized and frequently depicted creatures in fantasy art. Although they are sometimes portrayed as the guardians of fabulous treasure and secret gateways to hidden lands, these memorable beasts are more often shown wreaking havoc on villages and castles or locked in fierce combat with a heroic warrior. For this drawing I have chosen the latter scenario.

This exercise will draw upon the disciplines of figure drawing, composition and lighting and requires a pencil and a piece of paper. I used a Staedtler HB pencil on Winsor & Newton 300gsm cartridge paper.

Before jumping straight into the action I thought it would be helpful, for those of you who have not drawn a dragon before, to look at how relatively easy it is. Also, it will be a good warm-up exercise to prepare you for the main drawing.

I usually start any drawing by producing rough, loose sketches, keeping the line work light so that I can continue to draw over the top of it (Figure 1). I find reducing a subject to simplified shapes can be helpful while you are becoming acquainted with a new form, so I have shown here how the form can be broken down using some red shapes. I have not gone for the usual circles, blocks and cylinders – instead I have roughly drawn an oval for the body and created some pleasing curves for the tail and neck (Figure 2). When sketching the shapes, keep them loose and rough. Do not become too involved with drawing the shapes – remember you are drawing a dragon, and that is your focus (Figure 3). Try to let the lines flow. Once you have created a natural-looking pose that you are happy with, you can start to develop the sketch further by adding more detail (Figures 4 and 5).

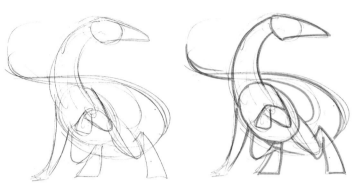

Figure 1 **Figure 2**

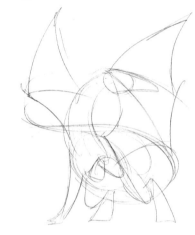

Figure 3

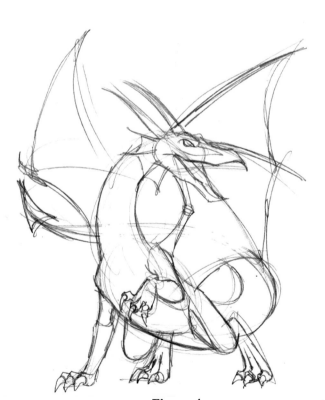

Figure 4

Figure 5

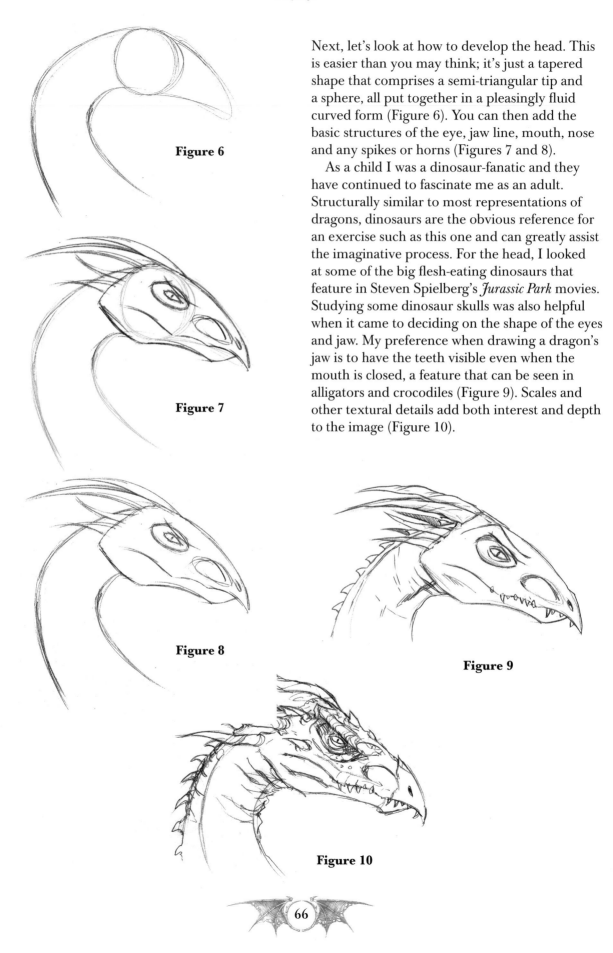

Next, let's look at how to develop the head. This is easier than you may think; it's just a tapered shape that comprises a semi-triangular tip and a sphere, all put together in a pleasingly fluid curved form (Figure 6). You can then add the basic structures of the eye, jaw line, mouth, nose and any spikes or horns (Figures 7 and 8).

As a child I was a dinosaur-fanatic and they have continued to fascinate me as an adult. Structurally similar to most representations of dragons, dinosaurs are the obvious reference for an exercise such as this one and can greatly assist the imaginative process. For the head, I looked at some of the big flesh-eating dinosaurs that feature in Steven Spielberg's *Jurassic Park* movies. Studying some dinosaur skulls was also helpful when it came to deciding on the shape of the eyes and jaw. My preference when drawing a dragon's jaw is to have the teeth visible even when the mouth is closed, a feature that can be seen in alligators and crocodiles (Figure 9). Scales and other textural details add both interest and depth to the image (Figure 10).

Figure 6

Figure 7

Figure 8

Figure 9

Figure 10

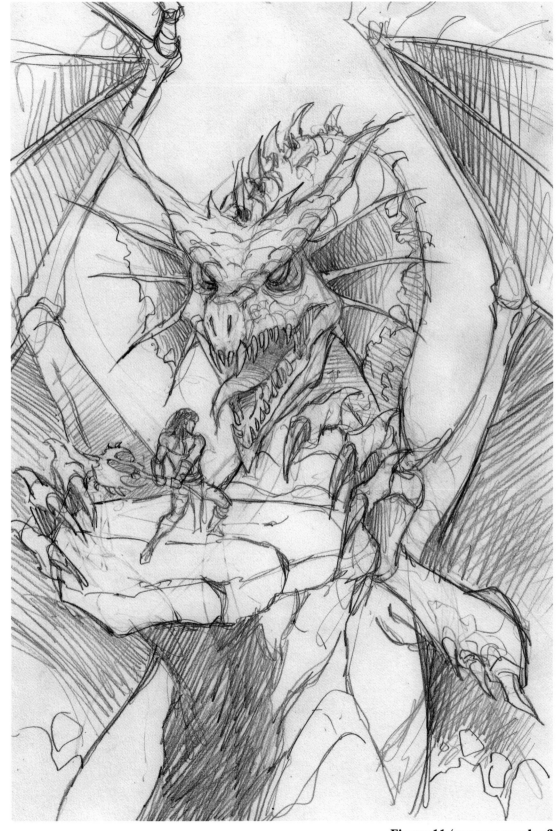

Figure 11 (see text overleaf)

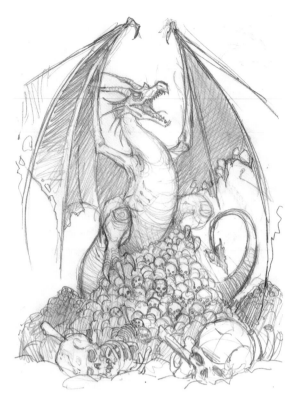

Figure 12

Figures 11–14 are the rough thumbnails and concepts explored in the thought process that helped me arrive at the final image. In most of the roughs (not all of them are featured here) the wings were used to draw the viewer in to the centre of the image, where the action is taking place. The ever-reliable, tried-and-tested framing devices of a large sphere and a pillar of smoke were used to isolate the shape of the dragon and draw attention to the action.

Although I liked the close-up, intense image in Figure 11, its composition didn't leave space for much scenery. Since this book focuses not only on the figures but also the environments that complete the picture and provide mood and atmosphere, I felt that a wider shot was necessary which incorporated both a full-figure dragon and its setting.

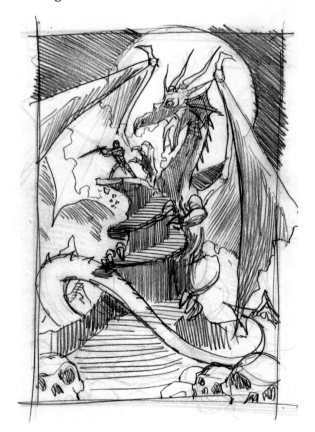

Figure 13

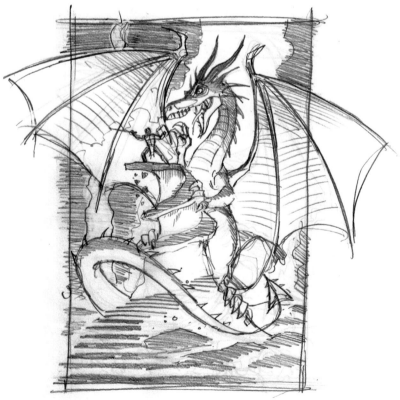

Figure 14

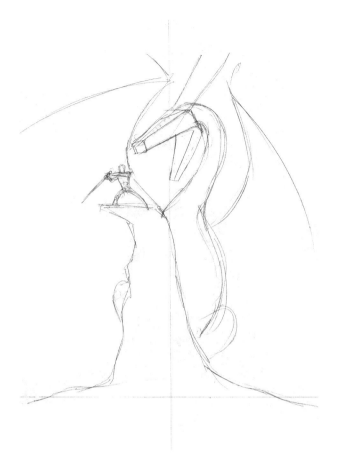

STEP 1

Start by plotting out the content of the layout. For the purposes of clarity I have adjusted the strength of the line work so that it prints clearly, but I recommend you keep the rough plotting light so that it can easily be corrected with an eraser and you can work over the top of it successfully. You will notice that all the elements are composed around a central vertical line. The dragon's head is at a very slight angle so the inside of its mouth will be visible. If it helps, think of the head as a tapered rectangle shape, roughly drawing the sides as I have done, then build the features around it.

STEP 2

Add the limbs, tail and wings to the dragon. Wrapping the tail around the stone ruin enables the dragon to further dominate the scene, and the wings provide a framing device. Pay attention to the form of the feet and hands, as these can be difficult to perfect. If necessary, practise sketching them on a scrap of paper before adding them to the artwork.

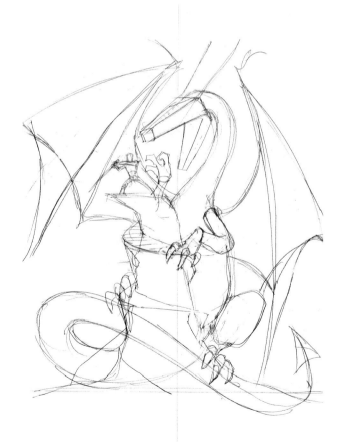

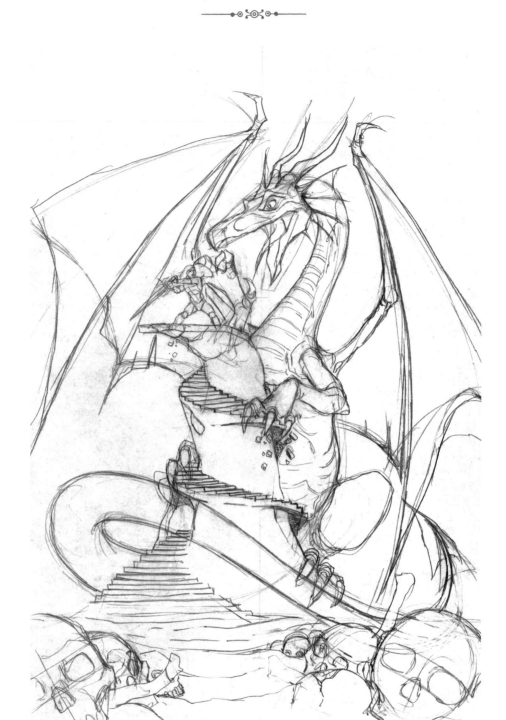

STEP 3

Begin to add more detail to the dragon and the ruin, taking time to plot the winding steps carefully. Notice that I have added other points of narrative interest, such as the dragon's claw demolishing a section of the steps, to suggest that this is a final battle, a point of no return for the warrior. You can also start to plot the foreground using a low point of perspective. The skulls in the foreground do not follow the perspective lines, as the ground is uneven and full of sunken areas. The skulls are there to suggest that many have tried and failed to conquer the beast.

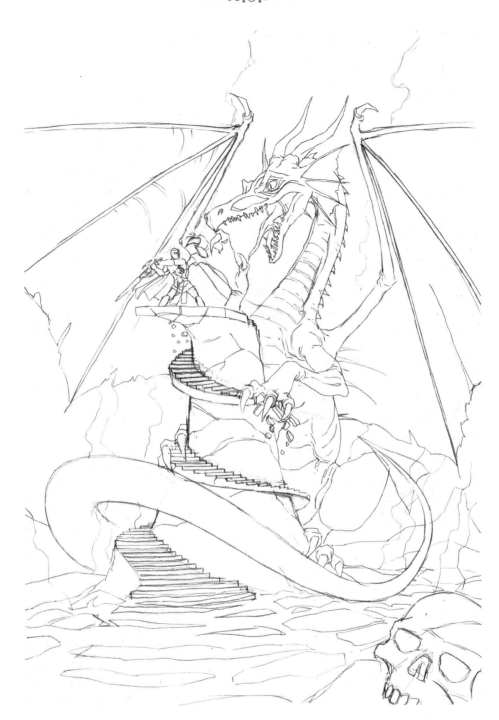

STEP 4

Take a look at the composition. Do the elements work well? What is the focus of the drawing? I decided that my eye was drawn too much to the skulls and I wanted it to be focused on the main point of interest – the battle scene. I removed most of them, leaving one at the bottom right as a reminder of previous defeats. I decided to draw the ground as broken and floating on a bed of molten lava, to make the environment even more perilous. Notice that I have adjusted the angle of the steps at the base. At this stage, if your drawing is looking a bit grubby, you might want to trace it on to a clean sheet of paper using a lightbox, if you have one.

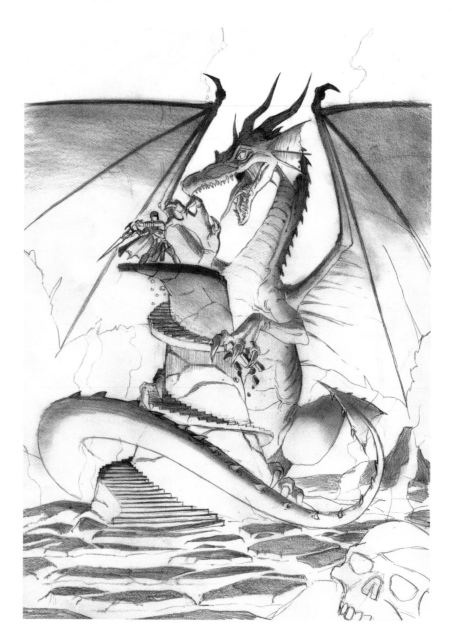

STEP 5

In order to begin shading the outline, you need to identify where the light source is coming from so that you can determine which areas are highlighted and which are in shadow. In this instance, since the ground is lava – a source of intense heat – it makes sense for the lighting to come from below, creating shadows to the higher outer areas of the dragon and the scenery. Begin to shade in these areas and identify the parts that will be darkest and will anchor the image (Figure 15).

Figure 15

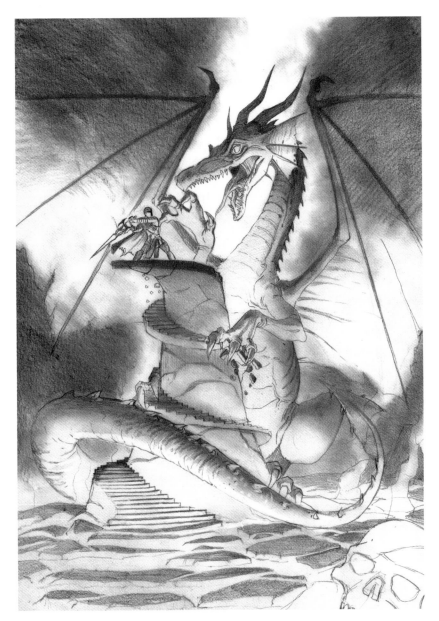

STEP 6

Once the darker areas have been identified, begin work on building up layers of tone over all areas of the drawing. This will act as a base layer upon which you can add layers of darker tone, more detail and textural interest.

Blend together the first layers of shading to meld the pencil strokes and create a smoother overall tone. I vary my tools for blending – I may use a blending stump for smaller areas and a sheet of tissue paper wrapped round my index finger for larger areas (Figure 16).

Figure 16

STEP 7

To create the textured effect on the dragon's wings, hold the pencil at a low angle, almost flat, and run it across the paper, using any texture within the paper's surface to add to the effect. Use this same technique on the dragon's skin, applying more pressure to create darker tones.

STEP 8

Once all the textures and tones have been applied, go over the drawing with an eraser to remove any unwanted pencil marks and shading where it interferes with the clarity of the line work.

STEP 9

I also use an eraser to create highlights, which help to lift the foreground from the rest of the background tone.

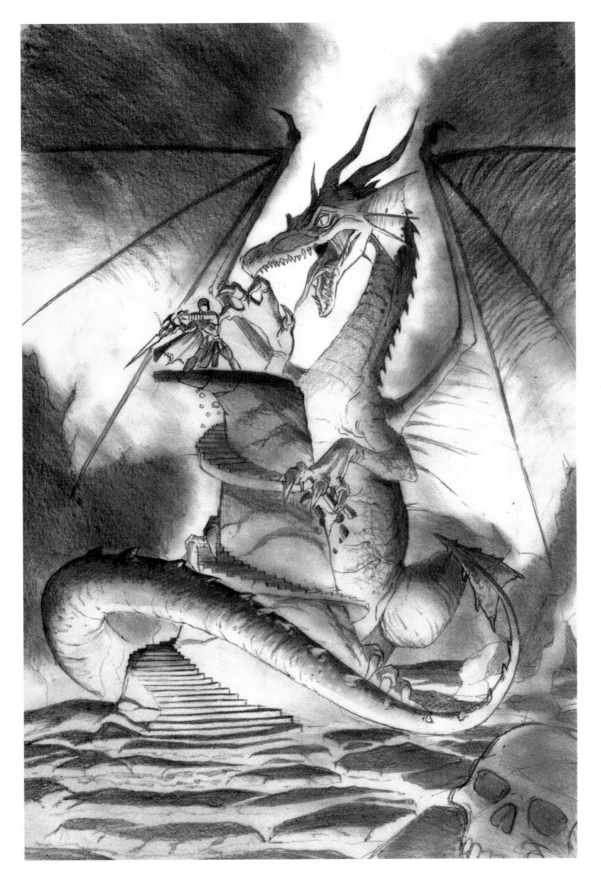

STEP 10

After creating highlights with an eraser, reapply pencil to any of the line work that may accidentally have been erased or smudged. You need to create a defined outline that will make the dragon stand out. Use as sharp a point as you can for this. Some artists prefer to use a technical pencil for crisp line work, but a very sharp pencil will do just as well. Make sure that details such as the claws and teeth, which should look razor-sharp, are very crisply defined.

STEP 11

Use the flat edge of an eraser to add shafts of flickering light emanating from the molten lava below the dragon. The larger, flatter eraser won't totally erase the pencil work – instead it will make the shafts of light appear slightly translucent. Lastly, use a smaller eraser to create finer highlights and give the effect of flames. Sit back and assess the piece, making any last corrections or adjustments as required.

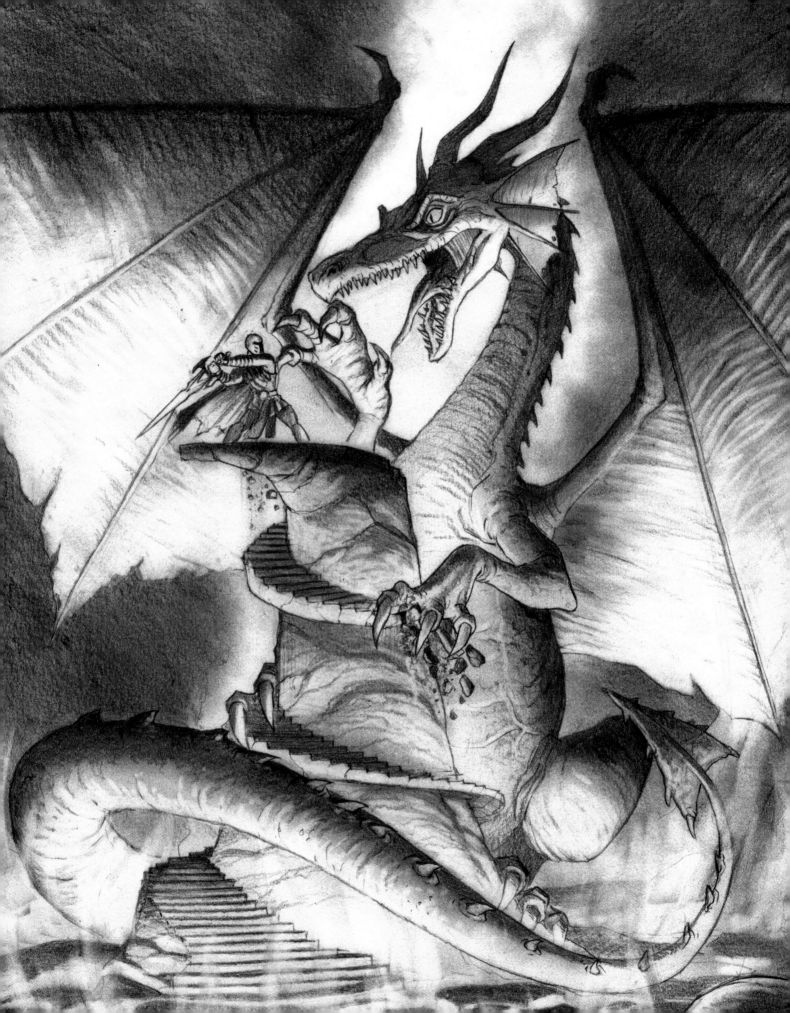

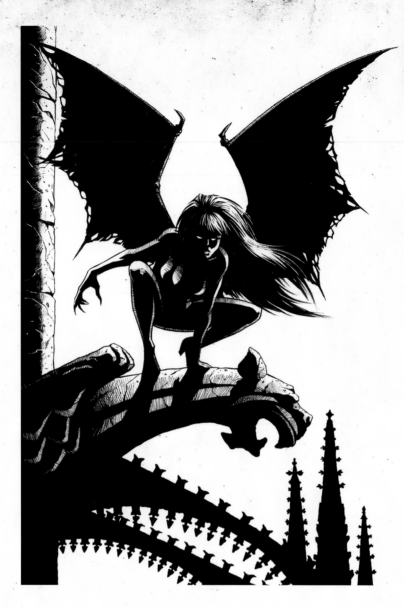

PROJECT 4

❖◦❖◦❖

CREATURE OF THE NIGHT

❖◦❖◦❖

Since my teenage years, I have been a fan of the comic-book character Vampirella and, more recently, Selene, played by Kate Beckinsale in Len Wiseman's *Underworld* series of vampire movies. This relatively simple artwork is inspired by both those characters. You will be able to produce it as a pencil or an ink drawing.

Initially, I had an idea to produce a drawing greatly influenced by Vampirella (Figure 1), in which the character is perched on a gargoyle and framed by a Gothic arch opening. However, having produced the rough thumbnail sketch, I realized it was not the layout I wanted to draw. I therefore produced another quick thumbnail sketch which looked more like a demonic Batman character (Figure 2). As soon as I saw it, I knew there was something about it I liked. I then created a third thumbnail sketch, returning to a female figure and including more Gothic architecture (Figure 3).

What I liked about the third thumbnail sketch was that most elements were more or less depicted in silhouette. It pleased me that the figure could work as a silhouette and details were left to the imagination of the viewer. Sometimes an image which requires viewer input can be more provocative than a more explicit one. The curves of the gargoyle and the flying buttress create a nice design, too.

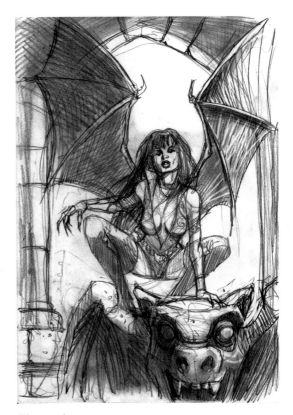

Figure 1

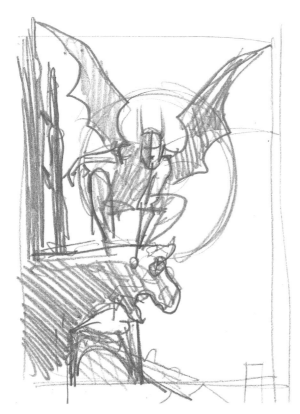

Figure 2

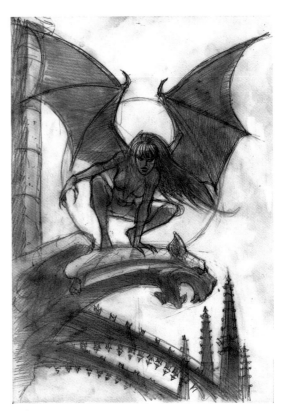

Figure 3

Since this image includes Gothic architecture, I thought it would be helpful to provide some images for reference. Almost any material you require for reference can be found on the internet, and it is well worth doing your own research so that you can create a better composition. Figure 5 shows an example of a flying buttress, a structural feature of many grand buildings and an aesthetically pleasing setting for a fantasy drawing. Some buttresses have ornamental stonework, as shown in Figures 4 and 5, which can be used to add texture and atmosphere to a drawing. Figure 6 is a pretty good reference image for the type of gargoyle depicted in the rough sketch, but there are hundreds of other examples available.

When I visit any towns or cities that have interesting architecture, I try to remember to take a camera and/or sketchbook with me in order to record any information that may be of interest at a later date. Figures 7–10 are examples of sketches from some of my days out. Figure 7 shows how crockets (hook-shaped decorative elements common in Gothic architecture) are used to decorate a spire. Figure 8 is a close-up drawing of how the detail would have looked before age and weathering took their toll, the results of which are shown in Figure 9. Figure 10 is a finial, a detail typically carved in stone and employed decoratively to emphasize the apex of a gable or other distinctive ornaments at the top, end or corner of a structure. Architectural finials were once believed to act as a deterrent to witches on broomsticks attempting to land on the roof.

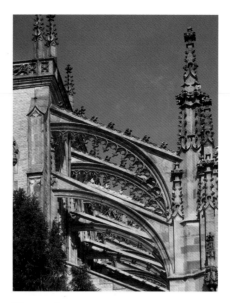

Figure 4

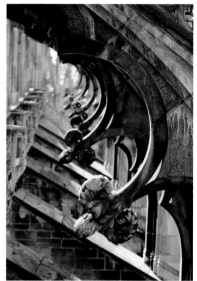

Figure 5

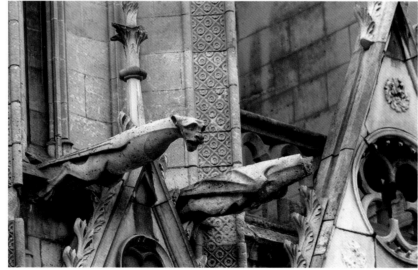

Figure 6

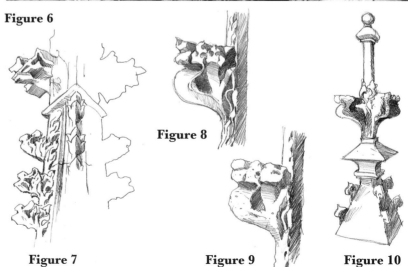

Figure 7

Figure 8

Figure 9

Figure 10

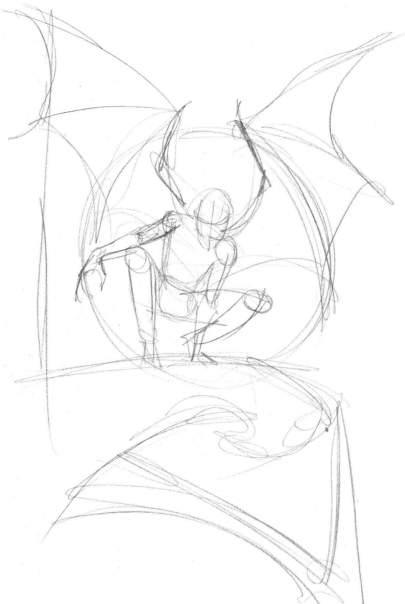

STEP 1

Start by loosely sketching out the composition on a large sheet of paper. Here, I started again and went back to basics, creating the figure using circles, ovals and cylinders and sectioning the face before fleshing out the construction shape. Using this method will help you to create a more balanced and accurate figure.

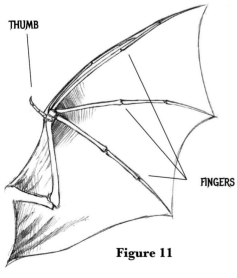

Figure 11

Practise drawing the anatomical features on a separate piece of paper (Figure 11), so that you are familiar with them and can render them accurately in the finished piece. When drawing wings resembling those of a bat or dragon, try to keep in mind the structure of a wing and how it is held together – not dissimilar to a human arm and hand. The bat has an arm in two parts, with four fingers and a thumb. The digits are very long, however, and the skin that forms the wing is stretched across the arm and fingers. The bone structure of a bird's wing is also similar (except that it does not have four fingers) and the 'arm' folds in the same way. Here, I decided not to draw the skin that covers the upper outer area of the arm on a bat's wing as I wanted to create a more angular shape around the head.

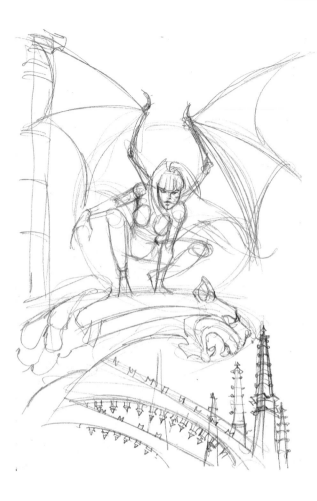

STEP 2

Draw in the outline of the surrounding building, referring to photos and the finished image for this project and making rough sketches on a separate piece of paper if necessary. It is a good idea to use vanishing points and guidelines so that the perspective is correct (see page 240), especially when drawing buildings. I have not drawn in too much detail on the figure, gargoyle or architecture, as they will mostly be solid black. I have sketched just enough information in order to plot the shapes as accurately as possible.

When drawing the decorative architectural details on the flying buttresses and the crockets on the spires, I went for irregular, inconsistent shapes. If you study the stonework of old buildings you will notice how age and the elements have worn away the shape of the stone, and I wanted to replicate this weathering.

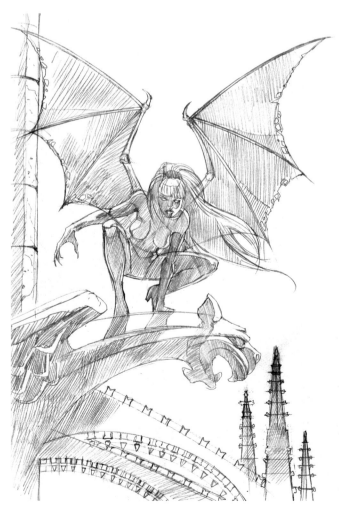

STEP 3

Now it is time to add highlights to the gargoyle and to the outer edges of the figure, to prevent them from looking flat. As I had decided to make this a black and white ink drawing, I chose not to include the full moon in the background, which was going to be used to frame the figure, as it was no longer needed. Nor did I add any highlights to the architecture in the background, so I didn't shade those areas.

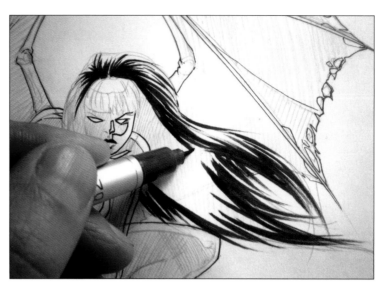

STEP 4

Once you are completely happy with the picture, it is time to ink it in, starting off by going over the outlines with ink. How I approach inking a drawing can vary each time. Sometimes I use a couple of brushes – one for fine detail and a larger one for filling in – or I may just use a Copic Multiliner brush pen as I can produce both fine work and broad strokes with the same pen. For this drawing I used a Faber-Castell Superfine pen to create an outline to ink to.

STEP 5

Ink in the hair without producing an outline first, as this could make it look too mechanical; there should be some texture to the outer shape of the hair. I used a Copic Multiliner brush pen, which produces flowing, natural-looking lines.

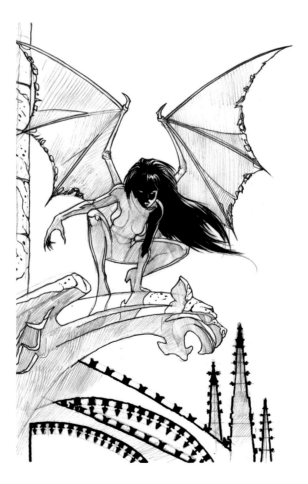

STEP 6

Use a brush pen rather than a superfine pen to ink in the architectural details, as these shouldn't look too precise and sharp.

STEP 7

Fill in the outlines in solid black, where required, using a brush and ink. Take care to leave highlighted areas white and do not smudge the ink. Leave the ink to dry thoroughly.

STEP 8

You can now start adding textures and tone. I applied ink to the stone wall using a flat brush. By loading the brush sparingly, the ink thins out as the brush travels across the paper, creating a dry-brush effect. The texture of the paper also adds to the effect, depending on its coarseness. Add in any hatching to areas that require shading. Continue to use a Faber-Castell superfine pen to create the hatching on the gargoyle and the wings.

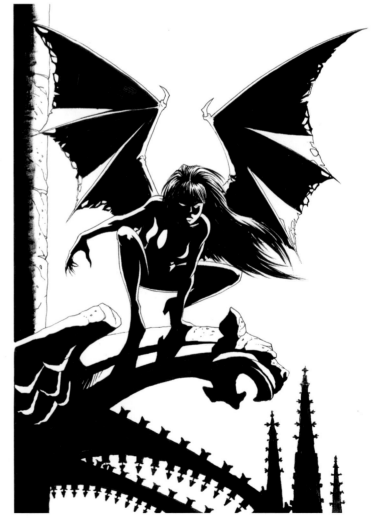

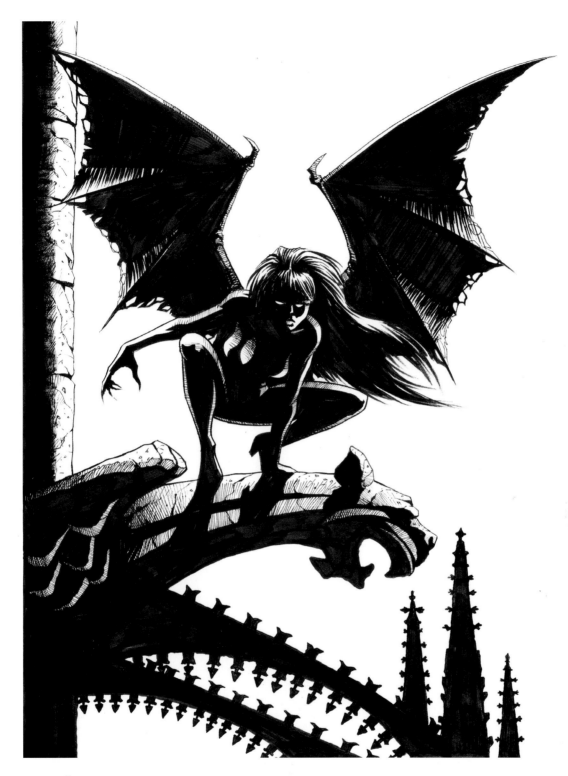

STEP 9

Now it is time to evaluate the drawing. Does the foreground stand out against the background, or is more work required? In this case, I was satisfied that the details and texture on the gargoyle successfully create the illusion of perspective, with the gargoyle and figure appearing to be some distance in front of the flying buttress and spires in the background.

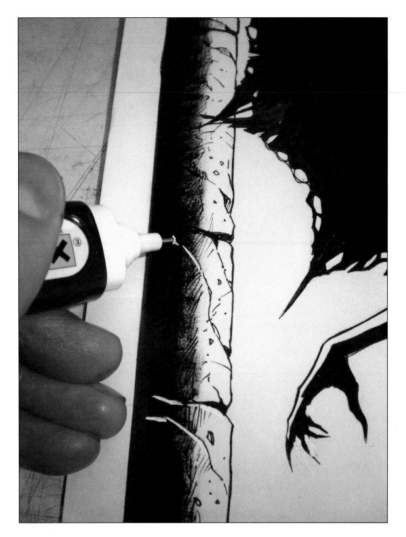

STEP 10

Once you are satisfied with the textural aspects of the drawing, assess whether you could apply more highlights to add extra interest. Using a Pentel correction pen, I sparingly drew in some fine cracks and specks on the stonework. Details such as these can also be created using opaque white ink and a fine brush or a sharp white crayon pencil. Use whichever medium you feel most comfortable with.

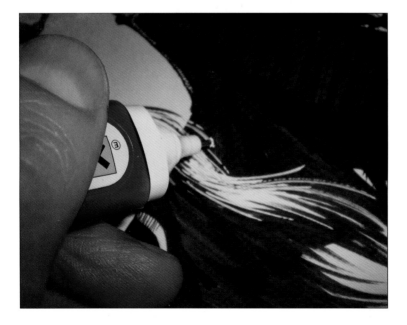

STEP 11

Add highlights to other areas, such as the hair (for which I also used the Pentel correction pen). Again, the same effect can be established using opaque white ink and a brush or a white crayon pencil.

STEP 12

Assess the image again. Are there any elements you think need changing? In this instance, I chose to ink over the detail on the inside of the wing (see facing page), but decisions such as this are largely a matter of preference. If you feel your drawing will look better with the detail remaining, then keep it; do whatever you feel gives the best result.

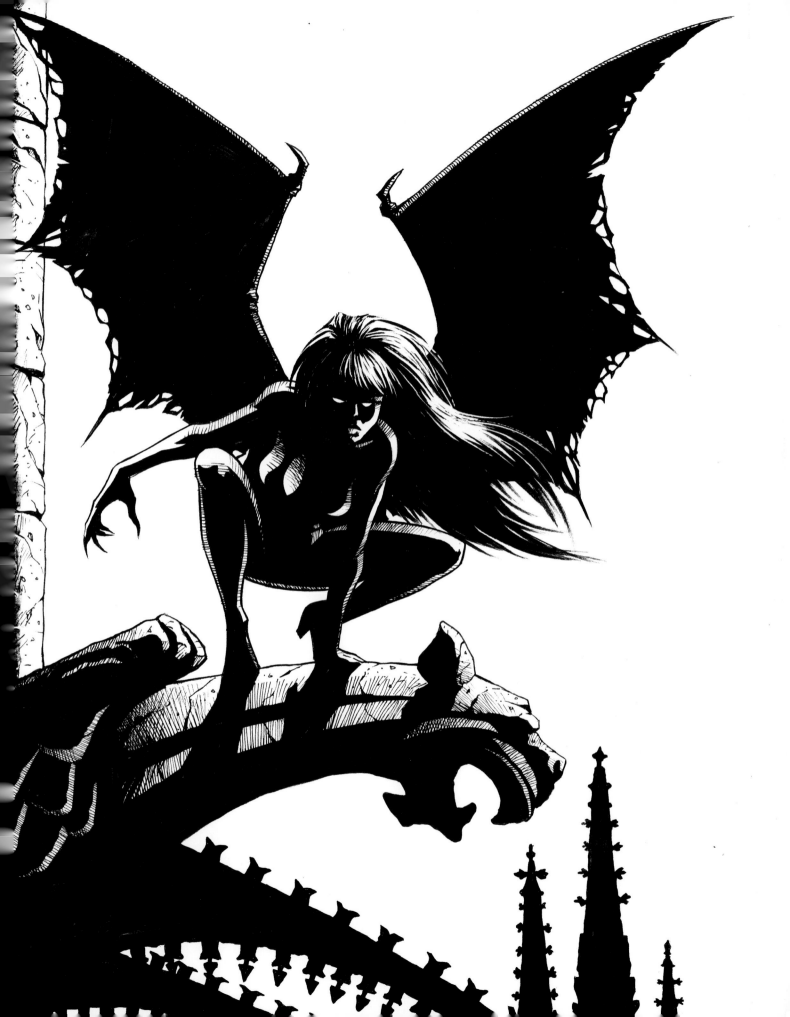

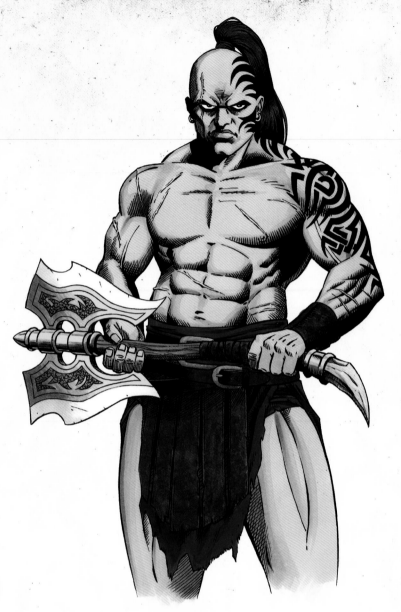

PROJECT 5

◦•⊙⊙⊙•◦

TRIBAL WARRIOR

◦•⊙⊙⊙•◦

This is an exercise in character development, inking and colouring. Learning to develop a figure from nothing other than ideas in your head is an important process in fantasy art. When I have been commissioned to create a character, whether for a video game or as concept art for a film, I go through a process of making a collection of rough sketches. Each of these explores a direction of thought and how the character could look, and the final design will sometimes be a combination of different parts of each concept sketch. This is probably the most fun part of creating fantasy art as you don't always know where the chain of thought will take you.

STEP 1

Here we have a collection of sketches that show the various stages of development for a character. I began by scribbling out a rough skeleton to determine the pose of the figure. I decided that he will be carrying a weapon which I roughly indicated with a stick.

STEP 2

The next stage is to decide on the build of the character, exploring whether the body will be muscular or slightly built.

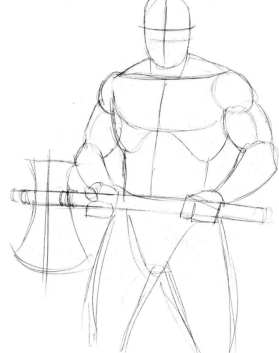

STEP 3

Having chosen the body shape, it is time to add detail to the figure and to settle on the type of weapon. For this exercise I have chosen an axe for the warrior to wield, but you can opt for whichever weapon you like (Figure 1 shows an alternative).

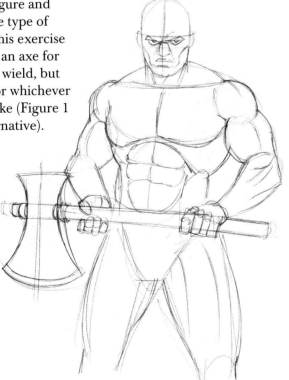

Figure 1

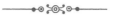

STEP 4

It is now time to explore different ideas that may or may not enhance the look of the warrior. Here I have begun by applying a tribal tattoo on his arm and the side of his face and head.

STEP 5

I decided to give my character a ponytail as an addition to his bald head, which meant that all of the tattoo would still be visible. I felt that the design of the axe was a bit weak, so I developed this further to create a more interesting weapon.

ADDING ARMOUR

Consider trying out a helmet and other types of body armour. This particular concept sketch illustrates that I have applied too much armour, resulting in elements that conflict with each other. This is not a good example of balanced design. You need to look at the armour you have added and check that elements work cohesively.

Figure 2

Play around with the different elements until you get it right. In this image I have erased the shoulder armour and added a cloak pin. This simplifies the design – it is less cluttered and there are no conflicting components. Remember, sometimes less is more!

Figure 3

STEP 6

Having been through the development process you should have a figure that you are happy with, and can now go ahead and apply ink. I have chosen to ink the original tribal warrior, without the armour and with the tattoo, as I felt it was the better character design of the two. The starkness of his mostly bald head allows you to focus on his fierce stare and facial scar. Also, because he has no armour, the scars on his body are visible, making him look more brutal. You may want to start inking the most interesting part of the drawing first, which for me is the head. I used a superfine pen for the facial details, especially the eyes.

STEP 7

A superfine pen can also be used for the hatching, as shown. I applied more pressure to the nib at the beginning of the stroke to create a heavier line, and gradually released the pressure towards the end to create a lighter line. This is best executed in a quick stroke, so do not think too hard about how much pressure to apply at the beginning and the end. It is best to practise a few times on a scrap sheet of paper first.

STEP 8

Once you have completed the head, move on to other areas. I continued with the superfine pen for the hair and scars (Figure 4) and then finished off the solid black areas using a brush pen. Using an actual brush and Indian ink would do the job just as well. Notice that I have applied a thicker weight of line on the underside of muscles such as the chest (pectorals) and biceps and embellished them with hatching to create the appearance of roundness of shape.

Figure 4

STEP 9

You may have to pause and consider different options during the inking process. In this case, I was not certain whether to ink the tattoos in solid black or to sketch them in thin line to be filled in with a coloured pen later, or even to leave the arm blank and draw the tattoo with a colouring pen. Leaving the tattoo in outline (as shown here) would make it easier to colour by keeping the colour within a confined space. Applying the tattoo with a coloured pen, however, would give an appealing finish. In the end I chose to ink in the tattoo using solid black, which looks powerful and also works well once the rest of the drawing has been coloured (Figure 5, below).

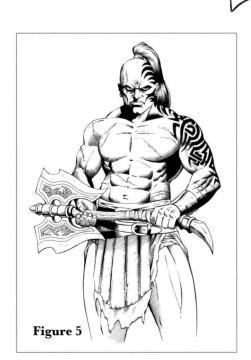

Figure 5

STEP 10

You can now move on to colouring the picture. For this drawing I primarily used Copic markers (see page 22). I began by laying down the base layers of skin tone, hair, clothing and the weapon. For the skin, I used Copic E53 Raw Silk and a Blush Letraset Pro marker (Figure 6). For the hair, leather straps and belt I used Copic E39 Leather. For the protective leather straps hanging from the belt I used Copic E35 Chamois (Figure 7), and for the loincloth I used Copic E09 Burnt Sienna (Figure 8).

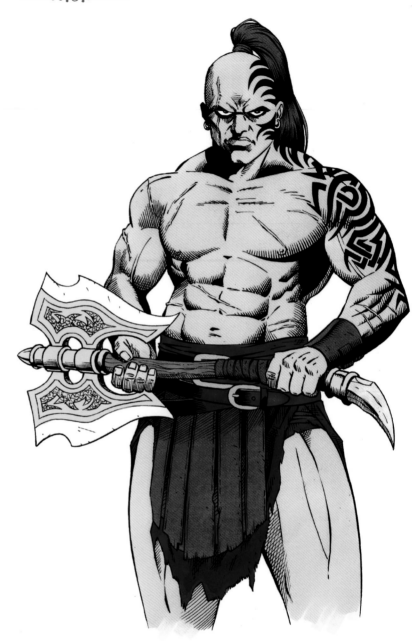

Figure 6

Figure 7

Figure 8

STEP 11

The base layer of colour should then be built upon using layers of darker tones. Lighter, subtle tones can be achieved by using the same colour marker over the base layer once it has dried. Start by finishing the skin layers. Here I used Copic E53 Raw Silk, E11 Barely Beige and E31 Brick Beige (Figure 9 and Figure 10).

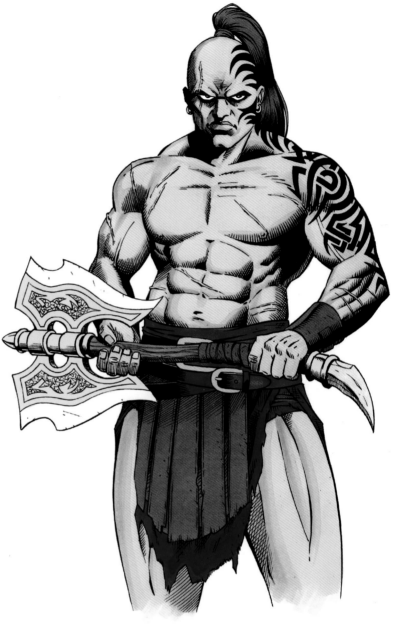

Figure 9

Figure 10

STEP 12

Having worked on the skin tones, turn your attention to the weapon, clothing and armour. I built the warmer tones of the axe head using Copic Y15 (Cadmium Yellow) and Y21 (Buttercup Yellow). The darker tones of the loincloth (Figure 11), leather (Figure 12) and hair (Figure 13) were created by adding a layer of E27 (Africano) followed by a layer of Copic W5 (Warm Grey). I did not want the leather to have a totally smooth appearance, so I purposely created an uneven layer by applying more of the Warm Grey in some areas than in others to create a worn effect. Using a marker with a nib that is drying up is good for this effect.

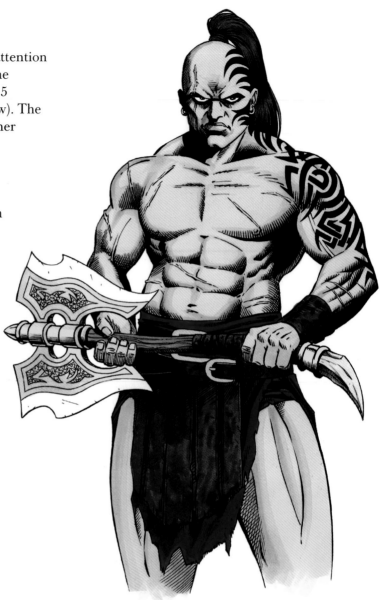

Figure 11

Figure 12

Figure 13

STEP 13

Finally, add the finishing touches to blend the colours. I applied a Copic W2 (Warm Grey 2) and W3 (Warm Grey 3) to the parts of the skin I wanted to appear darker, in particular the left side (as we are looking at him) of the figure, the head, shoulder, shadowed areas of the hands and the outer line of the leg – basically anywhere there was shadow that I felt needed some extra tone to blend lighter and darker areas. I used some thinned white gouache to make the scar tissue more prominent. I used a Copic W3 to add extra tone to the axe head.

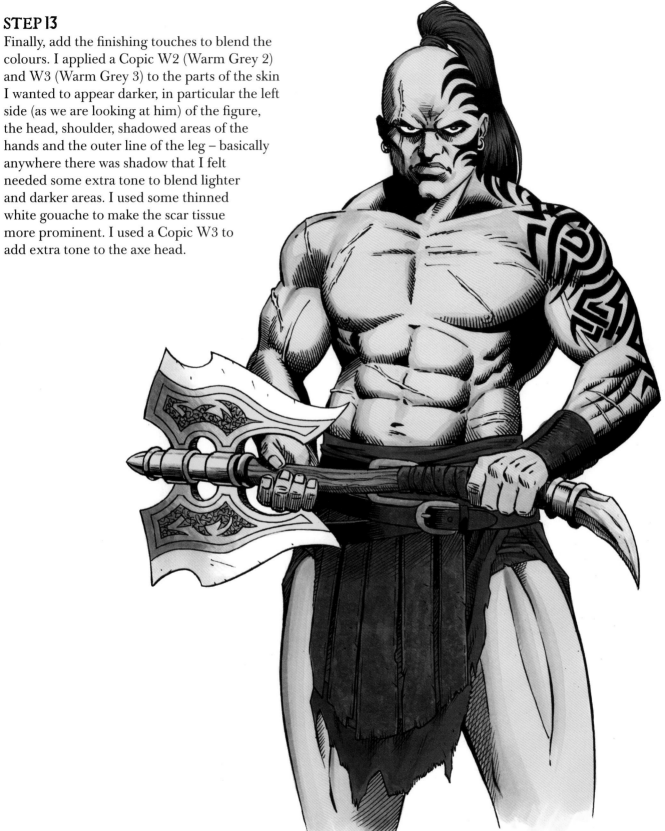

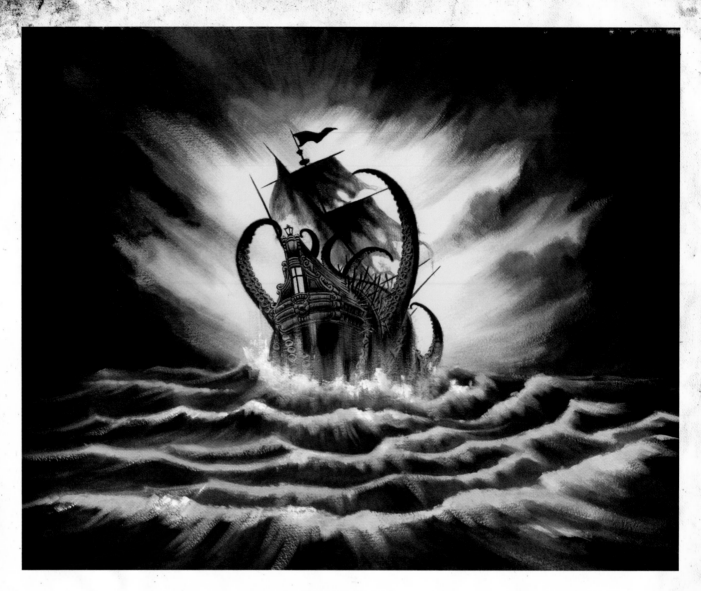

PROJECT 6

✦◦✧◦✦

THE KRAKEN

✦◦✧◦✦

I have long enjoyed watching movies that feature giant, tentacled marine creatures, such as *20,000 Leagues Under the Sea, It Came From Beneath the Sea* and *Clash of the Titans.* I am an unashamed fan of all Walt Disney's *Pirates of the Caribbean* movies, but my favourite is *Pirates of the Caribbean: Dead Man's Chest,* which features the mighty sea monster the Kraken. The above painting was inspired by a scene in which the Kraken takes down the ship the *Black Pearl.*

The painting was produced using Winsor & Newton gouache on cold-pressed 300gsm Arches Aquarelle Watercolour Paper.

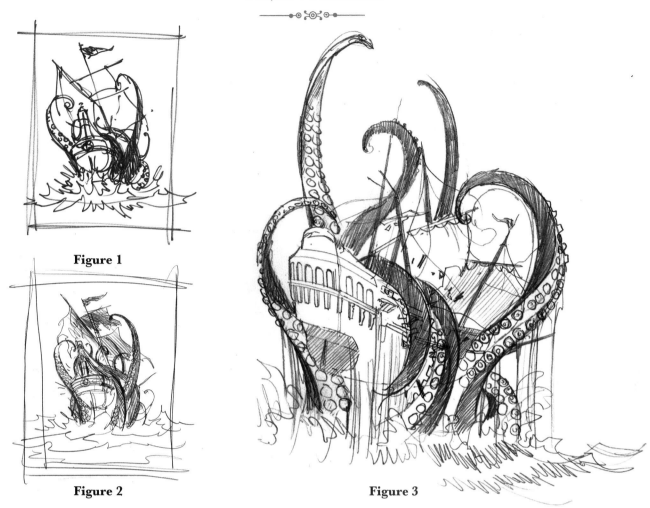

Figure 1

Figure 2

Figure 3

I started by drawing some rough thumbnail sketches to work out the position of the boat and how the tentacles should wrap around it. These early ideas are shown in Figures 1–3, and you can see the progression of the level of detail drawn and the different angles I tried out. I decided to use the set-up shown in Figure 2 and coloured the image using markers (Figures 4 and 5) to establish the colour scheme before I started painting.

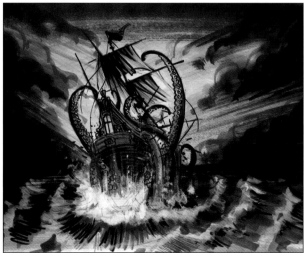

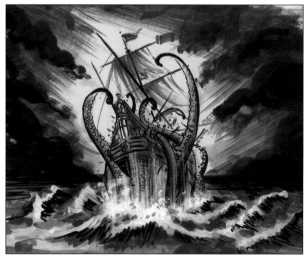

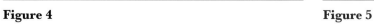

Figure 4

Figure 5

Before drawing the ship in the grip of the Kraken, I produced a quick sketch (Figure 6) to work out the shape of the ship accurately, ensuring that all the basic components were present and in the correct place. Sourcing reference material for unfamiliar subjects such as ships is always a good idea, particularly when you want them to look of a period, in which case the shape and detailing are especially important.

Figure 6

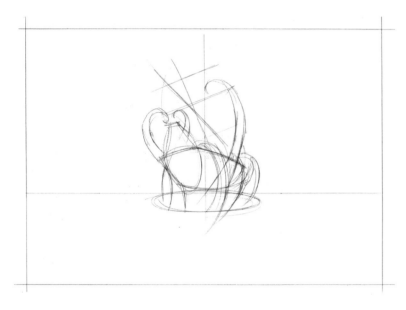

STEP 1

When you are going to paint on watercolour paper it is worth drawing the image first on standard paper (I used A3-size paper) and then lightly tracing the working drawing on to the watercolour paper. This prevents the watercolour paper becoming marked with workings out that then need to be erased, and makes for a much better end result.

Start by marking the horizon and plotting the image around a centre line. At this stage I was still undecided about whether to tilt the ship up or down. In the end I decided to show the ship being crushed by the Kraken's tentacles, which means that it would appear to be angled up and leaning to the left. I also drew in the position and action of the tentacles.

STEP 2

Add more details to the ship, trying to make them as accurate as possible. Roughly draw in the clouds and waves, arranging them so that they lead the eye towards the centre of the painting, where the action is taking place.

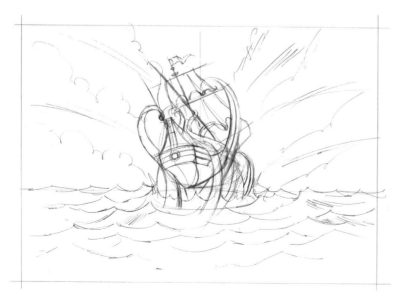

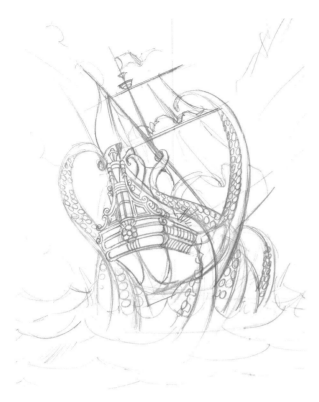

STEP 3

Refine the decorative detail on the ship's stern and on the tentacles. This ship is the result of a combination of reference sources, including some old books about sailing ships I have collected. However, by the time I finished it I realized the artwork was as much an homage to Frank Frazetta's painting *The Galleon* as anything else. Discoveries like this are part of the fun of fantasy art.

STEP 4

Shade the clouds and the rear of the ship to establish the areas that will have the darkest tones. The waves here are exaggerated, but when I drew smaller ones the image looked rather tame, so I went for bigger, more dramatic waves to create the appearance of a great disturbance in the sea.

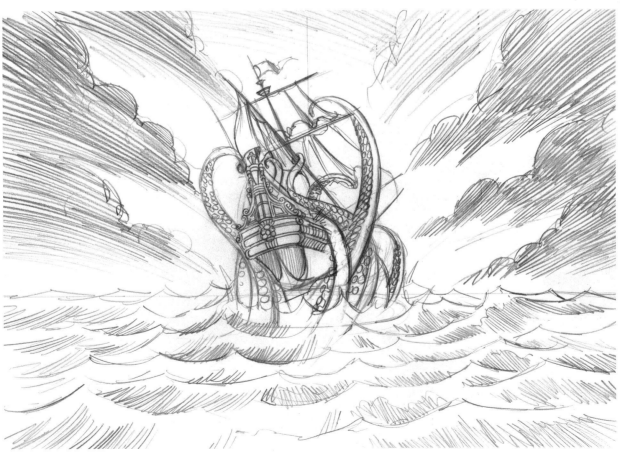

Once you are happy with the working drawing, trace it on to a sheet of watercolour paper using a lightbox. It is a good idea to stretch the watercolour paper first by laying it flat in a bath or sink of water and soaking it for 10–15 minutes, ensuring it is completely saturated. Lift it out and allow the excess water to drip off, then tape it flat to a clean, level board or desk with brown paper gumstrip and leave to dry. By saturating and then drying the paper before you add colour, you avoid running the risk of the paper buckling when you use numerous washes of paint.

When the paper is ready, angle the board or desk so that when you apply washes of colour the paint will flow downwards. I use an adjustable drawing desk, but if you do not own one you could try using more affordable portable easels or desk easels, which are available at most art and craft stores.

Once the paper is prepared and ready, assemble the paints you need to complete the art. I have kept to a simple palette, using the following tones of blue, yellow and green gouache: Sky Blue, Cobalt Blue, Winsor Blue, Prussian Blue, Cadmium Yellow, Yellow Ochre, Raw Sienna, Olive Green, Sepia and Jet Black.

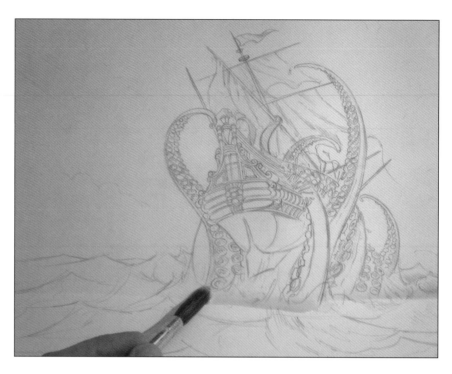

STEP 5

Apply a first wash of very watered-down Cadmium Yellow Pale. I used a size 12 Winsor & Newton sable brush.

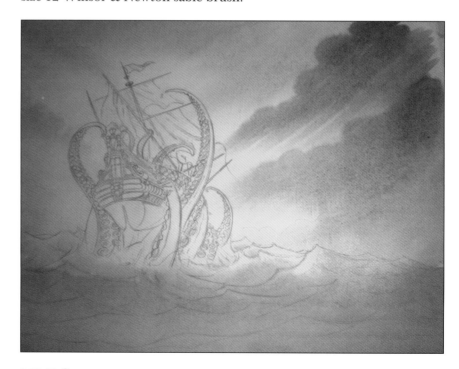

STEP 6

While the yellow wash is still wet, apply a wash of Sky Blue, allowing the blue to run into the yellow to create a soft blending effect between the colours.

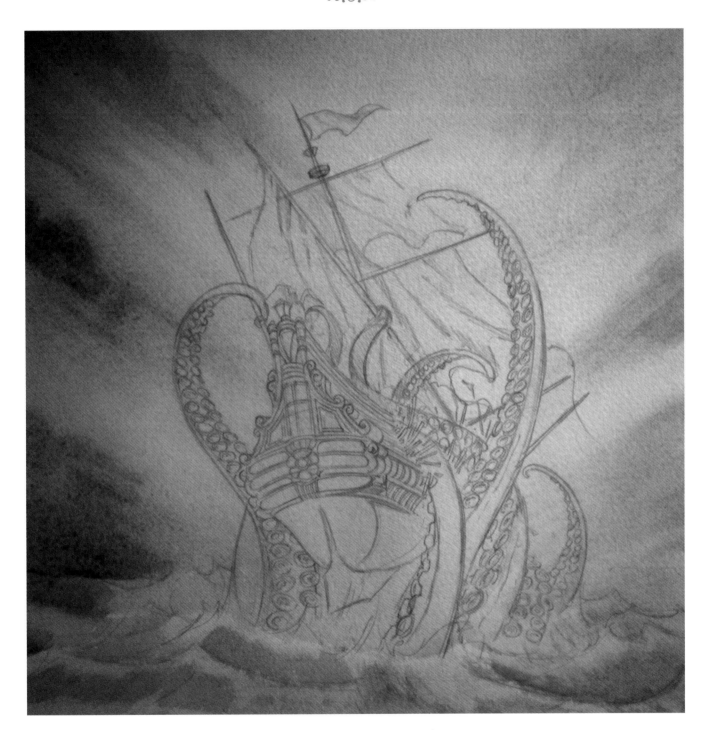

STEP 7

Build up the strength of colour in the clouds. I used Winsor Blue and Prussian Blue mixed with a very small amount of Jet Black. The Winsor Blue was applied as a concentrated wash, while the consistency of the Prussian Blue mixed with Jet Black was slightly thicker, but still wet enough to allow colour spread.

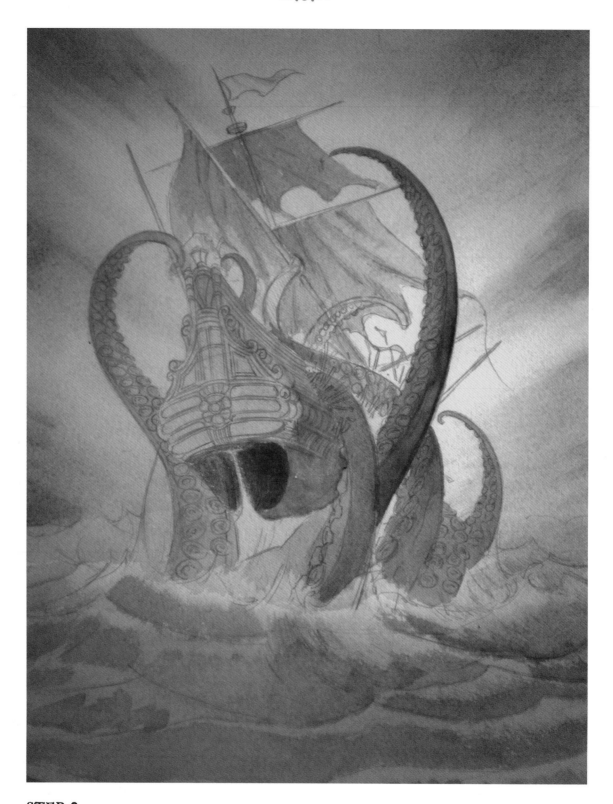

STEP 8

Allow the first washes to dry, then apply layers of Cadmium Yellow, Yellow Ochre and Raw Sienna to the body of the ship. Build up the colour of the tentacles using washes of Olive Green and Sepia, both with a hint of Jet Black. Add washes of Olive Green and Sepia to the ship's sails.

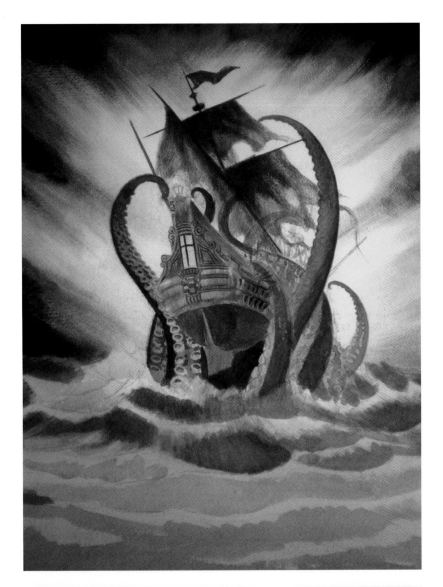

Figure 7

STEP 9

Apply thicker, less liquid layers of
Prussian Blue and Jet Black to the
clouds, using a dry brush effect
to break up the colour and create
texture (Figure 7). All brush strokes
should be directed towards the
centre of the image, so that they
surround the action. I used a size 8
flat shader brush.

STEP 11

Add thicker layers of Olive Green
mixed with Sepia and Jet Black to
build up the solid, darker tones of
the tentacles to give them more
presence. I applied darker mixes to
the very top and round the inside
and outer edges of the suckers to
create a sense of shape and depth.
I used a size 8 flat shader and a size
3 sable brush for the finer work on
the tentacles.

STEP 10

Add thicker washes of Olive Green mixed
with a tiny amount of Jet Black to the sails,
applying darker tones to the top of the sails.

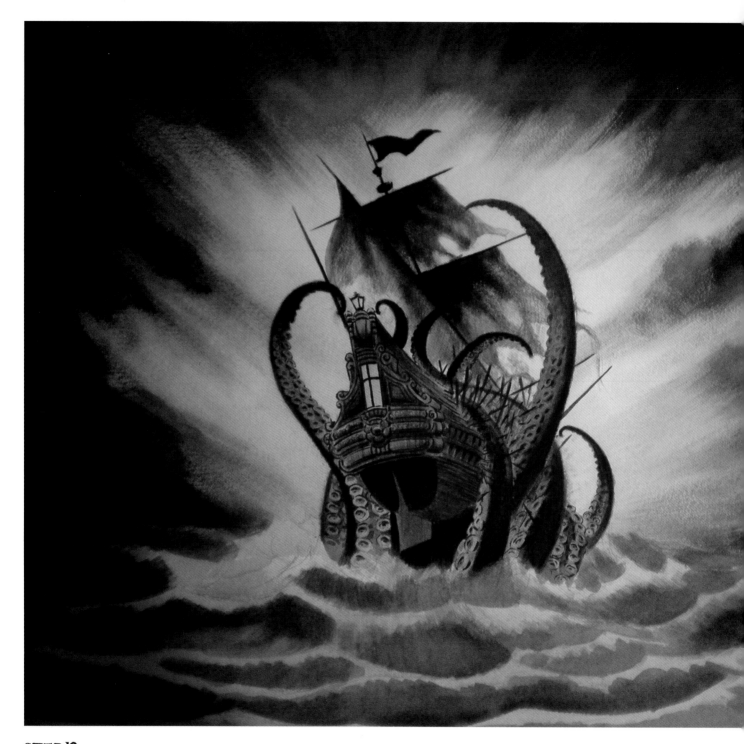

STEP 12

Using a size 8 flat shader and a size 1 flat shader, apply more concentrated layers of Cobalt Blue and Prussian Blue, both mixed with a little Jet Black, to the waves. You are aiming to add just enough black paint to darken each tone of blue. The waves should become progressively darker towards the outer areas of the painting.

 With a size 8 flat shader and thin pastes of Olive Green and Sepia, create a dry brush effect on the stern, to give some texture. Use darker tones of Sepia and Jet Black to highlight the detail on the stern, rudder and underside of the ship.

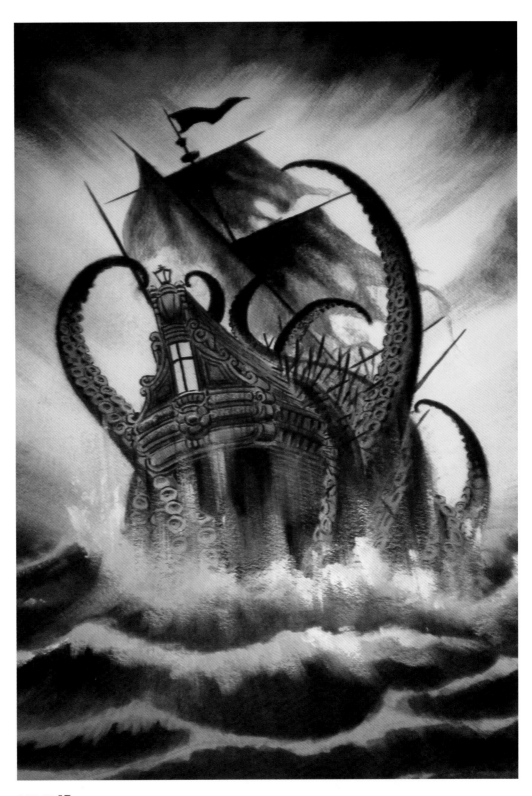

STEP 13

Using undiluted Permanent White, apply a dry brush effect to the surf of the waves and the base of the ship to create the illusion that the ship is being lifted out of the sea.

STEP 14

For the final touches, use a size 1 brush to apply Jet Black to the sails, tentacles and finer details of the ship to give them more strength. Use undiluted Permanent White and a fine brush to highlight details on the stern and the broken timbers.

STEP 15

Apply one last coat of black to the clouds and parts of the waves to give them more strength. This creates a dark, framing effect, drawing the eye to the centre of the image.

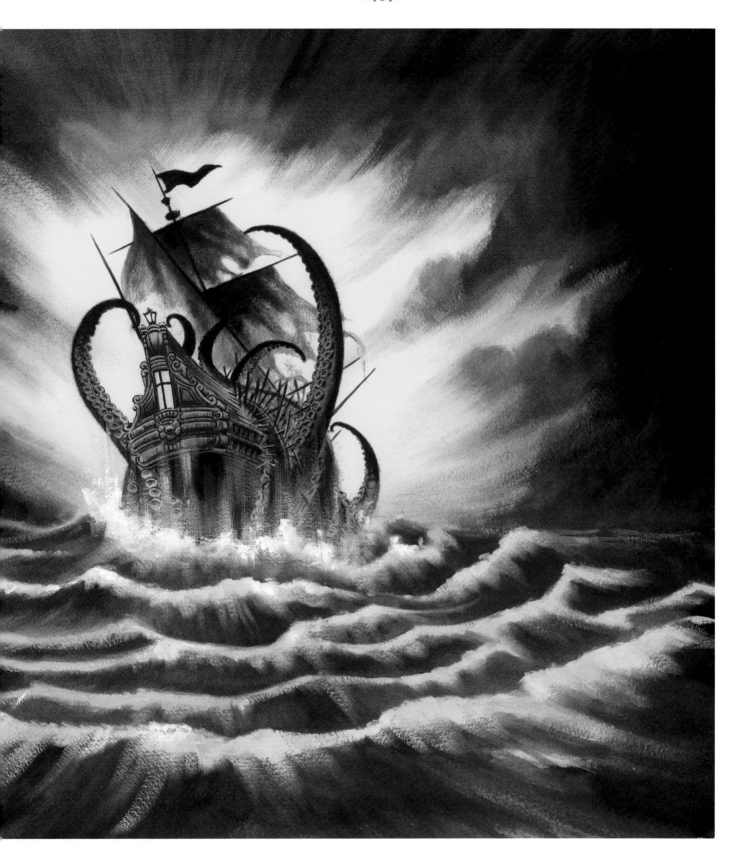

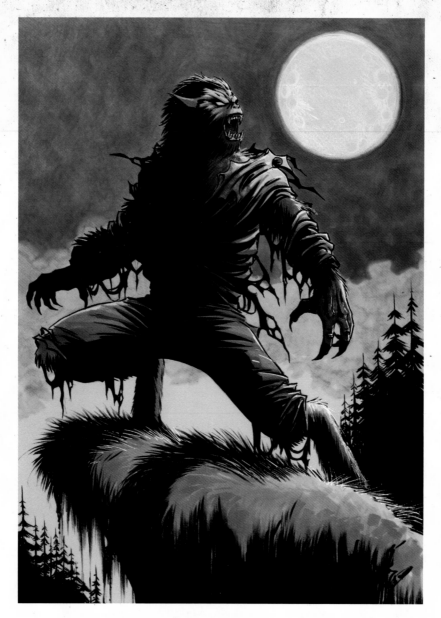

PROJECT 7

<div align="center">—◦※◦—</div>

WEREWOLF

<div align="center">—◦※◦—</div>

The werewolf reminds us of primal instincts within us all. It is a classic subject for lovers of horror films and fantasy art and really good fun to draw. I am a big fan of the 1941 Universal Pictures horror movie *The Wolf Man*, starring Lon Chaney, Jr. in the title role, but the above image is more influenced by the 2010 remake, starring Benicio Del Toro, and by *An American Werewolf in London* (1981) and *The Howling* (1981). This picture demonstrates how effective a simple layout and the application of colour and lighting with just a handful of markers can be.

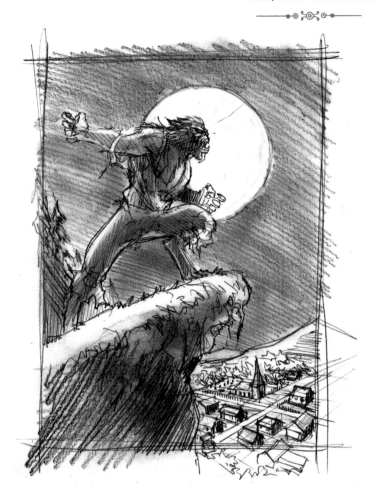

I started by sketching a few scenarios in order to work out the setting and stance of the character. My first idea was to have the werewolf howling on a clifftop above a small village (Figure 1), to imply that this was where the beast would find its next victims. However, much as I liked this idea, I felt that there wasn't sufficient focus on the beast itself, so I tried another approach and came up with Figure 2. This way, by making the werewolf larger, I could include more detail (Figure 3).

Figure 1

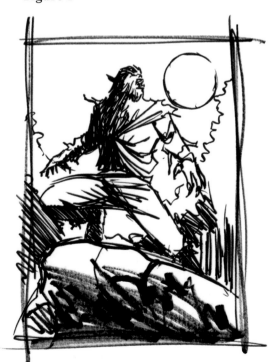

Figure 2

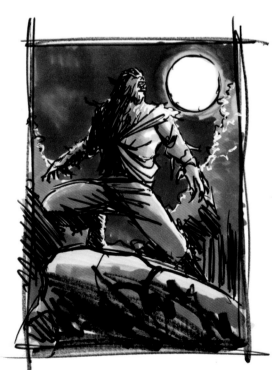

Figure 3

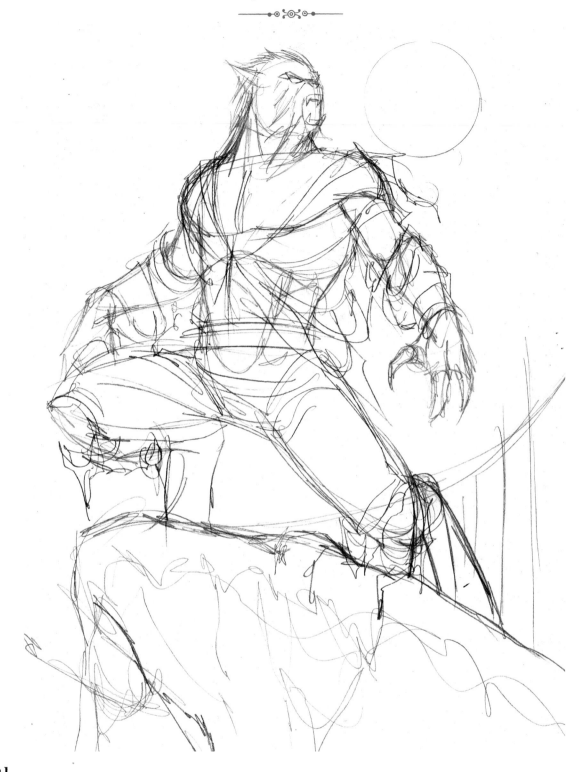

STEP 1

With the rough layout planned, you can begin to plot the figure and the surrounding elements using construction shapes, line figures or loose shapes, as I have done. I decided to reduce the amount of trees in the background so that they did not interfere with the figure. I also refined the shape of the grassy overhang (this could be a cliff-top, but I have made its appearance vague since it is merely a device upon which to perch the figure), so that I could add a small group of trees at the bottom left to suggest a sense of height. I also began to draw the details on the werewolf's face and plot how its clothing would hang.

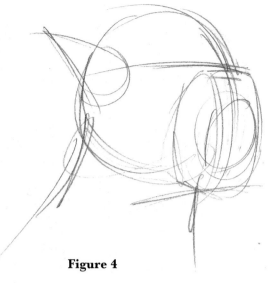

Figure 4

STEP 2

In order to get the face and head shape right, it is worth practising on a separate piece of paper. Approach drawing these elements in the same way as you would a human head, using the construction shapes shown as a guide (Figures 4 and 5). The main difference between the human and the werewolf face is that the werewolf's mouth and nose are positioned on a snout-like protuberance, a bit like a cat. The nose should be fairly flat, almost pug-like, but positioned high on the face. The teeth are enlarged, so the mouth should be bigger and wider than a human's to accommodate them. The ears are wolf-like and placed much higher on the head than a human's (Figure 6).

STEP 3

Try sketching the hands on a separate piece of paper too, adopting the same construction shapes as for human hands (Figures 7–10). The only main difference between them is that the werewolf is traditionally depicted with huge, sharp claws and thicker, heavier-built hands and fingers. It is important to instil some of the character into the position of the hands to make them appear dramatic and aggressive.

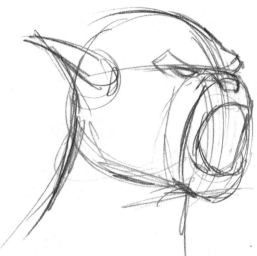

Figure 5

Figure 7

Figure 8

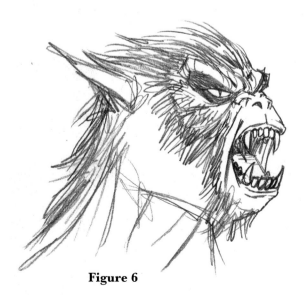

Figure 6

Figure 9

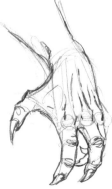

Figure 10

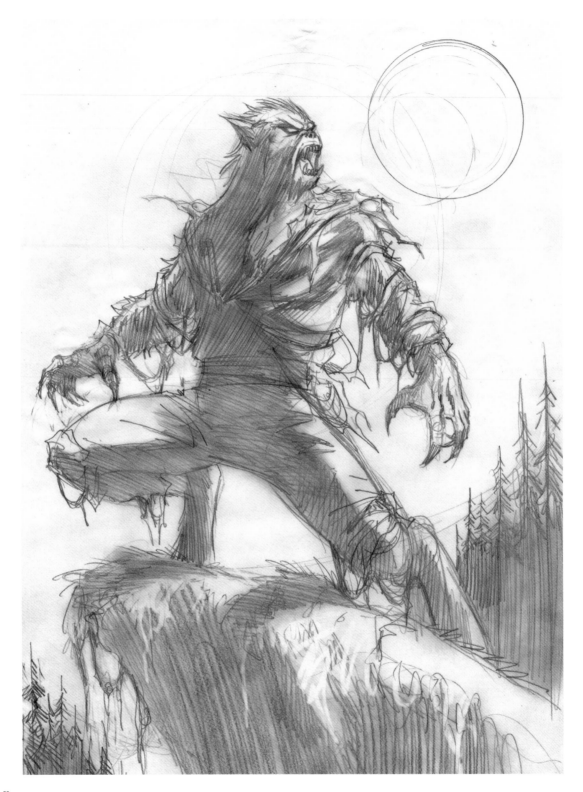

STEP 4

Once you have drawn the head, face and hands and are satisfied with them, add the clothing. I have made it so torn and tattered that it is impossible to get an impression of period. The position of the light source, the full moon, creates heavy shadows which also contribute to the vagueness of the clothing's appearance.

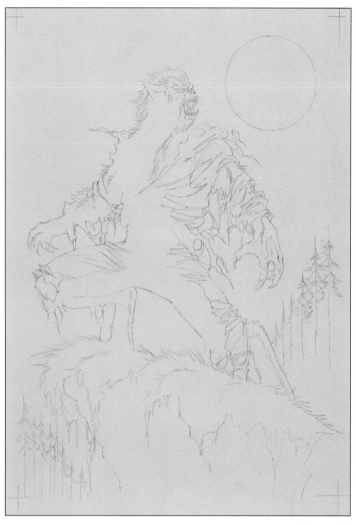

Figure 11

STEP 5

Trace the working drawing on to a piece of pale blue A3 paper using a lightbox. If you do not have a lightbox, you can do an image transfer instead. Rub a soft lead pencil across the back of the working drawing, completely covering the piece of paper. Tape the drawing to the A3 paper so that the covered side is securely positioned face down on the clean sheet and the working drawing is face up. Firmly trace over the working drawing with a biro or hard lead pencil. This will transfer the lead pencil on the underside of the drawing on to the clean sheet as an outline. Whichever method you use, you are aiming to create a clean outline on the blue piece of paper (Figure 11).

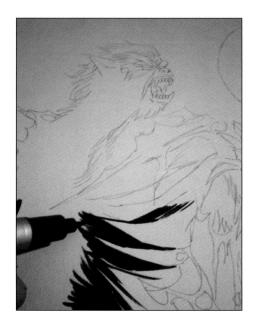

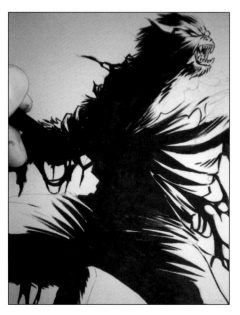

STEP 6

Using a Copic Multiliner brush pen, begin inking the drawing. This is a very easy inking job as it is mostly solid. Try to use the versatility of the brush nib to create a variety of line thicknesses so that the drawing does not look too technical and rigid.

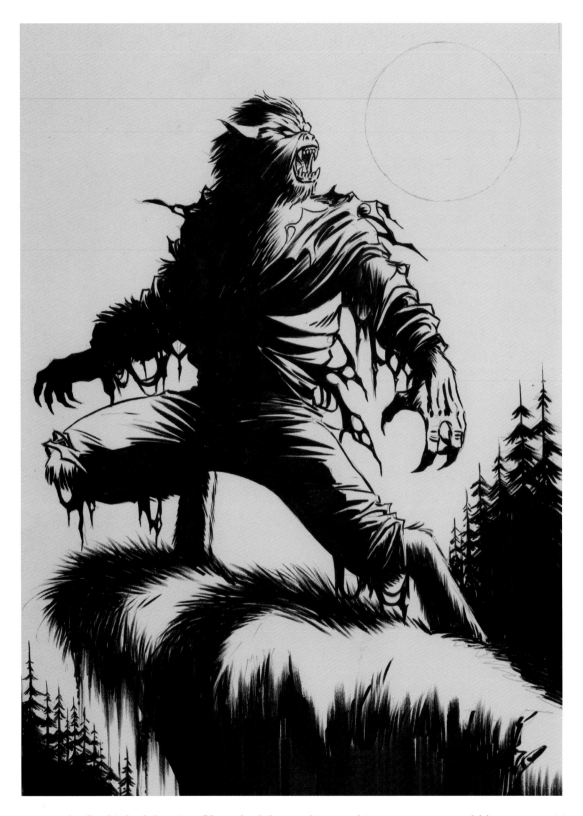

Here you can see the final inked drawing. If you had drawn this on white paper, you would have an exciting black-and-white drawing of a werewolf. But since this piece has been created on coloured paper, you can create more atmosphere using five Copic markers and a Pentel correction pen, as I will show you in the next few pages.

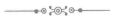

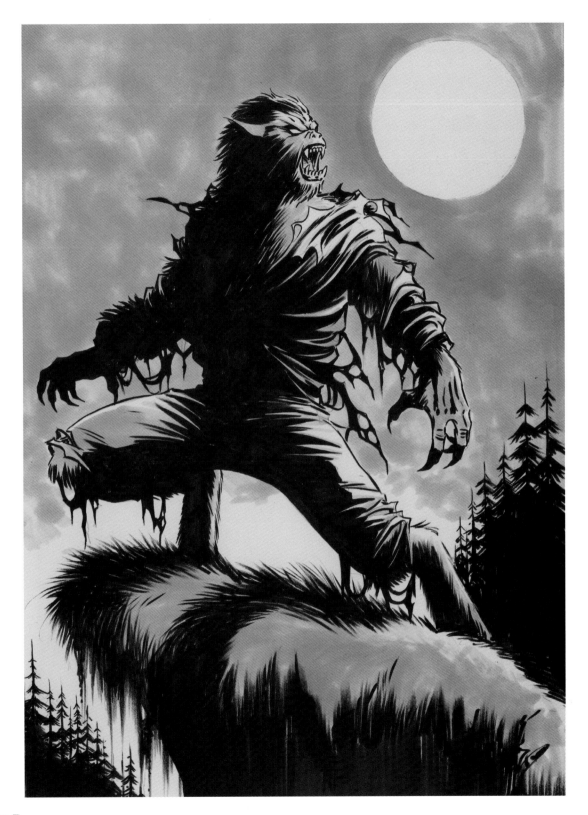

STEP 7
Use an Ice Blue (Copic B12) marker to create the base layer for the clouds and grass. I also used this marker to make a base layer for the darker tones of colour on the clothing and fur.

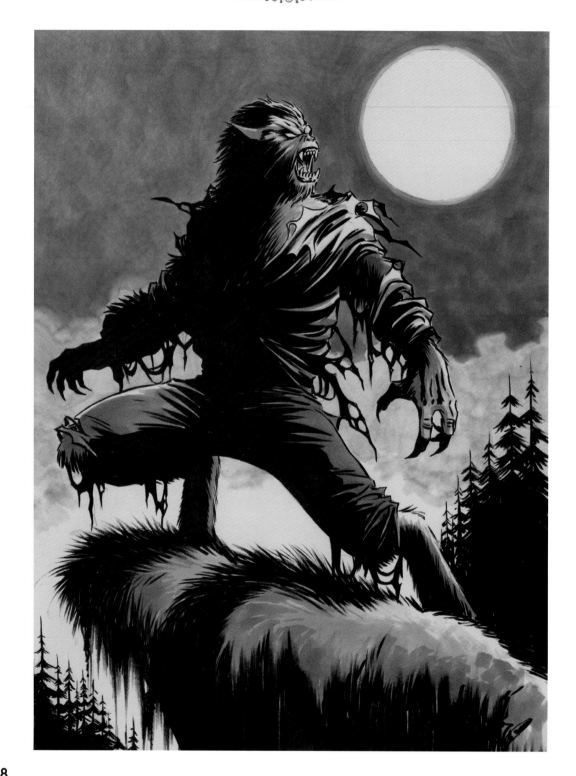

STEP 8

Create the darker tones of the sky with a Phthalo Blue (Copic B23) marker. This is not a particularly dark marker but, layered over the Ice Blue, it creates the right shade. I also applied it to the grass, clothing and hair to build up the colour tones.

Apply Warm Grey 2 (Copic WG2) to the fur and clothing, leaving highlights on the areas nearest the source of light (the moon). Warm greys are very useful for building up tone and texture.

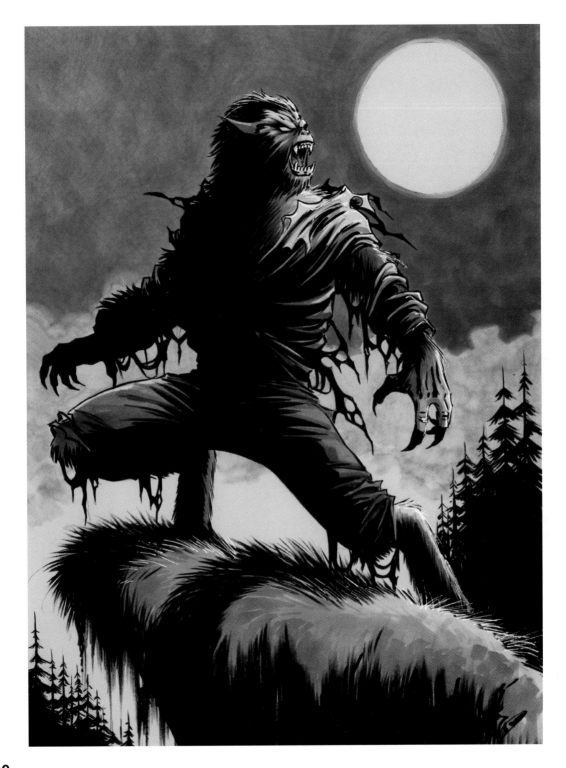

STEP 9

Apply Warm Grey 5 (Copic WG5) to blend the lighter tones and the solid blacks, particularly in the creases of the clothes and the areas of the fur nearest the solid black.

Use a Pentel correction pen to create white highlights round the outline of the figure and on random blades of grass. White gouache or Permanent White and a fine brush would create the same effect.

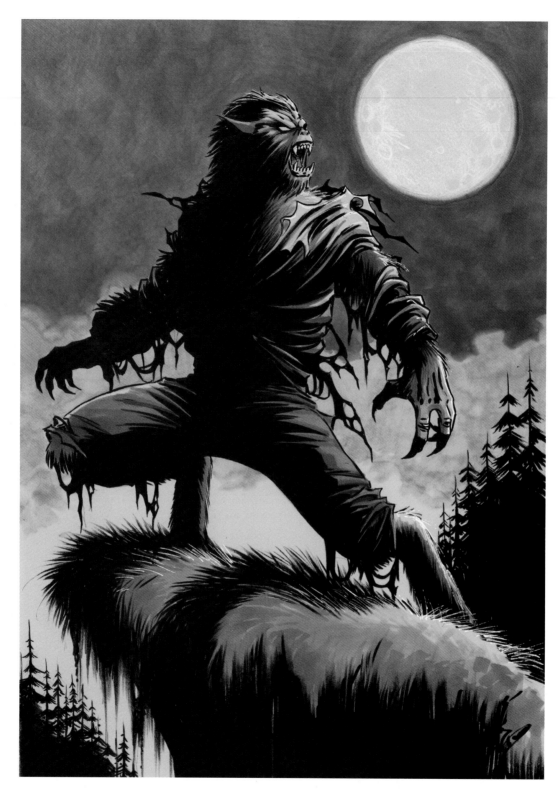

STEP 10
Use a white crayon
pencil to add soft
detail to the moon.

STEP 11
For the final touch, use a vermilion red (Copic R08) marker to
draw the blood on the mouth, hand and clothing. Once layered
over the darker tones, the red ink creates a blood-like effect.

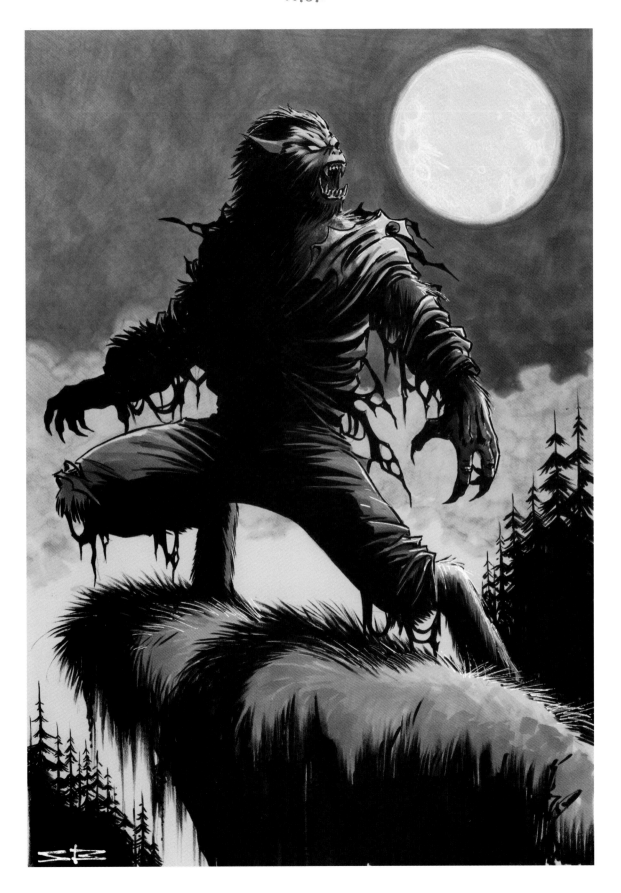

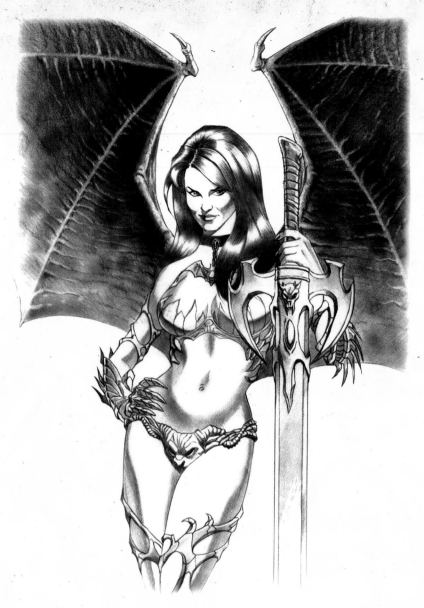

PROJECT 8

◦·◦●◦·◦

Winged Warrior

◦·◦●◦·◦

As with the Enchantress exercise on pages 56-63, I wanted to create a female character who, although she has anatomical additions that in real life most people would not find attractive, would still project a sexually provocative image.

I started by producing some rough sketches to determine the pose and the tone of the proposed work. I began with Figure 1 (below), but although the figure looks strong and confident, I felt that she also looked too rigid, so I decided to explore a new direction.

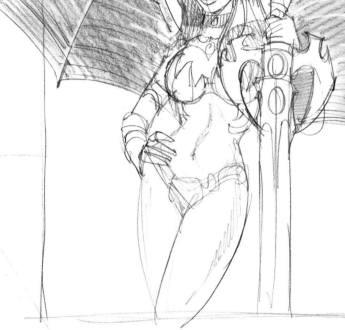

Figure 2

In Figure 2 I altered the look of the warrior, giving her wavy hair and lowering the angle of her head, which makes her appear more seductive but retains the confident, dominant look. I also rethought the clothing and although this figure is wearing less, the design of her outfit is more interesting. Once I was satisfied with the thumbnail sketch I proceeded to develop this into a finished piece of work.

Figure 1

STEP 1

It is best to start with a skeletal frame when you are a beginner, but once your confidence and ability have developed enough you may find that you can bypass this stage and go straight to a rough figure sketch.

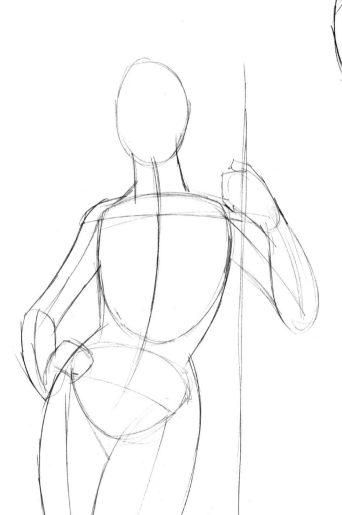

STEP 2

Flesh out the outer frame. As with previous exercises in this book, the balance of the pose is very important. Pay attention to the curve of the spine and the angle of the hips.

STEP 3

Roughly sketch out the shape of the wings,
which are based on a bat's wings (Figure 3).
As you can see in the diagram of a bat's wing
(Figure 4), the bone-like ridges that separate the
span of skin are actually fingers, and the claw at
the top of the wing is a thumb.

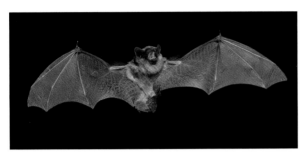

Figure 3

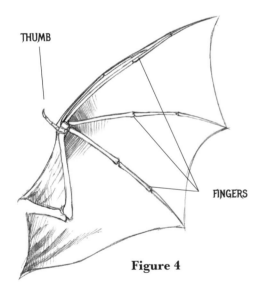

THUMB

FINGERS

Figure 4

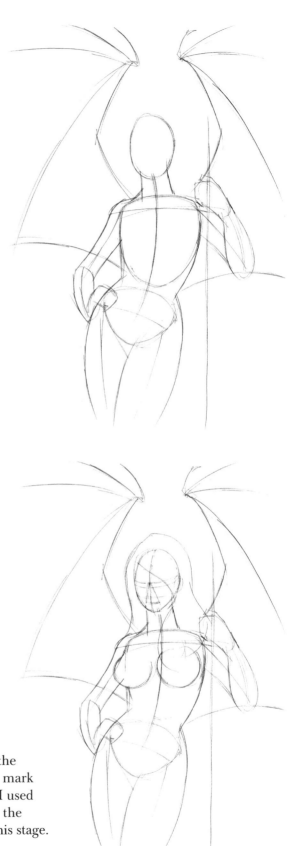

STEP 4

Sketch in the shape of the
breasts using ovals and mark
the outline of the hair. I used
simple curves to create the
shapes for the hair at this stage.

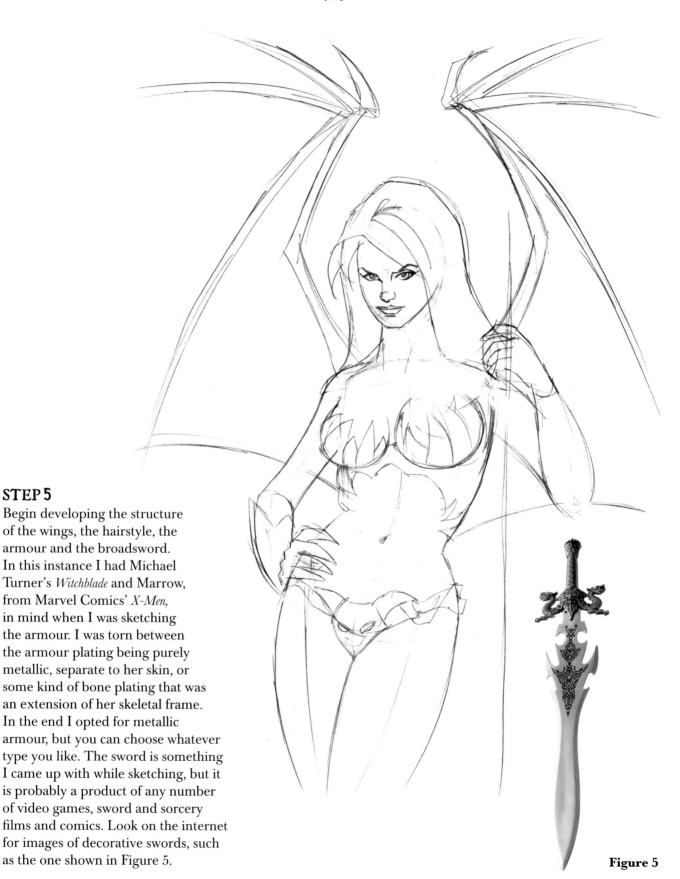

STEP 5

Begin developing the structure of the wings, the hairstyle, the armour and the broadsword. In this instance I had Michael Turner's *Witchblade* and Marrow, from Marvel Comics' *X-Men*, in mind when I was sketching the armour. I was torn between the armour plating being purely metallic, separate to her skin, or some kind of bone plating that was an extension of her skeletal frame. In the end I opted for metallic armour, but you can choose whatever type you like. The sword is something I came up with while sketching, but it is probably a product of any number of video games, sword and sorcery films and comics. Look on the internet for images of decorative swords, such as the one shown in Figure 5.

Figure 5

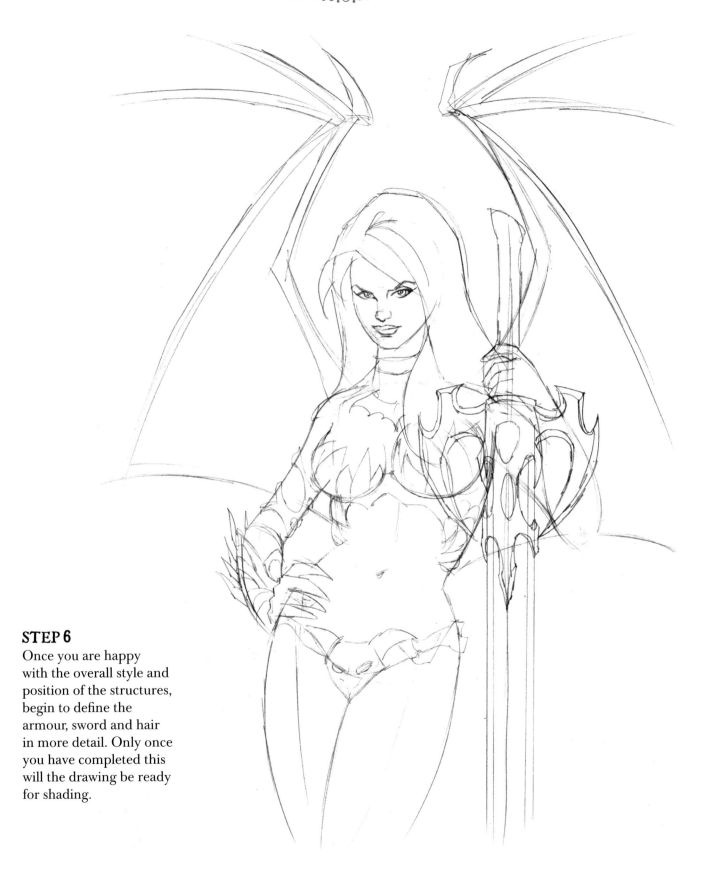

STEP 6

Once you are happy
with the overall style and
position of the structures,
begin to define the
armour, sword and hair
in more detail. Only once
you have completed this
will the drawing be ready
for shading.

STEP 7
Begin shading the hair, laying down the first layers of tone, but leaving highlights in areas to indicate a healthy shine that will contribute to the figure's appeal.

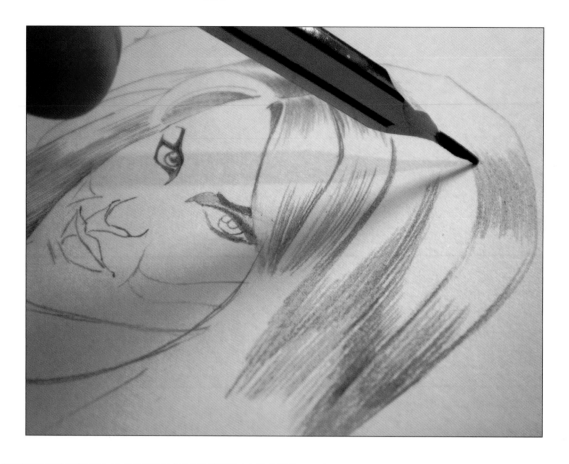

STEP 8
You can now shade the face. Here, the main features of the face have been kept simple and uncluttered. The eyebrows are simple, with chiselled curves that merge with the heavy eyeliner effect around her eyes. Getting the face right is crucial for creating a character with visual appeal. Notice that I have not drawn the entire nose. It is mostly defined by lighting.

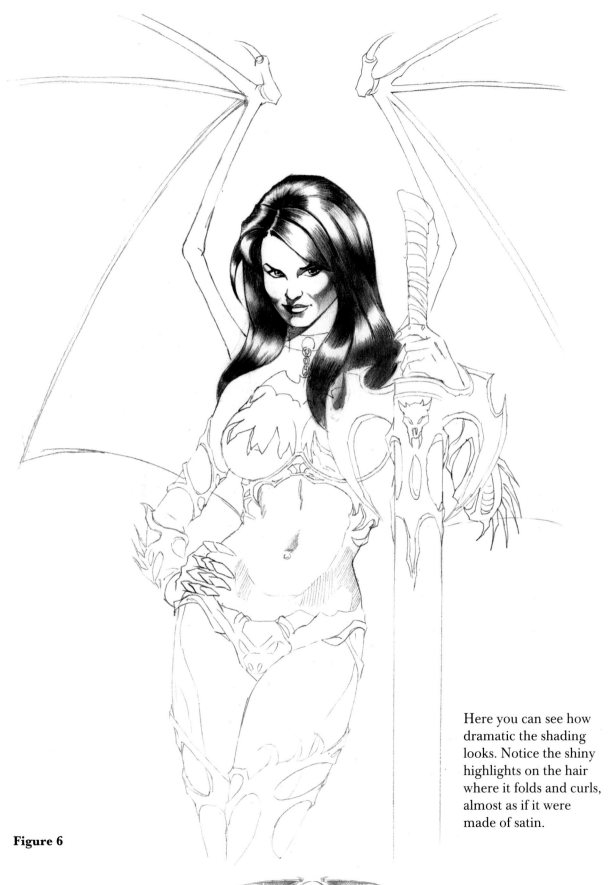

Here you can see how dramatic the shading looks. Notice the shiny highlights on the hair where it folds and curls, almost as if it were made of satin.

Figure 6

STEP 9

Apply some delicate pencil work to shape the contours of the body. When shading the skin be careful not to overwork it. Notice that only soft shading has been used to establish the contours of the body, such as the breasts, the tummy and the outer areas of the legs. The areas that will be most exposed to the light have been left white.

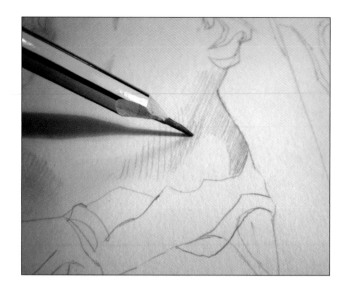

STEP 10

Now blend to create a smoother appearance. Use either a large blending stump or some tissue paper.

STEP 11

A second layer of slightly darker shading can now be laid over the top. Just apply a little more pressure than when creating the first layer. This second layer fades out towards the top of the tummy curve and gradually darkens towards the middle, before gradually fading out to the hips and the groin armour.

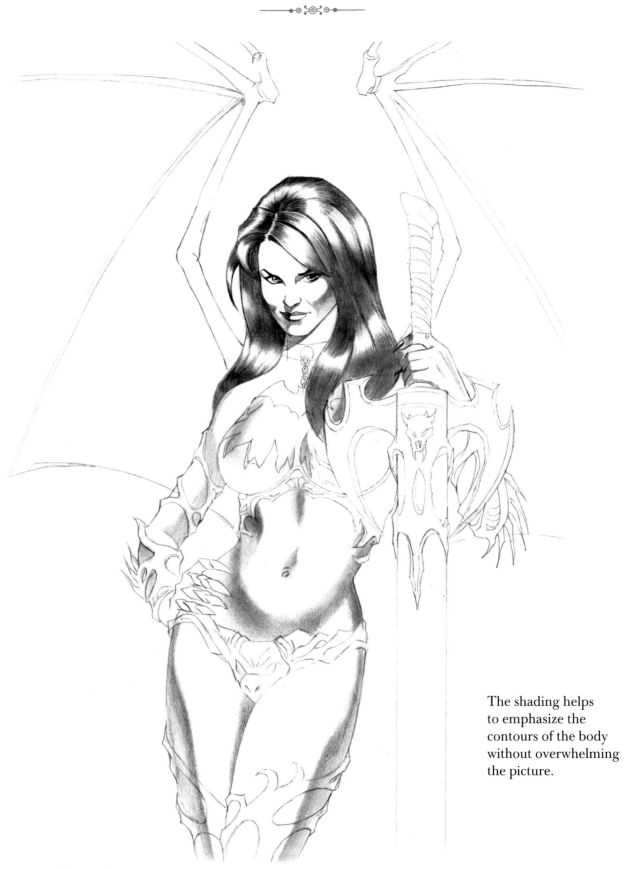

The shading helps to emphasize the contours of the body without overwhelming the picture.

Figure 7

STEP 12

You can now refine the look of metallic armour and add shading. On the breast cup the shading begins at the point where the breast curves away from the light, and a harder edge is applied. Notice that the shading begins to fade to light at the bottom left. This indicates a secondary light source, which helps prevent the shading from appearing too heavy.

STEP 13

The same approach should be applied to the glove, except that here the hard tone should be on the outer edge, with the graduation to softer shading travelling towards the right. This indicates that the secondary light is stronger nearer to the glove.

STEP 14

Once you are happy with the shading, highlights can be applied with an eraser to the outer edges of the joints and moulds of the armour to lend an extra dimension to the drawing.

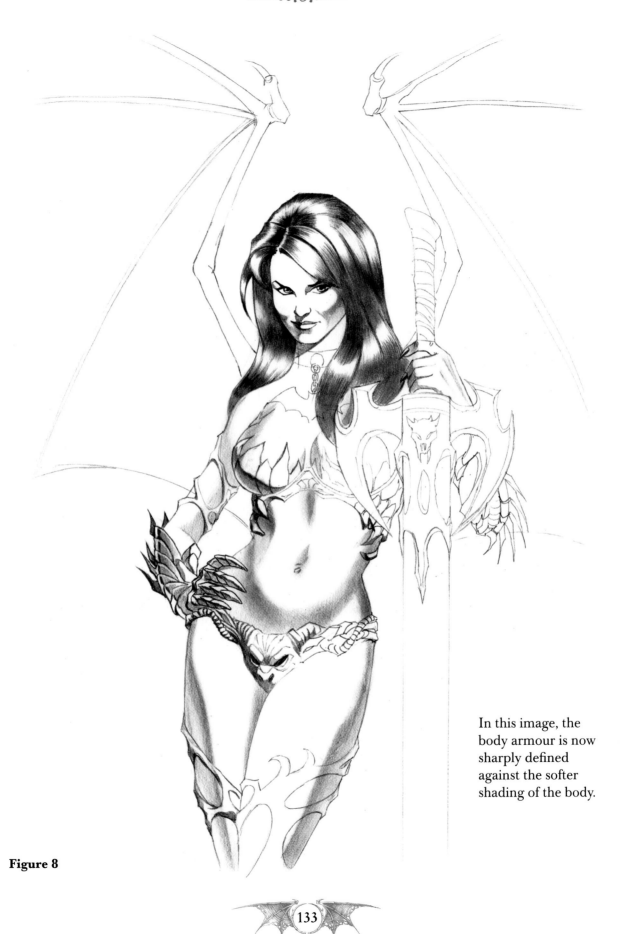

In this image, the body armour is now sharply defined against the softer shading of the body.

Figure 8

STEP 15

It is now time to turn your attention to the wings, which are based on those of a bat. Keep your photo reference to hand when adding detail to the wings (Figure 9). To start, shade the entire area of the wing using an HB or a B pencil and blend it with a blending stump or piece of tissue.

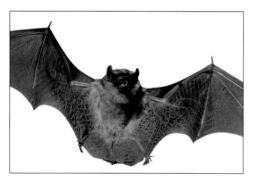

Figure 9

STEP 16

To create the texture of the wings, add more shading in some areas to create large spots of tone. These can then be blended to give a smoother appearance.

STEP 17

Next, highlight the fingers of the wings using an eraser. Notice in the photograph that the drawing is upside down. Whether I am using inks or pencils, I like to be able to move the paper around (rather than moving myself around the paper) to get to areas that would be difficult to access if it were taped down to a drawing board.

STEP 18

Further texture can then be added by shading along the outside of the erased highlight to give the finger a more three-dimensional appearance.

STEP 19

Create the textured skin running between each finger by using the flat edge of a pencil to create a ragged, uneven line.

STEP 20

Highlights can then be applied to the textured lines using an eraser.

Figure 10

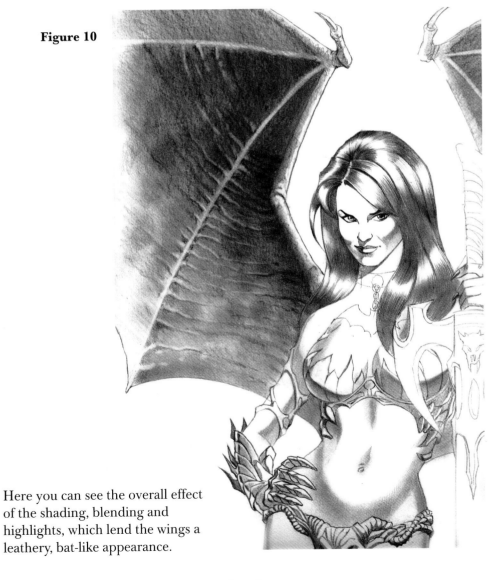

Here you can see the overall effect of the shading, blending and highlights, which lend the wings a leathery, bat-like appearance.

STEP 21

Once all the shading and textures have been applied, add a fine, crisp line round the detailed parts of the armour, the edge of the figure and any other areas that need that extra bit of lift. If there are any parts of the drawing that are blurred or smudged, these are the areas to tighten up.

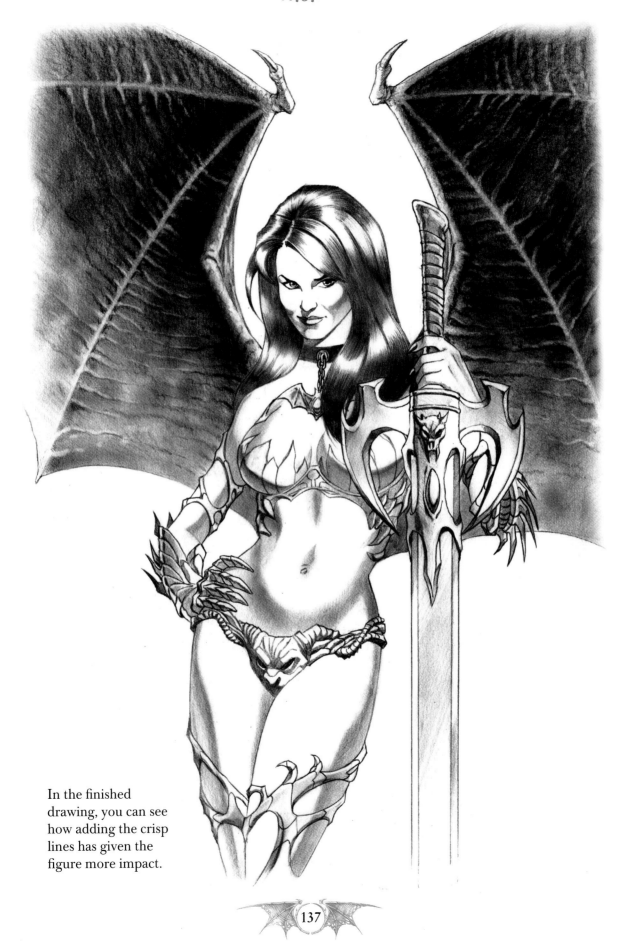

In the finished drawing, you can see how adding the crisp lines has given the figure more impact.

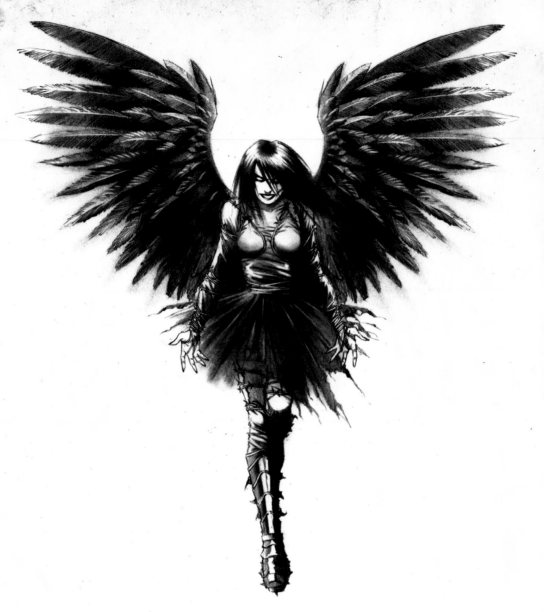

PROJECT 9

DARK ANGEL

For this image, I drew inspiration from Alex Proya's movie *The Crow*, starring Brandon Lee as the title character, which is based on the comic book of the same name by James O'Barr. I also based it partially on the character Pris from Ridley Scott's movie *Blade Runner*.

I liked the idea of creating a drawing that was the polar opposite of conventional angelic imagery, replacing white dove-like wings with huge black crow-like ones, and choosing a black leather/PVC look as opposed to a flowing white gown. The tutu suggests she is some kind of grungy gothic version of the black swan from the ballet *Swan Lake*, with chunky boots instead of ballet shoes.

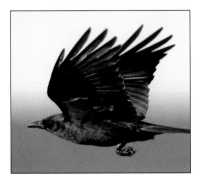

Figure 1

Start by collating some photo reference material (Figures 1 to 5) to provide inspiration and enable you to draw features such as wings and PVC clothing correctly.

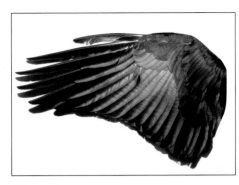

Figure 2

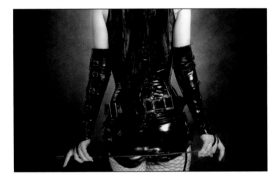

Figure 3

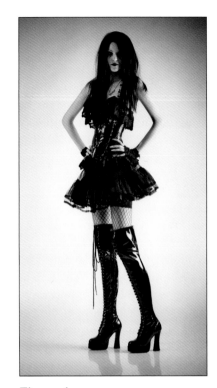

Figure 4

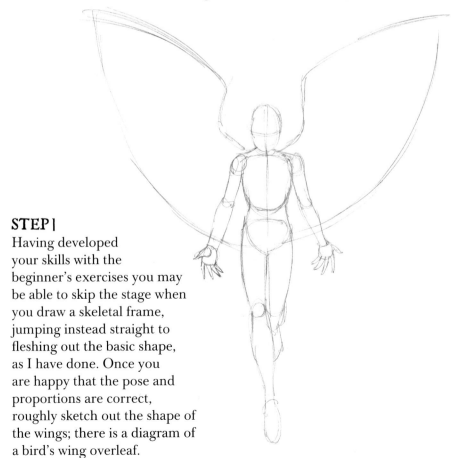

STEP 1

Having developed your skills with the beginner's exercises you may be able to skip the stage when you draw a skeletal frame, jumping instead straight to fleshing out the basic shape, as I have done. Once you are happy that the pose and proportions are correct, roughly sketch out the shape of the wings; there is a diagram of a bird's wing overleaf.

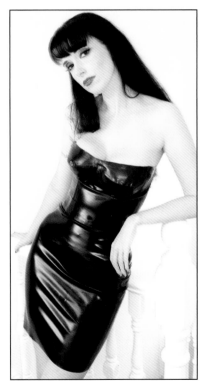

Figure 5

STEP 2

Start to develop the face and define the body shape. Roughly sketch the shape of the tutu. At this stage the hair has been kept to a simple shape that will be developed later.

STEP 3

To make the appearance of the wings more realistic it is a good idea to look closely at various types of bird's wings. Figure 6 is a diagram of the basic layout of feathers. It is not essential for you to be familiar with bird anatomy or to be an expert on wings, but a general understanding of their construction will help you to achieve a sense of realism. I have based the wings loosely on those of a crow or raven, taking the basic construction and applying some artistic licence to create a more symmetrical shape. The wings now appear to be a hybrid of angel's and crow's wings.

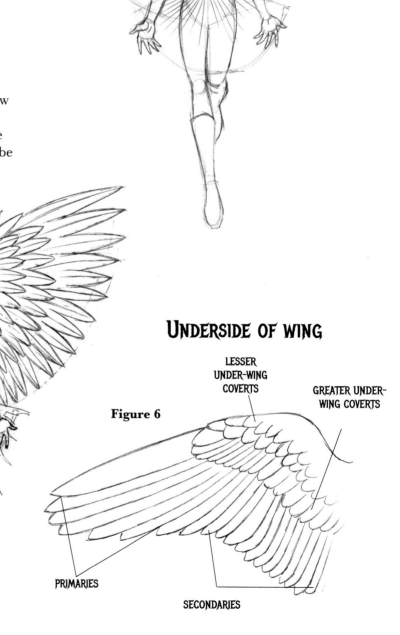

UNDERSIDE OF WING

LESSER UNDER-WING COVERTS

GREATER UNDER-WING COVERTS

Figure 6

PRIMARIES

SECONDARIES

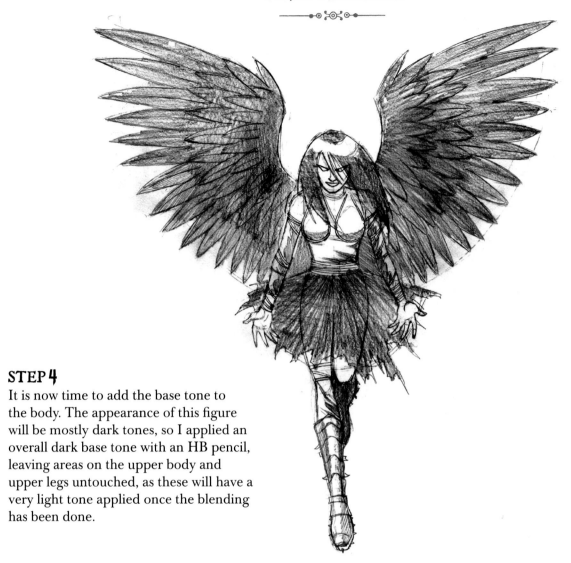

STEP 4

It is now time to add the base tone to the body. The appearance of this figure will be mostly dark tones, so I applied an overall dark base tone with an HB pencil, leaving areas on the upper body and upper legs untouched, as these will have a very light tone applied once the blending has been done.

ADDING DETAIL TO THE FACE, EYES AND HAIR

When constructing a young adult female's face it is important to keep the line work simple. To create an eerie, supernatural effect I left the eyes white, with no pupils or irises, and to make them stand out more I added heavy shading around the eye region (Figure 7).

To create the hair, work from the crown of the head outwards and downwards to form a simple outline (Figure 8). Block in shading, leaving white areas where the highlights are going to be (Figure 9), then blend the pencil work and reinstate highlights as necessary with an eraser (Figure 10).

Figure 7

Figure 8

Figure 9

Figure 10

STEP 5

The pencil work needs to be blended. I wanted a softer effect than I could achieve with a blending stump so I used some tissue paper (Figure 11).

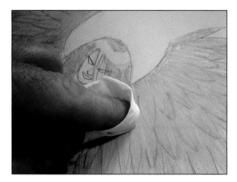

Figure 11

STEP 6

As this is a dark character, I felt that it would be appropriate to frame her against a background of dark clouds. To create the clouds, draw a very light outline of their position, leaving a white area behind the figure so that she stands out, then add a dark base tone to the clouds. This should then be blended and the edges of the clouds softened and shaped with an eraser (see page 138 for tips on creating cloud effects).

Other finishing touches can now be made. I used the fine edge of an eraser to highlight the feathers, and added highlights to the barbed wire and smaller folds in the material with a fine brush and some permanent white gouache. When creating highlights for a highly reflective surface such as PVC or patent leather, you will need to aim for really dark tones, or even solid black and harsh white highlights, as shown in Figure 5.

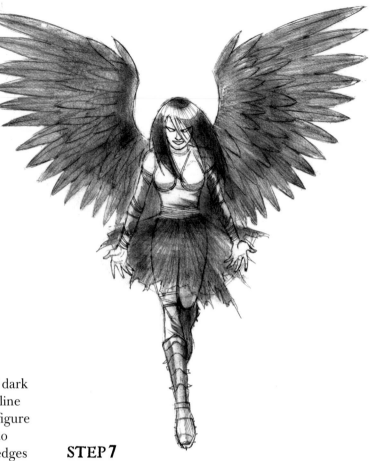

STEP 7

To finish the tutu, draw pencil lines from the hip area outwards towards the edge of the paper. The pencil work can then be blended together and some further darker pencil work laid over the top to create a ruffled effect. Use an eraser to create ragged outer edges, cutting back into the tutu in an uneven manner.

The pencil work for the wings should be gently blended together before the highlights are added. The feathers and other detailed areas such as the barbed wire can then be clearly defined with a sharp pencil to create a crisp line.

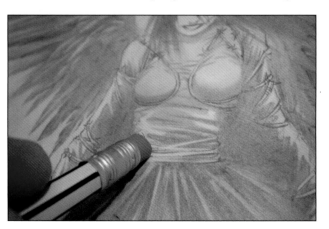

After completing the drawing I scanned it and then imported it into Photoshop, where I adjusted the hue to give it a bluish tone. This gives the final image a moody atmosphere and adds impact.

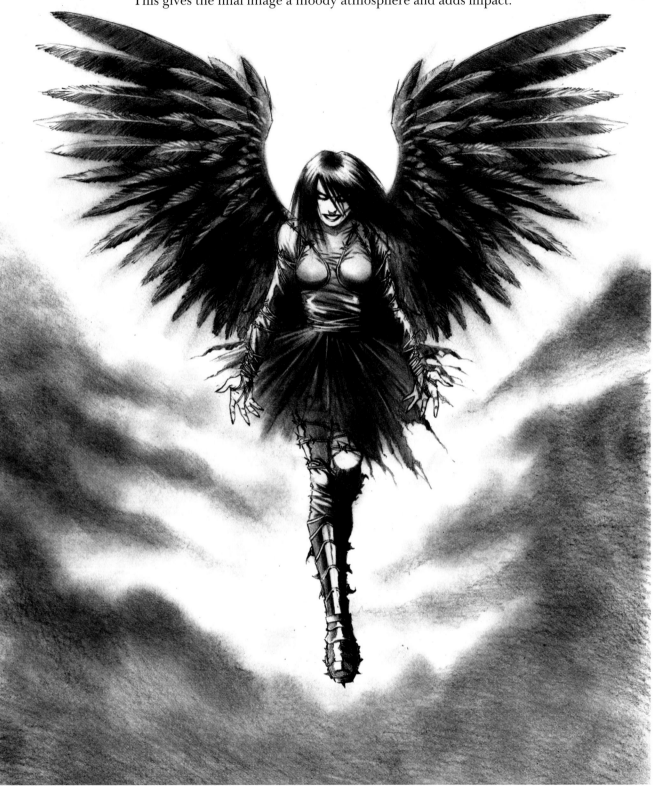

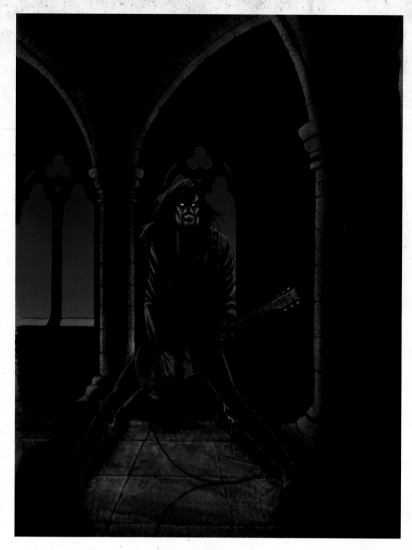

PROJECT 10

◦•◦⟡◦•◦

ROCK'N'ROLL
VAMPIRE

◦•◦⟡◦•◦

This drawing was inspired by two movies: Robert Rodriguez' *From Dusk Till Dawn* and Alex Proyas' *The Crow*. The images of undead rock musicians which feature in both have stuck with me over the years. This artwork was produced on 300gsm cartridge paper, using a combination of a Palomino Blackwing 602 pencil and a HB Staedtler pencil, then coloured in Photoshop. It would also work well as a monochrome pencil or ink drawing.

Figure 1

Figure 2

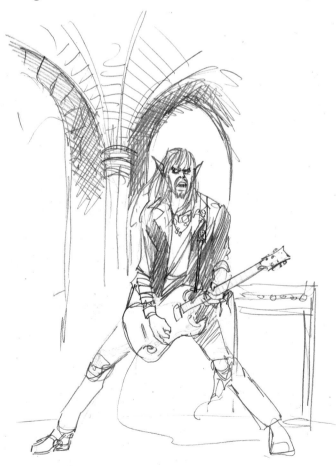

Figure 3

I began by producing some rough sketches of rock/metal guitarists (Figures 1 and 2). Initially the character I envisaged was based on Norwegian black metal guitarists with a demonic twist. I knew what setting I wanted, but wasn't sure of the pose. These sketches helped me see what did and didn't work. At the end of the process I decided that, although I really liked them, these drawings were moving away from my original idea, so I filed them away for use on another piece and started again.

This time I decided to go for more of a 1980s goth/punk feel, playing down the drama of the guitar shapes and making the instrument more low-key (Figure 3). Although I really like over-the-top, dramatic, in-your-face visuals, I also like more subtle imagery where the lighting and space set the tone as much as the figure.

STEP 1

Begin to plot the drawing using the vaulting and Gothic window in the background to frame the figure. In order to get the detail correct for a more realistic setting, it is important to source some reference materials, either by producing rough sketches on location in a small pocket-sized sketchbook (Figure 4) or by taking or looking up photos (Figures 5 and 6). Keep this reference material in folders, both real and virtual, and over time you will build up an archive of invaluable information and inspiration that can be accessed quickly and easily.

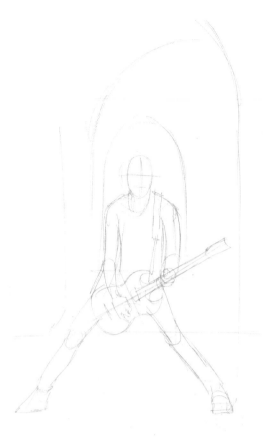

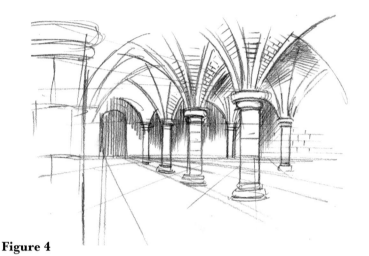

Figure 4

Figure 5

Figure 6

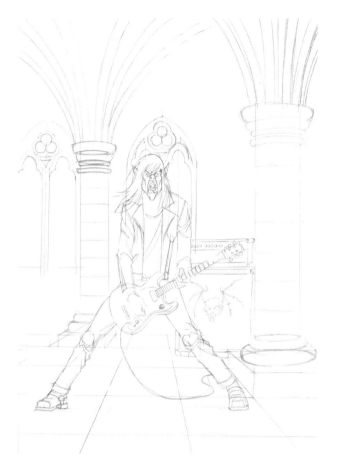

STEP 2

To plot the layout correctly, take time to draw some perspective lines (see page 240), which will enable you to gauge the position of the pillars and the size and angles of the flagstones on the floor.

STEP 3

Referring to the photos of Gothic architecture, begin to apply details to the pillars and vaulting. Since this will be a dark environment you need only be concerned with the basic structural details. Do some research and choose equipment you like the look of, then use it to help you draw the guitar and amplifier. Having spent a lot of time attending rock concerts I am very familiar with sound equipment as well as guitars. I was going to model the guitar on a Fender Stratocaster, but in the end I based it on a Mosrite guitar, simply because the shape appealed to me at the time. It could also easily have been a flying V-shaped Ibanez guitar. The amp is based on a Marshall amplifier and the skull and crossbones image on the front is a nod to gothic rock band Avenged Sevenfold.

STEP 4

Once the working drawing is complete, trace it on to a clean sheet of cartridge paper using a lightbox.

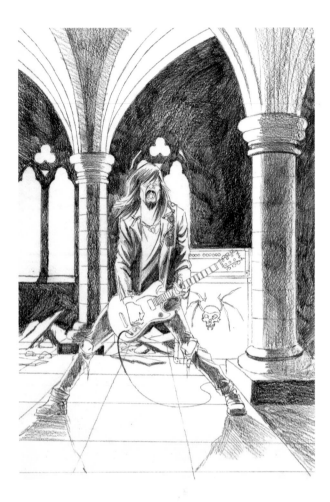

STEP 5

Begin to establish the darker, blacker areas using a pencil (I used a Palomino Blackwing 602), applying heavier pencil work in the background and lighter tones to the pillar in the foreground.

STEP 6

Blend the pencil work to a smoother finish using a blending stump rather than a piece of tissue, so that you can be really accurate.

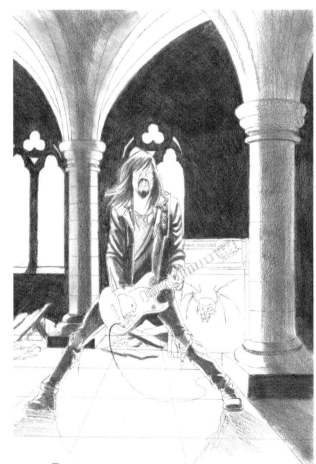

STEP 7

Using a Staedtler HB pencil, apply some mid-range tones to the vaulting and pillars. Pay attention to where the light source is coming from and position the highlights appropriately.

STEP 8

Using a sharp Staedtler HB pencil, add some detail to the lighter areas of stonework that will be more visible and add shading to the underside of the stonework. Even though the colouring and lighting will obscure most of the details, they will add texture.

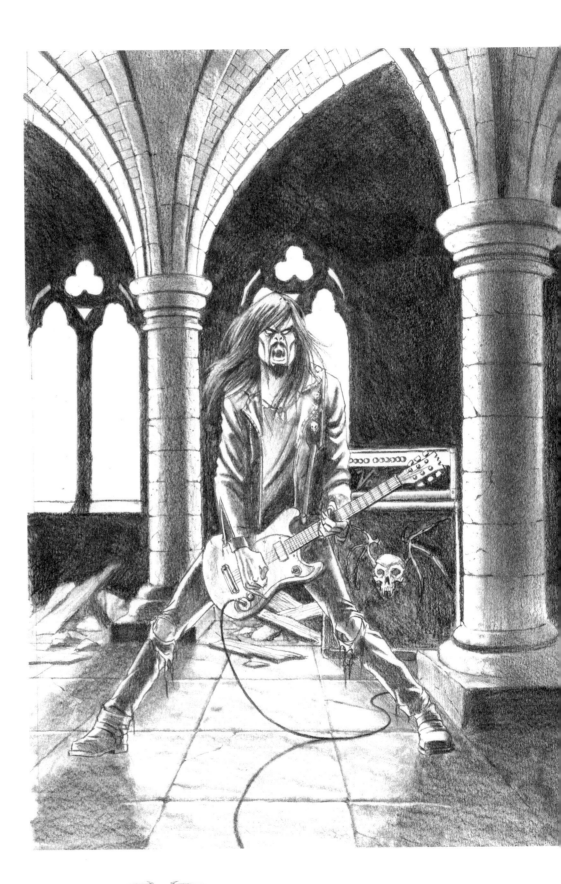

STEP 9

Still using a Staedtler HB pencil, apply lighter tones and texture to the flooring by lightly running the flat end of the lead across the surface of the paper.

STEP 10

Again, using a sharp HB pencil, tighten up the finer details of the figure, paying special attention to the hair and face. Little details such as the holes in the T-shirt and the skull decoration on the guitar strap give character to the figure. Although these are small details and not immediately noticeable, they provide important information and add interest.

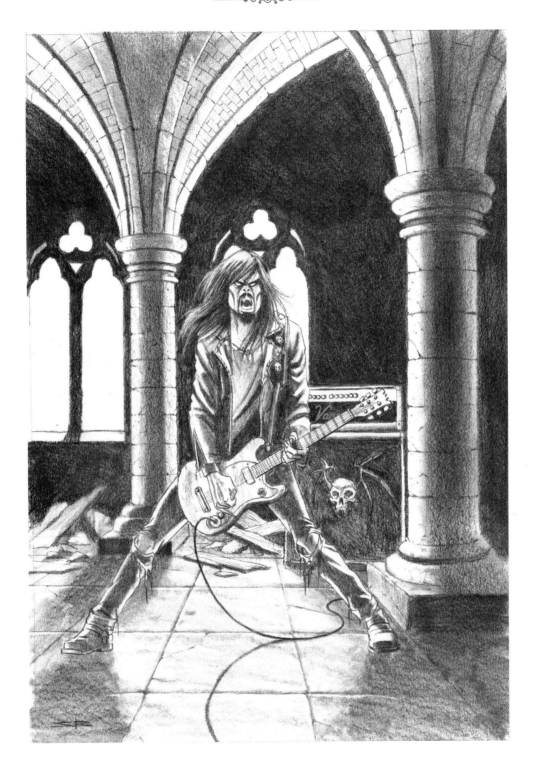

STEP 11

Once all the pencil work is finished, assess the drawing. Are more highlights required? Does the line-work need blending more? I did some additional blending on the stone floor using a blending stump and added some subtle highlights to the stonework, pillars and figure using the sharp end of an eraser.

At this stage you could stop, since the pencil drawing is complete. Alternatively, you could ink the drawing, colour it using markers, or do as I did and scan the image and colour it using Photoshop.

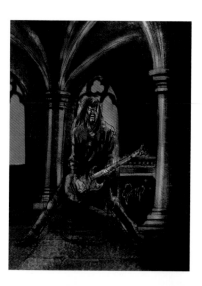

Figure 7

The rough colour work in Figure 7 was created early on, after I produced the thumbnail sketch. I scanned the image, imported it into Photoshop and created a colour scheme. At the time I thought the colours worked, but when I looked at it again I realized that the tones were not correct for giving the impression of the setting sun seen through the window. When I came to produce the final image I decided to keep the colour palette simple, as I do for most illustrations.

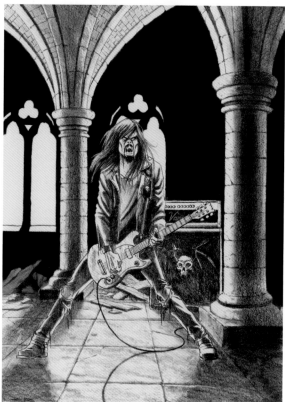

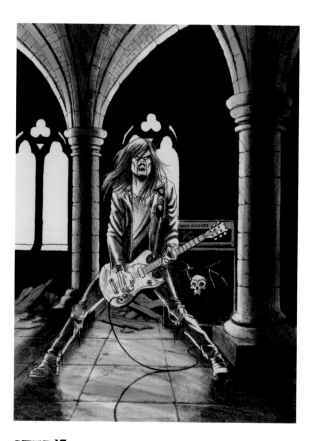

STEP 12

Once you have imported the final pencil illustration into Photoshop, create a base colour layer of pale orange by using the Fill option on a low opacity, on the Multiply setting. All the brushwork here was done using a single brush I created by scanning a pencil rubbing. You may have other brushes that better suit the way you work – try things out and have fun experimenting.

STEP 13

Create a new layer, set to Multiply, and use a brush to add a pale olive green to the shadowed areas of stonework. Notice how this immediately changes the atmosphere of the piece.

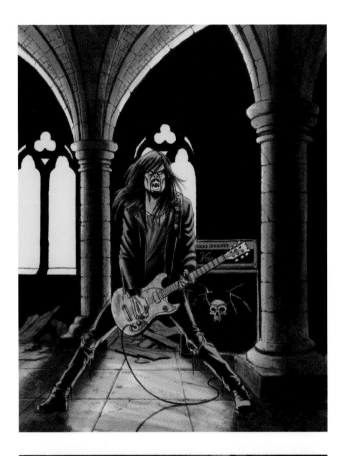

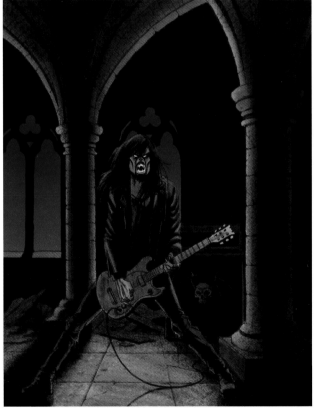

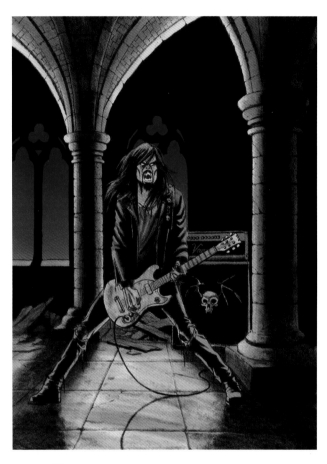

STEP 14

Continue to build up tonal work on the stone with separate layers of pale olive and warm grey, set to Multiply, until you achieve a range of subtle tones.

STEP 15

Colour the sky, seen through the window, using three layers. The first layer is orange, the second is red and the third is a darker red with a hint of black, which I used for the darker upper tone. All layers should be set to Multiply.

STEP 16

To finish off the interior of the church, apply a few layers of orange. I adjusted the opacity of the first layer to create the right tone to blend with the olive colours underneath. Then I built up the darker, warmer tones with deeper shades of orange, the last of which had a percentage of grey in it.

STEP 17

Once you are happy with the setting, focus on the figure. Strengthen the shadows using a dark warm grey and refine the features of the face. Add details to the guitar. Finally, add bloodstains and spatters around the vampire's mouth and clothing and on the guitar.

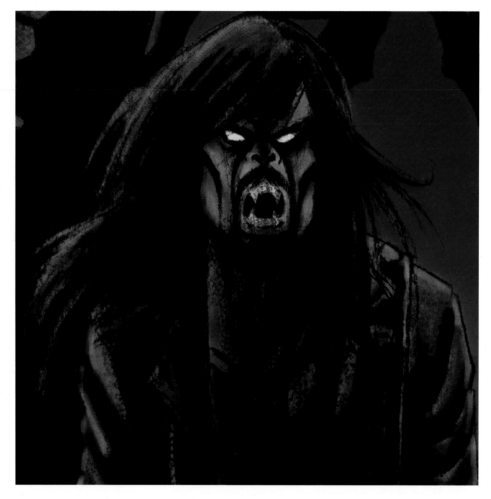

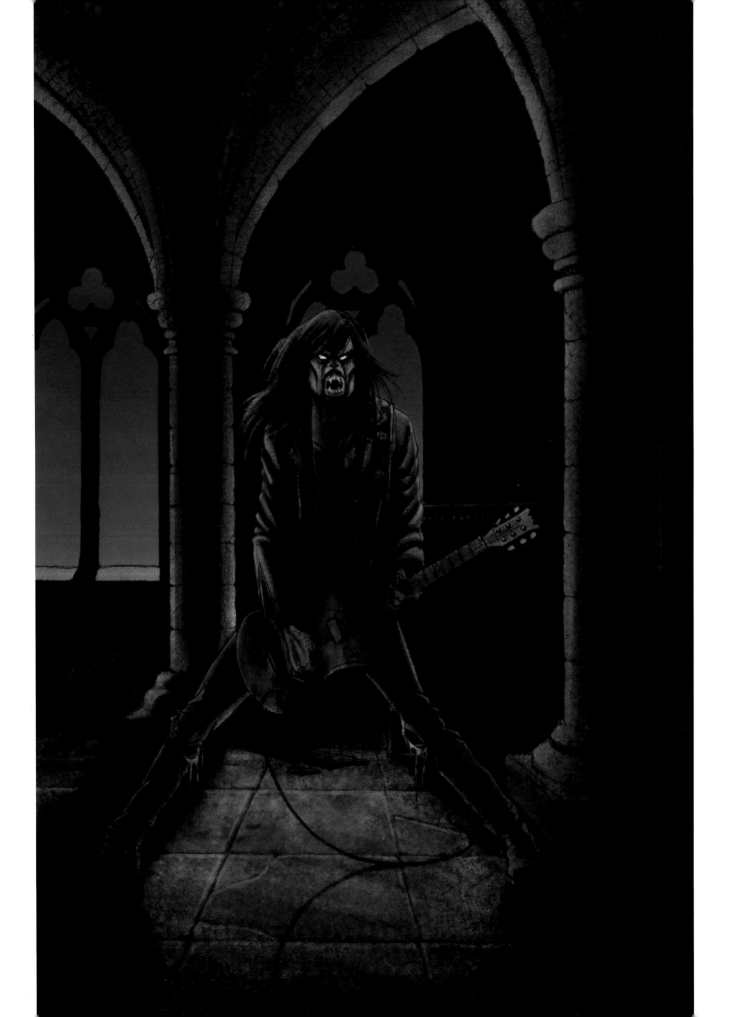

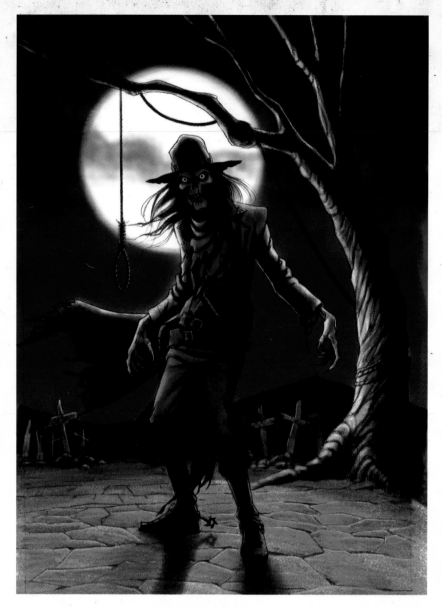

PROJECT II

◦•◦•◦•◦

WILD WEST REAPER

◦•◦•◦•◦

I'm a big fan of zombie movies and Gothic Westerns. I love the imagery of Sam Raimi movies such as *The Evil Dead* and *Darkman* and the highly stylized camerawork of Sergio Leone's Spaghetti Westerns. One of my favourite scenes in *The Good, the Bad and the Ugly* is the final showdown in a parched graveyard. With that in mind, I came up with the idea for this midnight scene with a ghostly gunslinger. This image would work well as a pencil drawing or inked in so it stands out more. But I decided to take the piece a step further and colour it using Photoshop.

I began by producing some rough ideas in colour, using markers. The first idea (Figure 1) shows a classic duel pose that is imposing and menacing. The moon frames the figure, allowing it to stand out against the midnight sky. However, although I liked this layout I didn't think it was creepy enough. I felt the figure needed to look more craggy and other-worldly, so I made some sketches in which it has a more skeletal appearance, resembling a rotting corpse. The curve of the back and the legs creates a nice shape and adds to the eeriness of the character without diminishing the sense of threat. I then played around with a couple of colour variations to decide upon the right atmosphere (Figures 2 and 3). I felt that a midnight setting created the right mood.

Figure 1

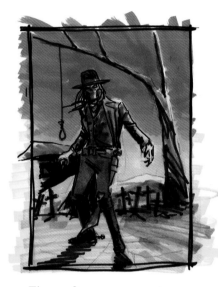

Figure 2

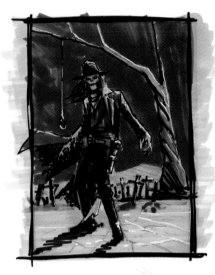

Figure 3

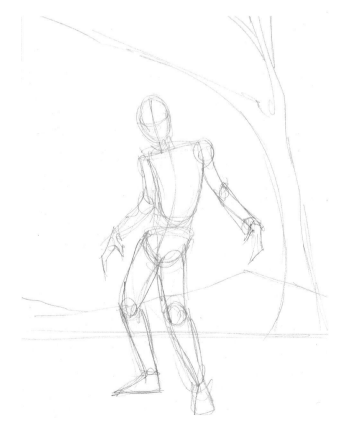

STEP 1

Having sketched out the drawing in rough, you can start afresh on a clean piece of paper. My drawing was produced on 300gsm rough cartridge paper using a combination of a Palomino Blackwing 602 pencil and a HB Staedtler pencil. Begin to plot the drawing, making the tree in the background echo the shape of the figure. Notice the low horizon line. When drawing the character, keep in mind the tips on figure drawing on pages 31–35 and break down the form using whichever method you prefer. Here, I used construction shapes.

STEP 2

Once you are happy with the basic stance, you can flesh out the figure and add clothing. Because I watch so many films and read so many comics, my head is crammed full of visual references and information I can draw upon. For this project I called upon my visual memories to create a hybrid of Sam Raimi's *Darkman*; the cowboys in the train station scene in Sergio Leone's *Once Upon a Time in the West*; and Virgil Cole in Ed Harris's *Appaloosa*. Combining references in this way may not create an authentic Wild West visual, but this is fantasy art and using artistic licence is a lot more fun than slavishly reproducing stereotypes.

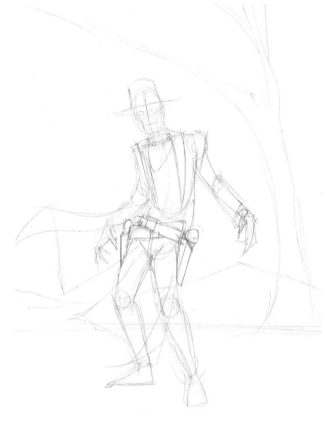

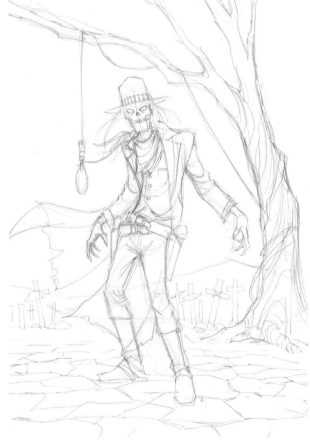

STEP 3

Now you can add details to the background and the figure. Think about each element and the impact it has upon the atmosphere. In my drawing, the tree has taken on a more twisted, craggy appearance and I've added a hangman's noose to further frame the figure. I have made the wooden grave markers more weathered and beaten. The hills in the background, once blackened, will add contrast and make the grave markers stand out more. I have given the figure long, wispy, tatty hair on his skull-like head, which contributes to his creepy appearance, and added details to his clothing so he looks more like a zombie gunslinger.

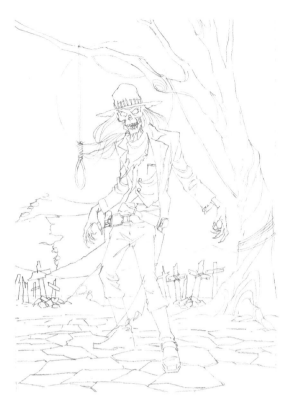

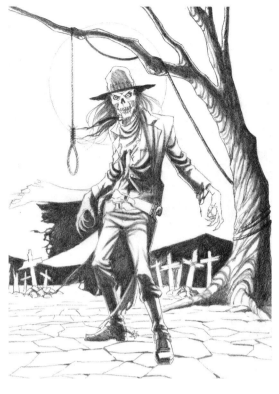

STEP 4

Once you are happy with the image, trace the outlines on to a piece of cartridge paper using a pencil and lightbox, if necessary. If the original workings out are drawn softly, you can simply clean up the drawing using an eraser.

STEP 5

Fill in all the dark areas that will lend the drawing strength, then use a blending stump to blend the pencil work for a smoother finish.

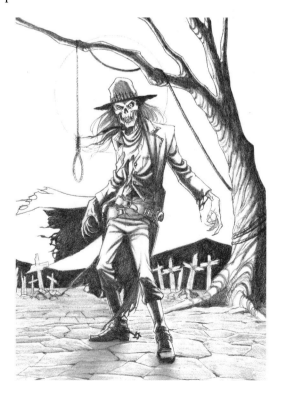

STEP 6

Add light and mid-tones to the ground and clothing using a pencil. I have purposely left more areas of lighter tone on this drawing to enable me to colour and light the image in Photoshop. Even if you are producing a monochrome version of this drawing, it is a good idea to leave lighter areas so that the drawing does not look too flat.

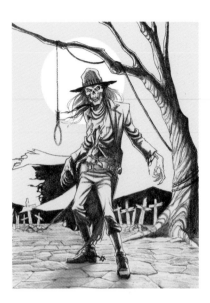

STEP 7

Once you are happy with the pencil work, you can either stop or try colouring the image. You may choose to use paint or markers, but I turned to Photoshop for this artwork. Scan the drawing and import it into Photoshop. Create a pale blue base layer, set to Multiply, using the Fill option and adjusting the opacity.

I decided to add a full moon in the background so the figure stands out well in the foreground. I was hesitant at first as I thought this detail might be a bit clichéd, but I found that it actually added to the mood of the scene.

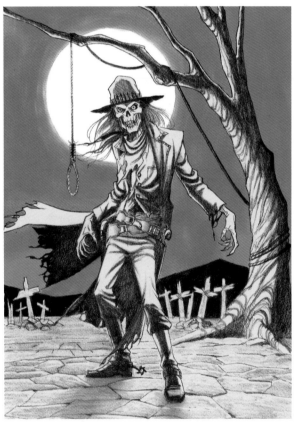

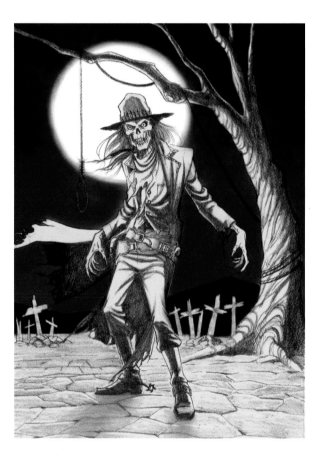

STEP 8

On a new layer, set to Multiply, add a darker shade of blue to begin the build-up of tone for the midnight sky. I used a brush I created by scanning some pencil rubbings and then raising the contrast. I find this digital brush works in a similar way to a real brush, creating comparably rough or broken strokes.

STEP 9

Add an ultramarine tone as the final layer of blue, again set to Multiply. On another layer, set to Multiply, apply some dark grey at the top of the image to stop the sky from looking too flat. I also used the blue to wash over the hills in the background to darken their appearance.

STEP 10

Apply a mid-grey layer set to Multiply to darken the ground. You can adjust the opacity setting to create the right amount of tone. A mid-warm grey tone layer makes the clothing just different enough in colour for the figure to stand out from the background. I have purposely left rough highlights around the edge of the figure so that it doesn't get lost against the background colour.

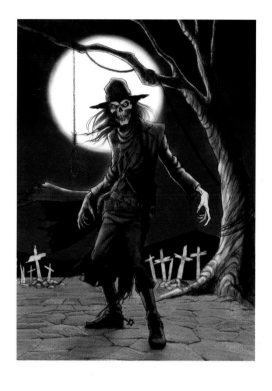

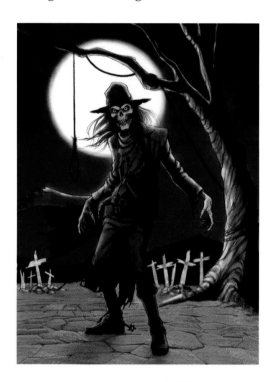

STEP 11

Using a dark grey layer, set to Multiply, apply the heavy darker tones to the hills, the figure and the tree, giving strength to the image. I tried applying a black layer, but it was too heavy for my taste, so I opted for a grey.

STEP 12

Apply layers of pale warm greys to the clothing and face to blend the colours and add more depth. All layers should be set to Multiply.

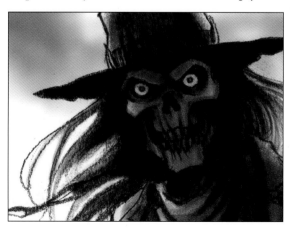

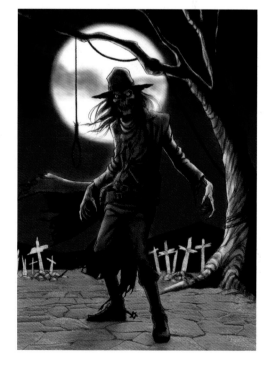

STEP 13

Build up the deeper, darker tones of the face and hands using pale blue-greys and warm greys set to Multiply. Adjust the opacity on each layer if you feel that some of the brushstrokes are too harsh.

In reality, a figure situated in front of such a bright moon would be cast in silhouette. However, I wanted some of the character's features to be visible so I took some artistic licence with the lighting.

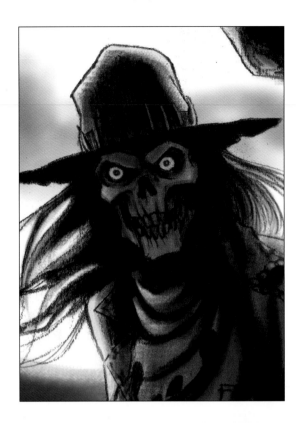

STEP 14

Finally, add some highlights to the figure, the grave markers, the cracks in the ground and the tree. For this I used an opaque layer of pale blue. This is the only layer I have used on the Normal rather than the Multiply setting. I adjusted the opacity to slightly reduce the opaqueness of the highlights. Check that you are happy with the final image, and make any adjustments you want.

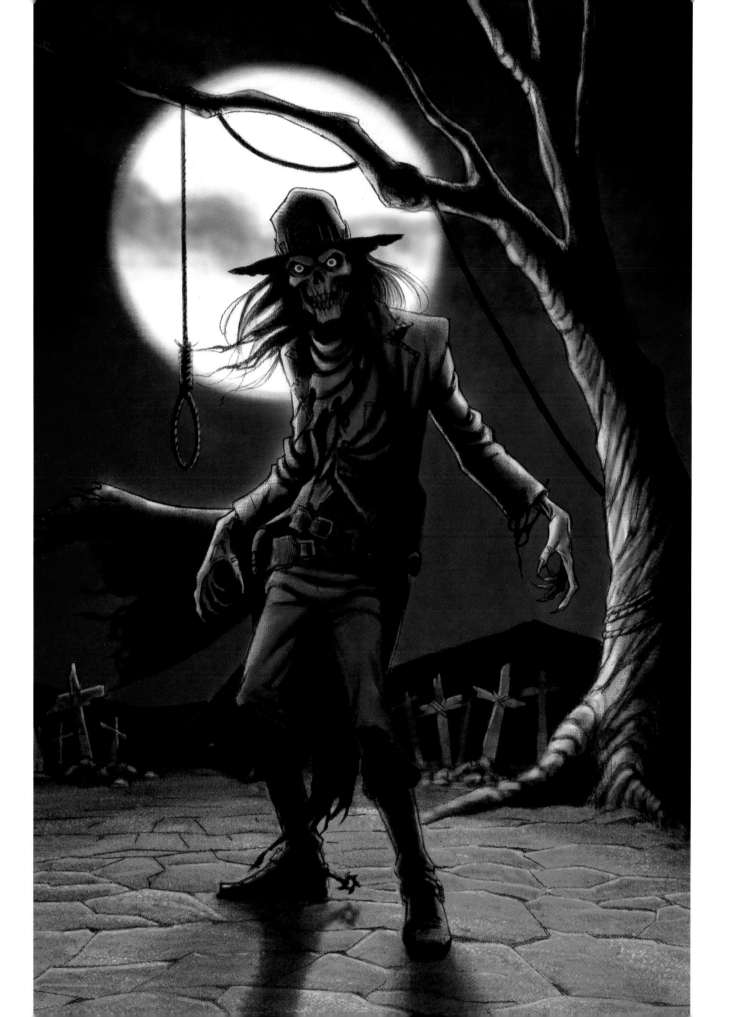

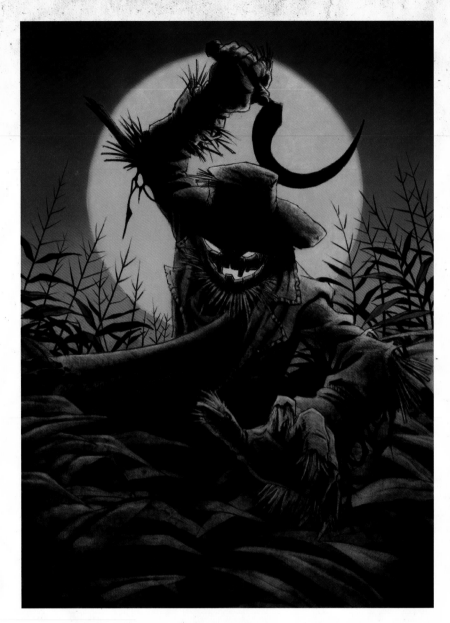

PROJECT 12

◦◦◦∘◦◦◦

HALLOWEEN

◦◦◦∘◦◦◦

As a child, I was taken to see Walt Disney's animated feature film, *The Adventures of Ichabod and Mr Toad* (1949), which contains the tale of *The Legend of Sleepy Hollow*. I loved the story and imagery of Ichabod Crane and the headless horseman. As a teenager, I went to see Tobe Hooper's *The Texas Chain Saw Massacre* (1974) and was equally impressed by its macabre visuals and narrative. Imagery from both films informs this drawing, as well as references from other sources and, of course, my imagination.

Initially, this character was going to be a creepy-looking scarecrow that had been brought to life to terrorize a remote run-down farm with a rusty but lethal sickle. I sketched a few ideas of a sack-headed scarecrow (Figure 1), which I thought had some merit, but I decided they looked too much like the DC Comics character The Scarecrow, one of Batman's well-known adversaries. So I changed tack and developed a series of thumbnail sketches of a pumpkin-headed scarecrow in order to find the right content and layout.

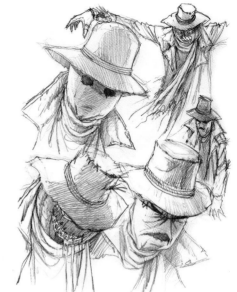

Figure 1

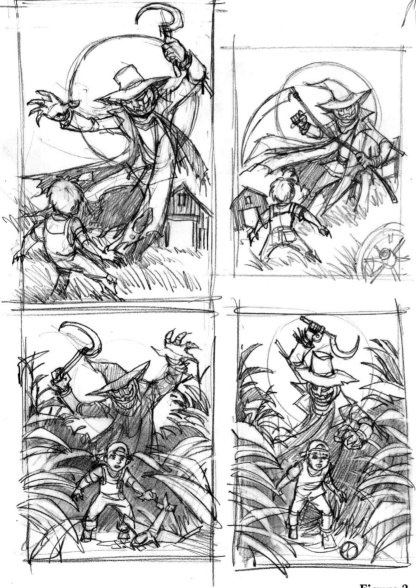

Figure 2

The first ideas I developed depicted a scarecrow terrorizing a young farm boy (Figure 2). Although I liked these, I was not completely satisfied with the tone and atmosphere. Then I remembered the 1974 promotional posters for *The Texas Chain Saw Massacre*, a simple yet striking image which showed the central character, Leatherface, waving a chainsaw above his head in a field of crops. Nothing else – no other people in the shot. I realized that the power of the image was derived from the uninterrupted connection between Leatherface and the viewer, and that by removing the figure in the foreground of my drawing I would be able to create a similarly strong link.

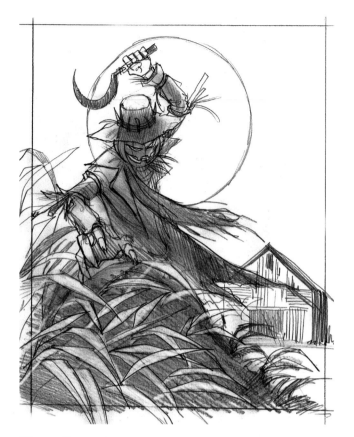

Figure 3

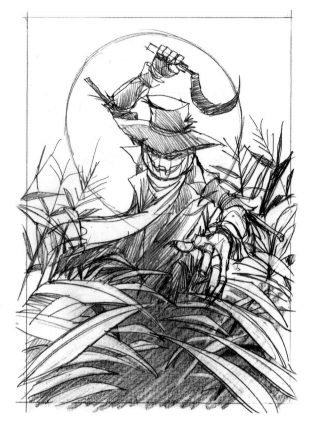

Figure 4

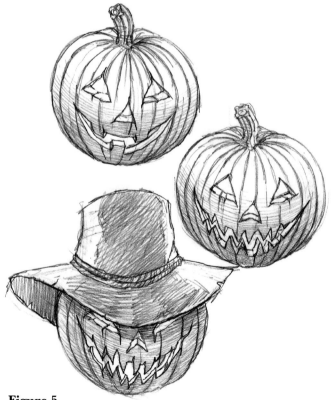

With this in mind, I developed two more thumbnail sketches (Figures 3 and 4), which I felt worked much better. I really liked the wide shot (Figure 3), which allowed me to introduce background details such as the barn and to re-create the atmosphere of *The Texas Chain Saw Massacre* poster. However, I eventually decided on the tighter shot (Figure 4), as it draws the viewer closer to the menacing scarecrow.

Before developing the final drawing I explored a few styles of pumpkin head to see which had the right creepy vibe (Figure 5). I thought jagged teeth would look scary, but once I had drawn them I felt they looked a bit clichéd. I decided in the end to go for a classic Halloween pumpkin, which was more understated but created the visual I was looking for. You may want to give your pumpkin jagged teeth – as with most details when drawing, there is no such thing as right or wrong and it all comes down to personal preference.

Figure 5

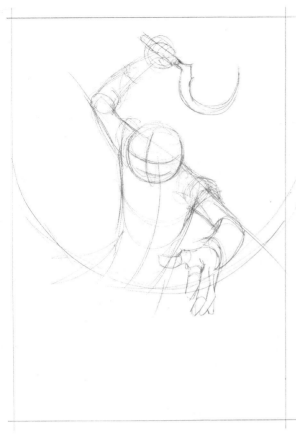

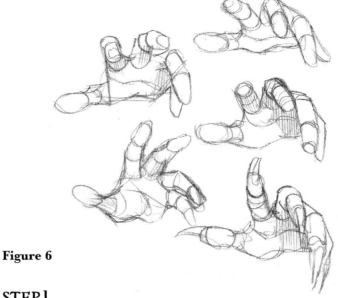

Figure 6

STEP 1

As the artwork has a central composition, it makes sense to plot the drawing around a centre line. I roughly marked out the shape the crops would make (Step 1). You will notice that this echoes the shape of the sun.

I wasn't completely satisfied with the hand reaching out that I had drawn in the original thumbnail sketch. I therefore held my hand in various positions and used a mirror to see how it looked, then drew a series of sketches (Figure 6) so that I could assess which pose would work best.

STEP 2

Start filling in the details, sketching the crops before you begin work on the figure. I drew the stalks coming into the frame from the outer edges of the paper, growing less dense as they reach the centre. It may look as though I have drawn a lot of randomly placed leaves, but when you shade in the picture you will notice that their arrangement creates a dark, shadowy space in the middle that draws your eye to the scarecrow.

For the clothing, I chose to draw a tatty overcoat, scarf and hat, the style and details of which are obscured by the rips, tears and general dirtiness of the garments. The gloves are workman's gloves – the type a farmer or construction worker might wear.

The clothing is baggy and the skeletal structure of the scarecrow is based on a wooden cross-shaped frame rather than a human body. I wanted the arms to be long and thin – reminiscent of a scene in the Wes Craven movie *A Nightmare on Elm Street*, in which Freddy Krueger chases a victim down an alley with spindly arms reaching out to the walls, preventing any chance of escape.

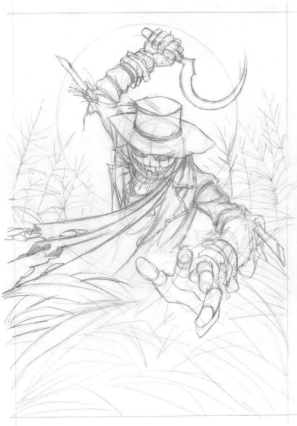

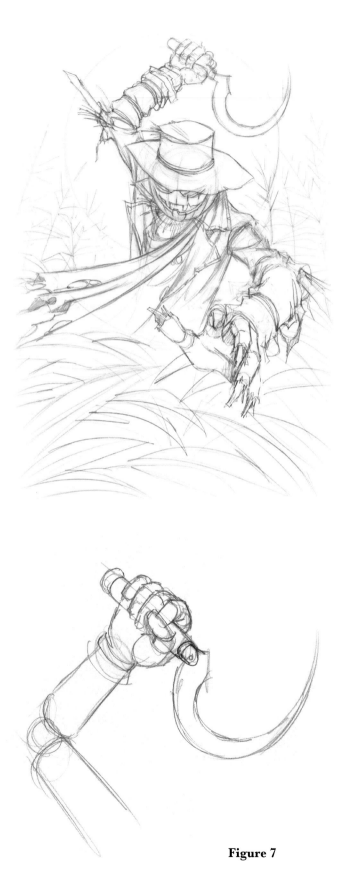

STEP 3

Having plotted the drawing, take a step back and assess it. When I studied my drawing, the raised arm holding the sickle caught my eye straight away; everything about it just looked wrong. I replicated the pose in a mirror and found that the position of the arm was not correct. After studying the pose carefully, I returned to my desk and practised redrawing the arm on scrap paper before amending my drawing (Figure 7).

STEP 4

Check the drawing one more time, then trace the image on to a sheet of cartridge paper using a pencil and a lightbox, if you have one. You should now have a clean, accurate outline to work to (Figure 8, opposite).

Figure 7

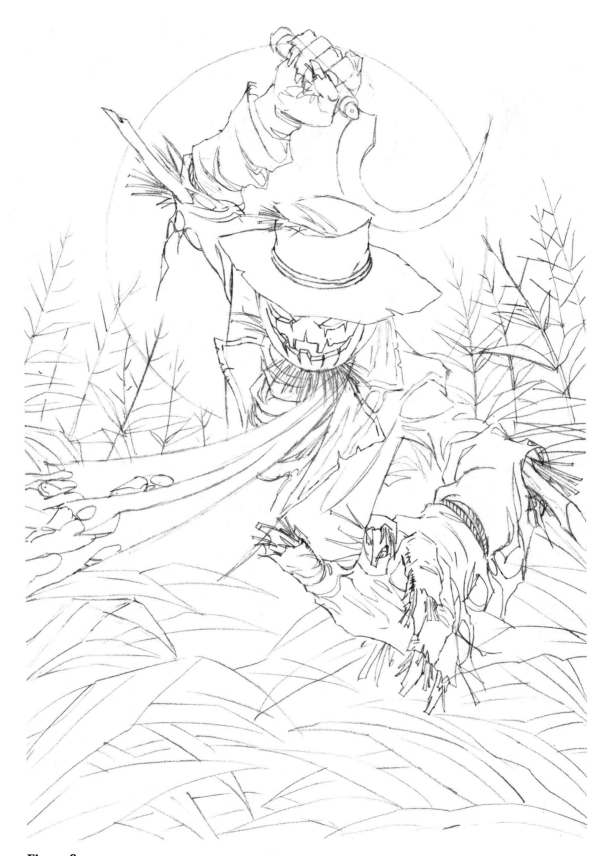

Figure 8

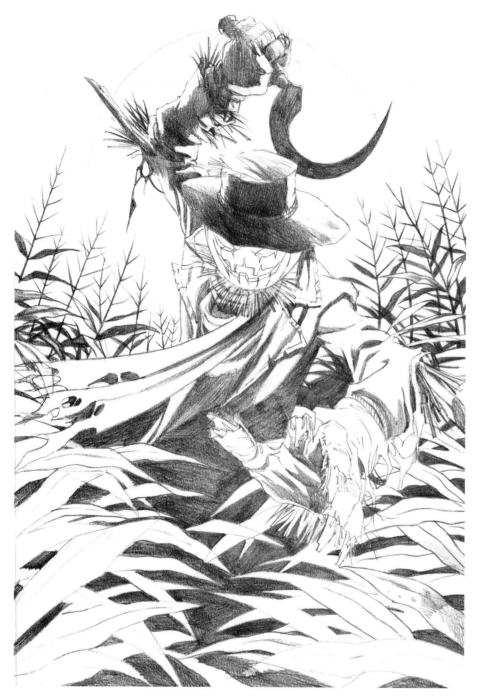

STEP 5

Using a Palomino Blackwing 602, darken the areas that will give the image its strength and weight. You may notice in my drawing that the darkened areas run up the centre of the page, creating a linear design. This is a deliberate device to make sure the viewer's eye does not wander away from the main point of interest.

STEP 6

Use a blending stump to achieve a smoother, more opaque finish on the darker areas of shading. Figure 9 on the facing page shows the finished result. As a pencil drawing, this artwork is now complete. However, you can take it a stage further and add colour, as I have done, if you like.

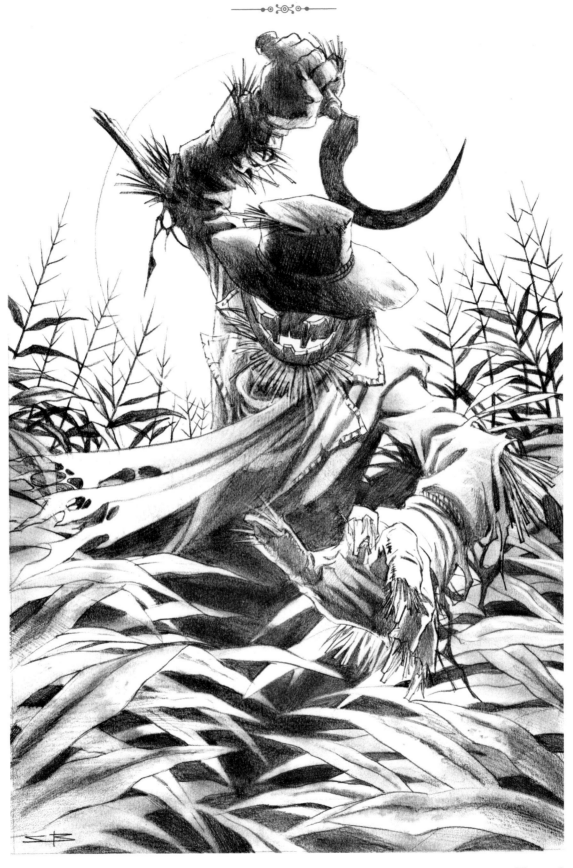

Figure 9

STEP 7

Scan the drawing and import it into Photoshop. Apply a first layer of base colour using the Fill option, set to Multiply. Here, I used a very pale warm yellow as a foundation for the warm tones.

I added colour to the sky in three layers. The first of these was a deep orange, over which I placed another layer of deep red, followed by a layer of dull red with a percentage of black in it to create the darker tones at the top. All the layers were set to Multiply. I mainly used just one brush to apply the colouring. This is a customized brush I created from a pencil rubbing (Figure 10), but it is likely that there are similar brushes available on the internet that you can download for free.

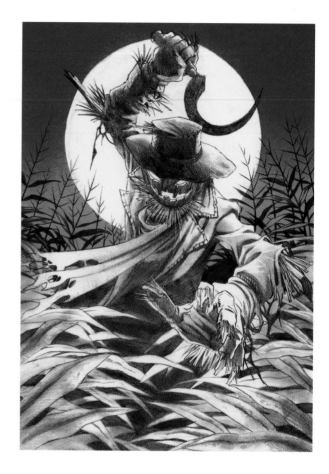

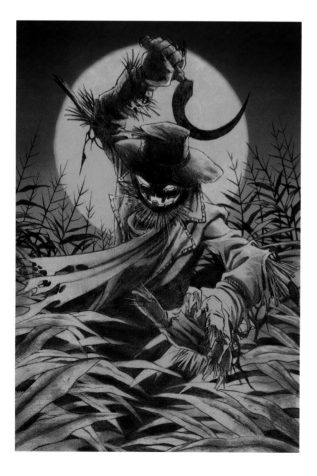

Figure 10

STEP 8

On another layer, apply a rich deep orange for the sun. Use the same orange for the rest of the image, but put it on a separate layer in case you need to adjust the opacity to blend with the olive tones that are going to be added. Both layers should be set to Multiply.

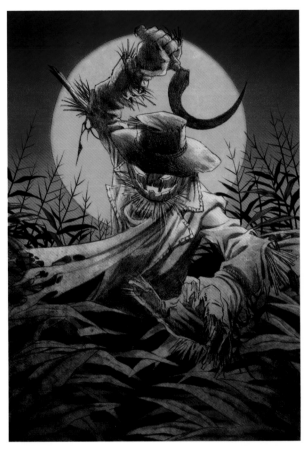

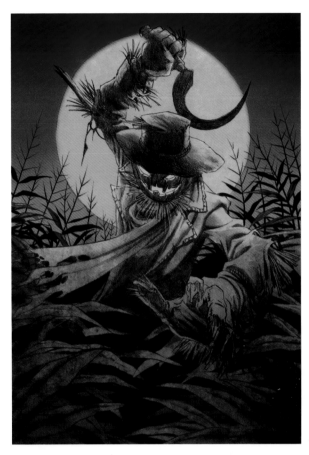

STEP 9

Begin to build up the colours for the crops using layers of olive green. In this step picture I have deselected the orange layer shown in Step 8 so you can get an idea of the tone of the green, but you don't need to do this. I have merged the green with the outline of the scarecrow in order to create a subtle tonal blend as I apply other colours. All layers are set to Multiply.

I have returned the orange layer in Figure 11 to show how the colour blends with the olive greens, creating rustic and darker tones.

Figure 11

STEP 10

Enlarge the diameter of the brush tool, zoom in and dab the olive green over details such as the leaves to create textural detail and interest.

STEP 11

On another layer, using the same brush and a dark warm grey, apply texture to the scarecrow's clothing. With the layer set to Multiply, make a denser grouping of strokes to create darker tones.

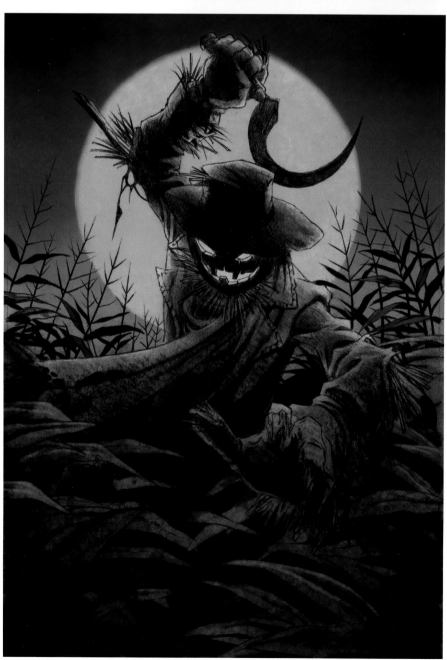

STEP 12

Create the darkest tones using a dark warm grey that is about 25 per cent lighter than a solid black. I applied this to the scarecrow, the really dark areas of the crops at the bottom of the picture and the silhouetted crops in the background.

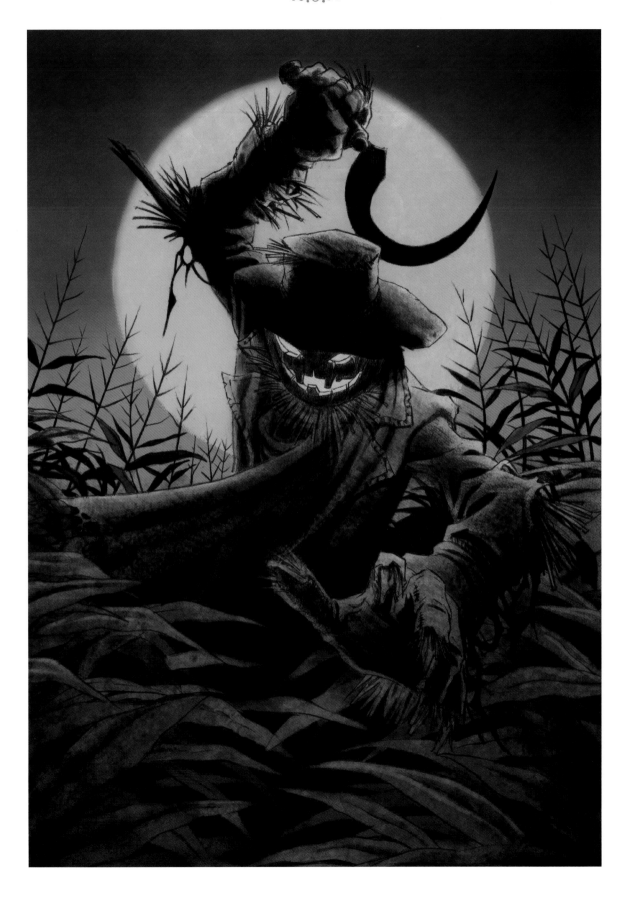

STEP 13

On the top layer, apply yellow and light orange highlights to the scarecrow to make him stand out even more from the darkened background. The highlights should be set to Normal rather than Multiply (meaning they are opaque rather than transparent). Use highlights to pick out the gloved hand reaching towards the viewer and on the clothing and straw hat, both of which have light cast on them from the glowing pumpkin head.

STEP 14

Finally, apply an orange tone to the inside rims of the eyes and mouth to add depth.

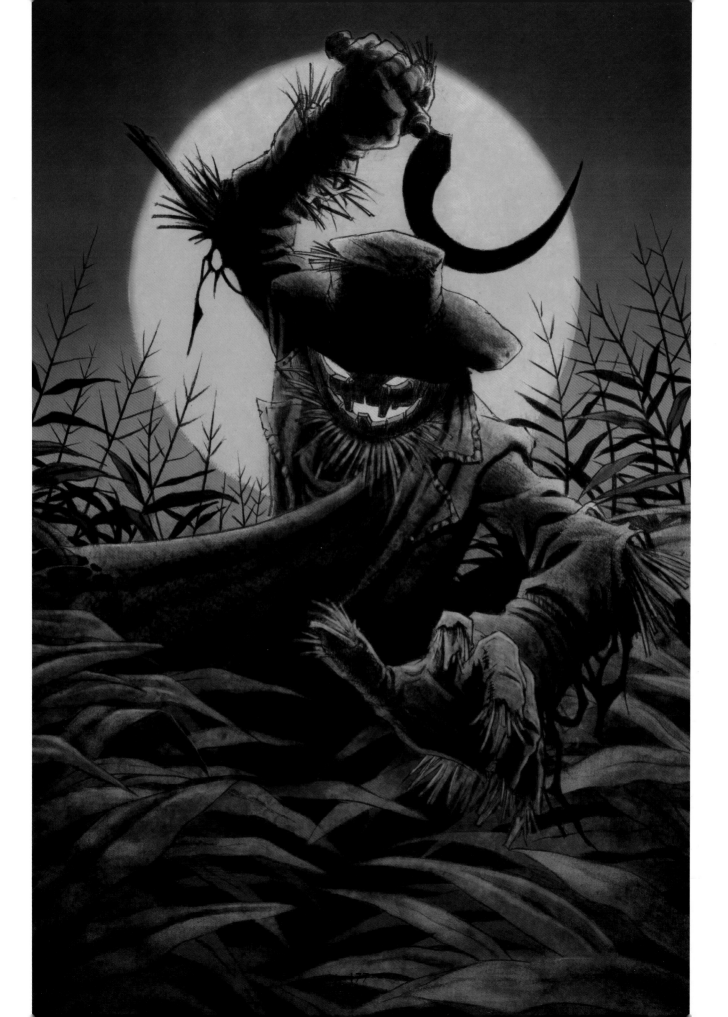

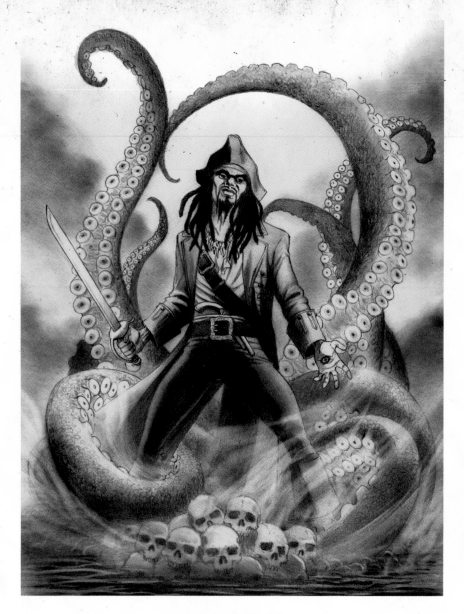

PROJECT 13

PÍRATE

During my childhood I saw many seafaring adventure movies. Some were sci-fi movies, such as *Twenty Thousand Leagues under the Sea* and *It Came From Beneath the Sea*, and others were high adventure movies, such as *Treasure Island* and *Moby Dick*. The visual imagery of these and more modern feature films, such as Walt Disney's *Pirates of the Caribbean,* has had a strong impact on me and informs much of my artwork. Pirates, giant sea monsters and other supernatural creatures all make for great fantasy art and this exercise combines elements of all three.

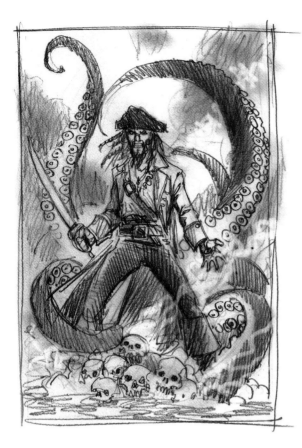

Figure 1

Before embarking on a piece of art it is good practice to produce some quick, rough sketches to determine the layout of your proposed work. These thumbnail sketches help an artist explore a number of concepts in a short space of time, using a minimal amount of expensive materials. I began this exercise by sketching a few thumbnail layouts to explore various compositions, before settling for the one that worked best (Figure 1).

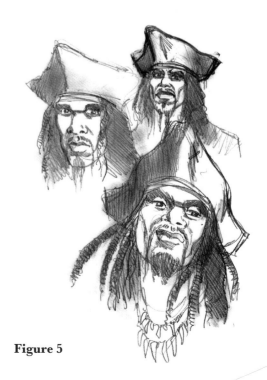

Figure 4

Having decided upon the composition of the picture as a whole, you need to think about what the main character will look like. The kind of pirate I had in mind was a person of Caribbean origin with dreadlocks. I sourced a few photo references (Figure 2 and Figure 3) and produced some quick character sketches (Figure 4 and Figure 5) to determine the look of my figure.

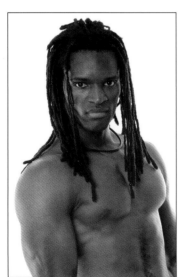

Figure 2

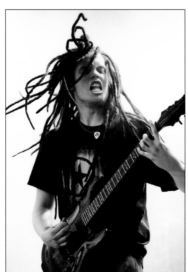

Figure 3

Figure 5

STEP 1

Generally, when a professional artist begins to work up a piece of art from a thumbnail, he or she will enlarge the thumbnail either using a photocopier or by scanning it, opening it on a computer and increasing its size there. However, if you do not have access to these facilities then it is best to redraw the image from scratch at the correct size. Drawing a faint centre line on both the thumbnail image and the larger piece of paper will help you balance your layout.

Start by loosely sketching the body, the stance of the pirate and the flow of the tentacles around him. Notice how the two largest tentacles are framing the character; this is a method used by many artists to draw attention to the main point of interest. Also roughly sketch out a pile of skulls at the pirate's feet.

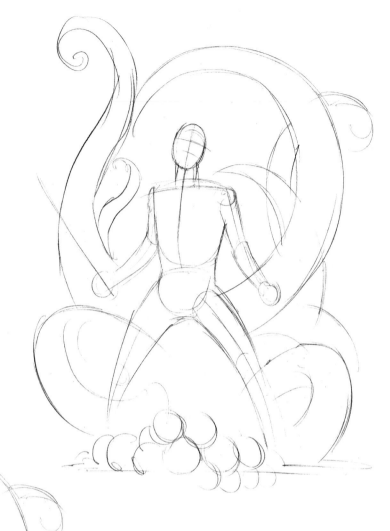

STEP 2

The next step is to sketch out the clothing. It may be a good idea to search the internet to see what reference material you can find, or maybe watch a few pirate movies.

STEP 3

Now you can start to develop the details of the clothing and weapons and begin to draw the face.

ADDING DETAIL TO THE TENTACLES AND SKULLS

Tentacles

To draw convincing tentacles it will be helpful to study some reference material, such as this picture of an octopus (Figure 6). Notice that the tentacles have two rows of suction cups and that they are not all perfectly aligned. The drawing will look more interesting if the suction cups are a bit irregular and point off in different directions, but make sure that they fit with the curves and twists of the tentacle (Figure 7).

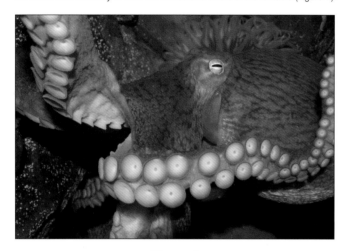

Figure 6

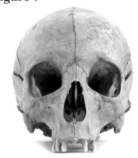

Figure 7

Skulls

Study the photo of the skull (Figure 8) and you will notice there are curves and recesses around the eye sockets and also around the cheekbones. These shapes will differ from skull to skull so you do not have to be too accurate. Most adults have roughly 14–15 teeth on each row, but this varies and when a skull is seen from the front the back teeth are not visible. When drawing an ancient-looking skull, removing some of the teeth gives a more weathered look.

Drawing a skull is similar to drawing a face, but a bit easier, and it is best to start by practising a few on a separate piece of paper. First, draw a circle, then divide it into quarters and draw a square roughly below the centre line (Figure 9). Now add the eye sockets and a hole for the nose, and indicate the position of the mouth (Figure 10). The eyes are basically irregular-shaped circles. Try not to make them too perfectly round – notice there are flat parts too. The nose is like a triangle with rounded edges. Add the teeth (Figure 11), then shade in the eye sockets and nose (Figure 12).

Figure 8

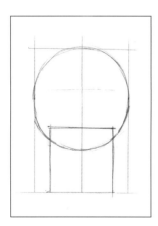

Figure 9

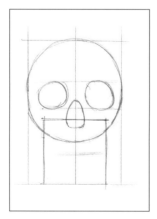

Figure 10

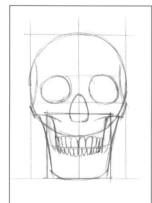

Figure 11

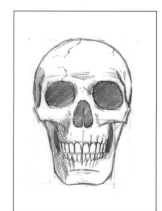

Figure 12

STEP 4

Once you are happy you can draw a skull, add the details to the pile of them at the pirate's feet. Aim to draw the skulls in an irregular arrangement, overlapping and placed at different angles.

STEP 5

Add the final details to the tentacles, paying attention to the suction cups and making sure that they do not look too aligned and symmetrical. The details on the skulls should also vary slightly so that they do not all look the same. One of the keys to creating convincing artwork is to make it appear as natural as possible. The more mechanical and precise it seems, the less realistic it looks (unless you happen to be drawing machinery, in which case, be precise).

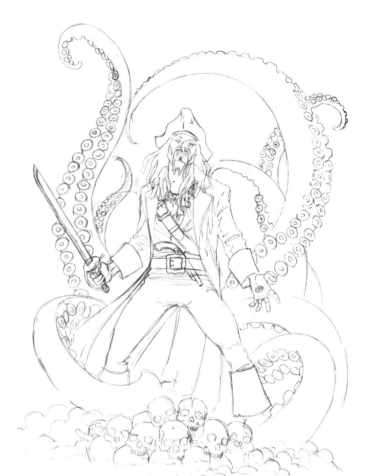

STEP 6

You can now begin the shading. I started with the main areas in shadow, such as the folds of the clothing and the underside of the tentacles, as well as the hair, which is not in shadow but which I wanted to be a mass of black.

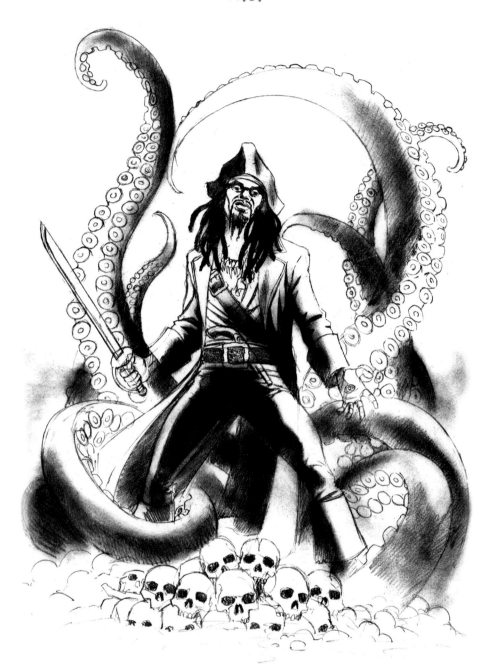

STEP 7

Blend the pencil work to create a smoother finish, and begin to add the mid-range tones to the clothing and tentacles using a blending stump or tissue paper (Figure 13).

Figure 13

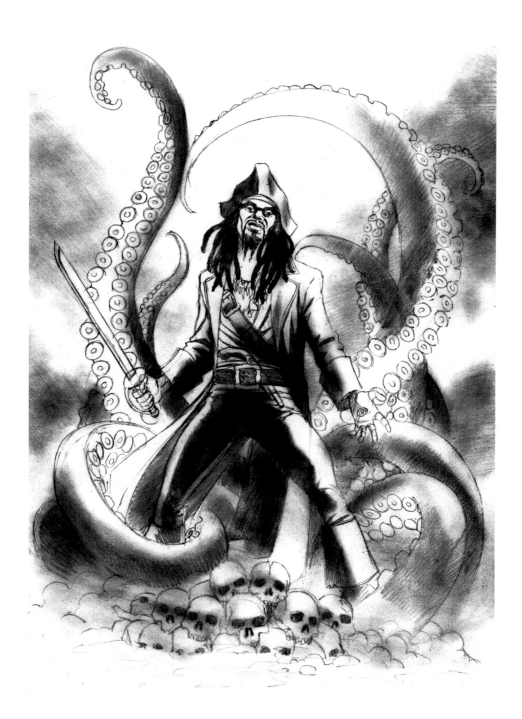

STEP 8

For the background, I wanted to create ambiguous cloudy shapes that could be either sky or steam, like clouds of mist rising from the water and around the tentacles. Use an HB pencil to create some cloud-like shapes and blend them together with your finger, using circular motions. Add some extra layers of pencil in places and blend these to create the effect of moving clouds of mist. I found using a piece of tissue worked better for this than a blending stump.

Add some tonal shading to the skulls and blend it to create an overall tone, so you can create highlights with an eraser later on.

STEP 9

Create the skin detail on the tentacles by blending layers of pencil, then apply fine line work over the top, drawing tightly grouped squiggles and swirls (Figures 14 and 15).

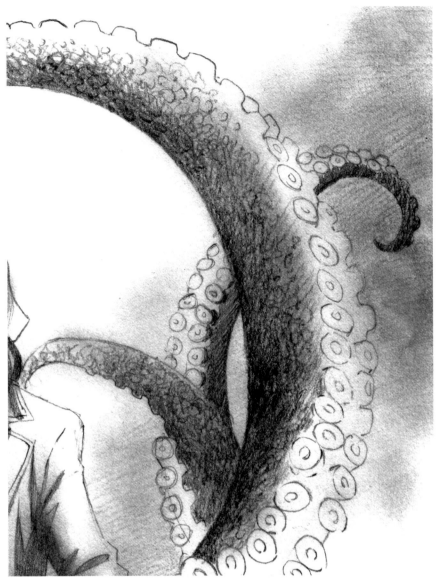

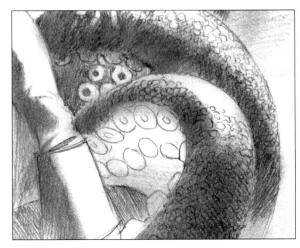

Figure 14

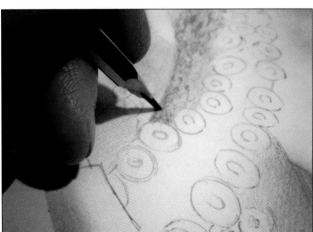

Figure 15

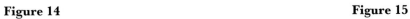

STEP 10

Having added detail to the outer skin of the tentacles, the underside now needs to be developed. This can be done by drawing irregular lines across the width between and around the suction cups, using the flat edge of a pencil (Figure 16).

Sourcing some photos of water ripples (Figures 17 and 18) will enable you to create the water effect shown in the drawing opposite.

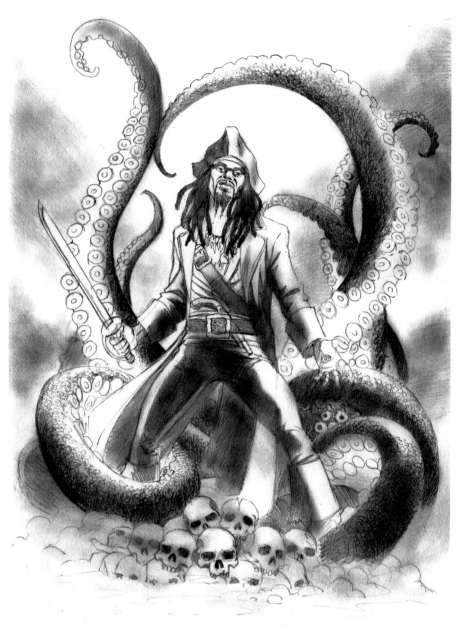

Figure 16

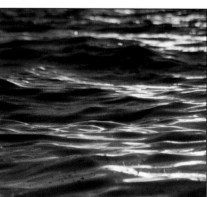

Figure 17

Figure 18

Here you can see that the drawing is almost finished. All it needs now are highlights and some swirling mist.

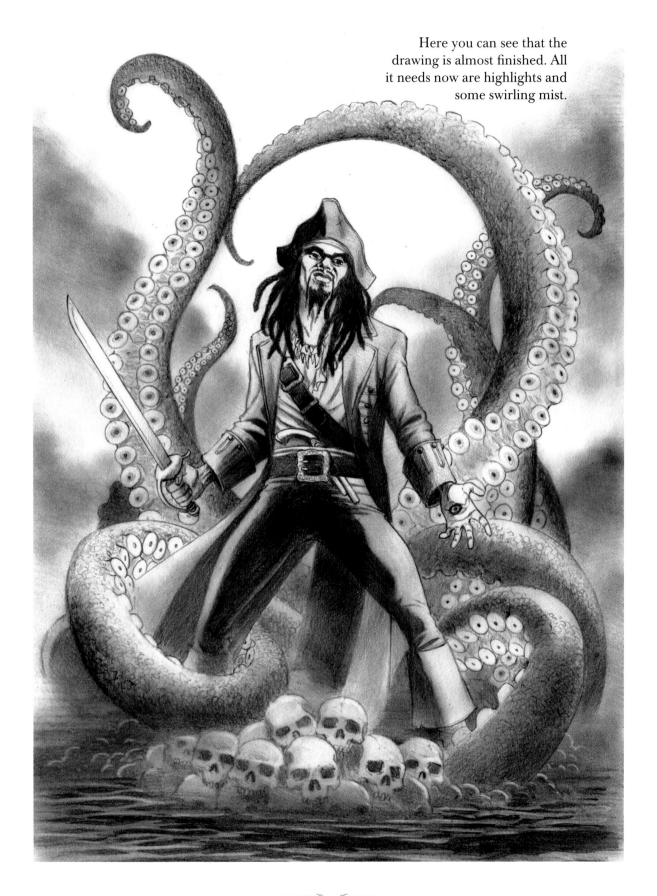

STEP 11

Before creating the swirling mist you should apply highlights to all areas that are looking a bit flat and need emphasizing. Use an eraser to add them to the right-hand side of each skull, and add some mottled highlights to the curves of the tentacles and some of the suction cups.

Figure 19

STEP 12

Some additional darker pencil work can be used to strengthen the ripples before highlights are added with an eraser (Figure 19).

STEP 13

Leave the mist until last, so that it is applied over the highlights, to create a more believable effect. I achieved this by dragging a stump of a well-worn eraser over the skulls, around the tentacles and behind and in front of the legs. Finally, if there are any parts of the drawing that need defining, apply a crisp pencil line with an HB pencil. You can see the completed drawing on the facing page.

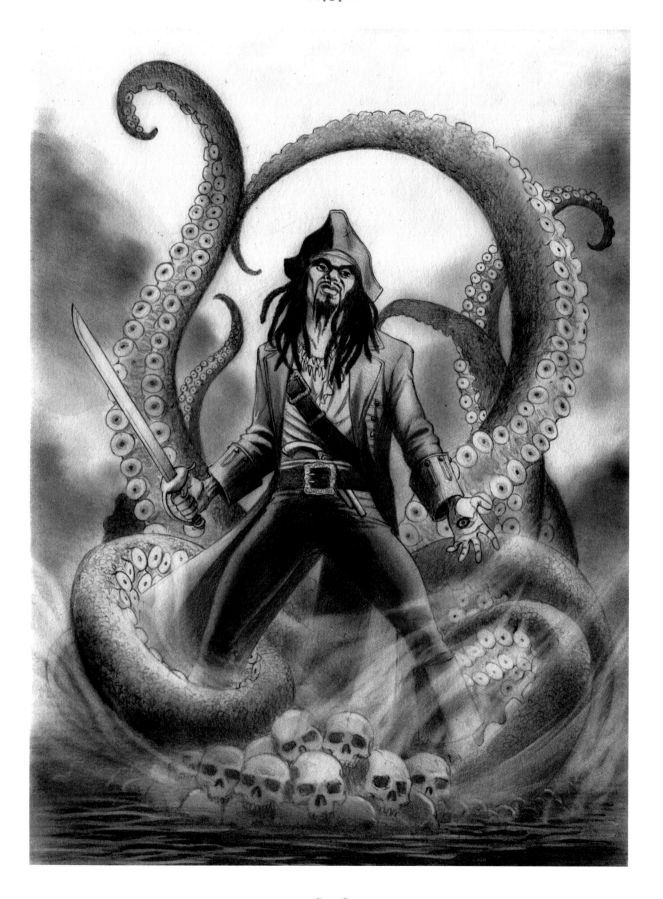

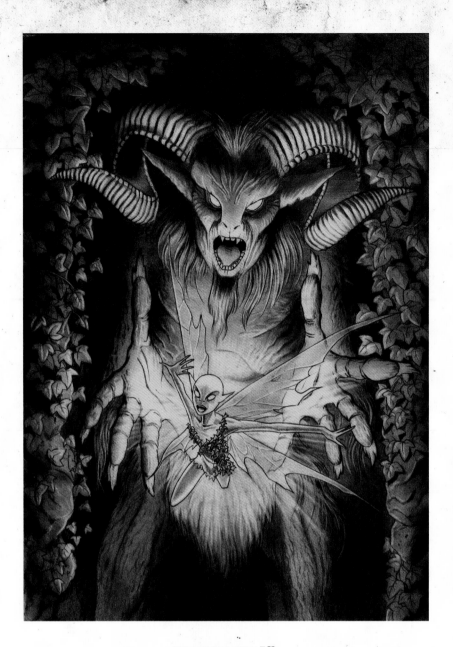

PROJECT 14

❊❊❊

THE ENCHANTED

❊❊❊

I was inspired by Guillermo del Toro's film *Pan's Labyrinth* when I was drawing this image, although there are some differences between the faun and fairies in the movie and the ones in this exercise. I didn't want to draw an exact re-creation of the characters in the film, so I purposely relied solely on my memory rather than looking at clips. Fantasy films are often a rich source of inspiration, and this drawing pays homage to del Toro's beautiful work.

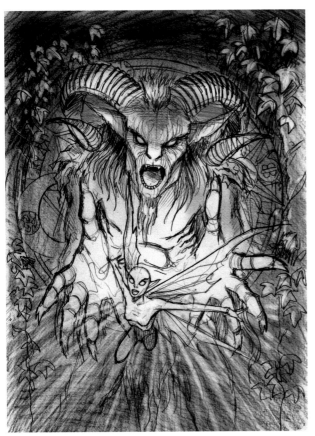

Figure 1

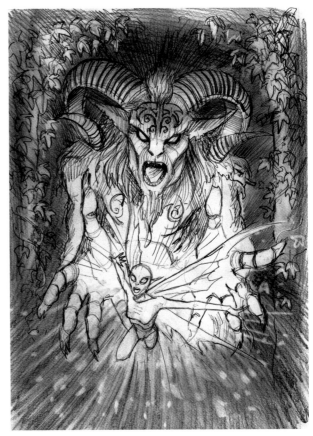

Figure 2

I started by creating some rough thumbnail sketches exploring variations on a theme. In Figure 1, I included a magic symbol behind the faun, which framed the subject. Initially I liked this approach, but then I thought it was too contrived, so I placed the faun and fairy in an archway covered in ivy (Figure 2). I preferred the uncluttered layout and decided to use it.

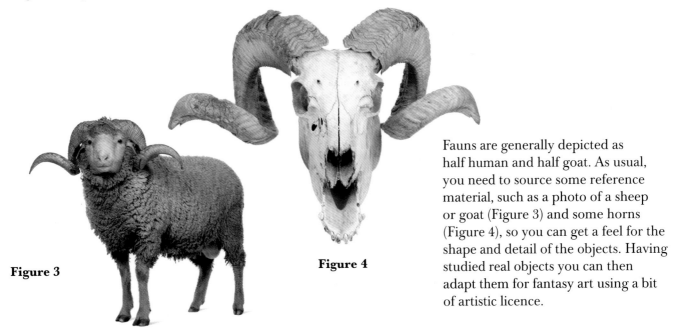

Figure 3

Figure 4

Fauns are generally depicted as half human and half goat. As usual, you need to source some reference material, such as a photo of a sheep or goat (Figure 3) and some horns (Figure 4), so you can get a feel for the shape and detail of the objects. Having studied real objects you can then adapt them for fantasy art using a bit of artistic licence.

Before I began the final piece of artwork, I wanted to make sure that I was happy with the faces of the faun and the fairy. Although I liked the middle and bottom sketches of the faun (Figures 6 and 7), I felt they looked a bit too evil, so I decided to use the top sketch (Figure 5).

I also explored a variety of ideas for the design of the fairy (Figure 8) before deciding on the final design. I chose Figure 9.

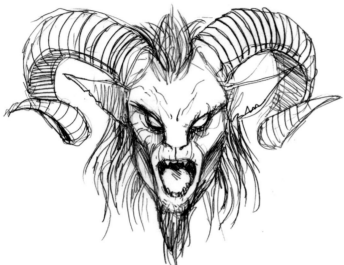

Figure 5

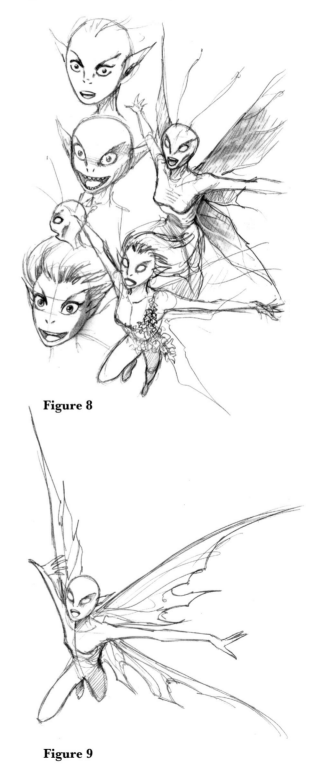

Figure 8

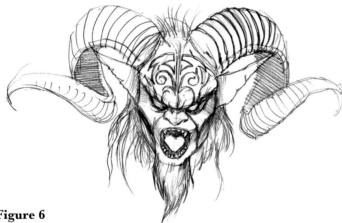

Figure 6

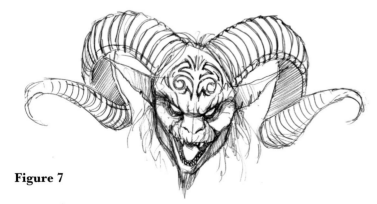

Figure 7

Figure 9

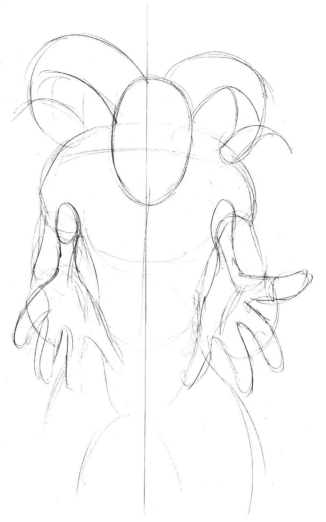

STEP 1

Draw a vertical centre line to help balance the composition. You can then compose the figure work for the faun around this.

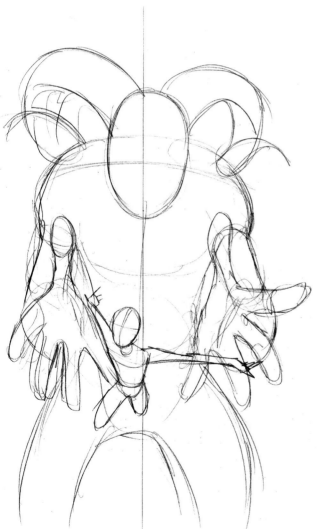

STEP 2

After establishing the faun's position, draw in the basic shape of the fairy. I chose to place her off-centre, to the left, rather than making everything symmetrical.

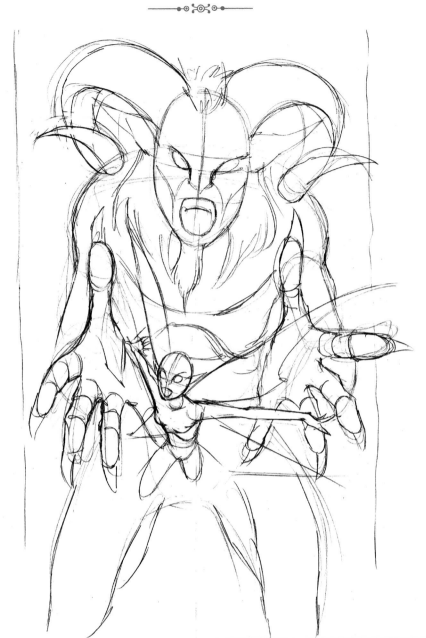

STEP 3

Once you have established the positions of the figures, focus on the outer surrounding detail, which in this case will be a stone arch covered in ivy. I was familiar enough with ivy to be able to draw a believable representation, but it helps to have a visual reference (Figure 10). This shows that an ivy leaf consists of three or five points, and some appear to be almost triangular, so a mixture of all three leaf shapes would create authentic foliage.

Figure 10

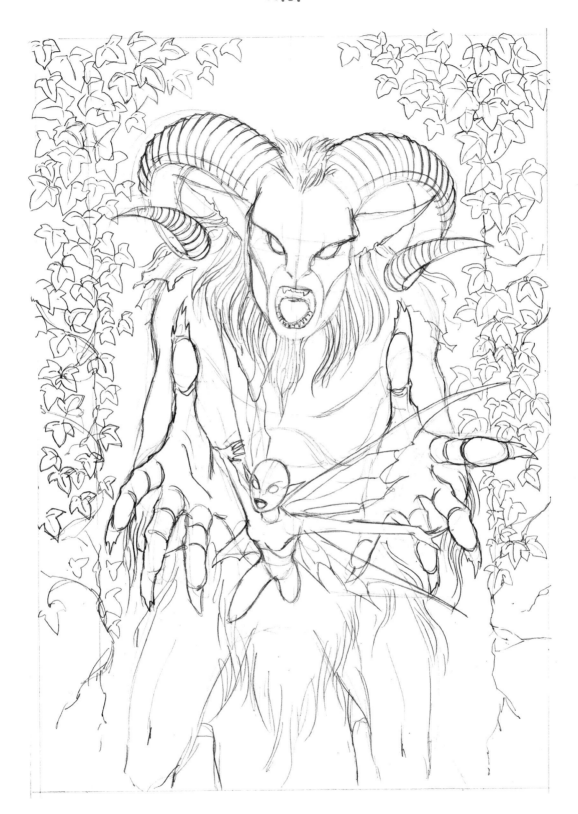

STEP 4

Keep the leaf shapes simple and gradually cover the stone pillars, trying to make the foliage appear to grow naturally upwards.

STEP 5

You can now consider the characters' costumes. Rather than leaving the fairy naked, I thought it might be nice to continue the ivy theme and create a kind of short ivy dress. The leaves here are a lot smaller than those climbing the stone archway.

STEP 6

Once all the line work has been established, add shading to the background with a B pencil. I used an HB towards the bottom of the page for a lighter tone as I knew I would be erasing some of it to form highlights, and it is easier to erase HB lead.

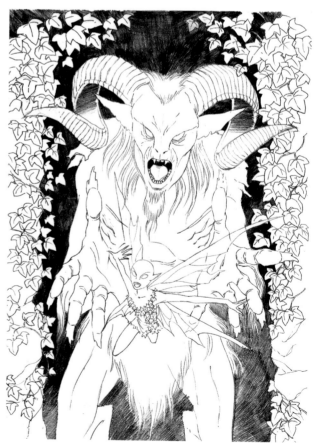

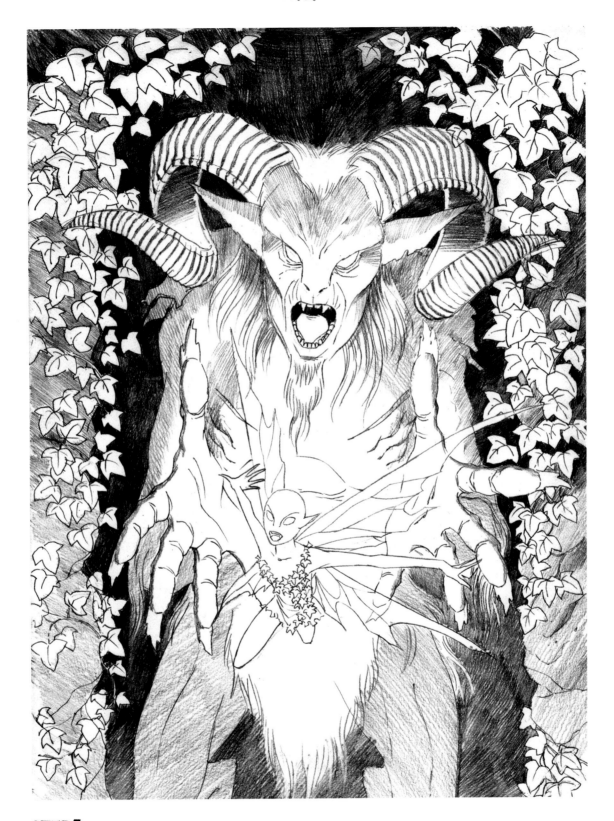

STEP 7

You can now apply mid-range tones to the stone wall,
the faun's legs and the outer edges of the arms.

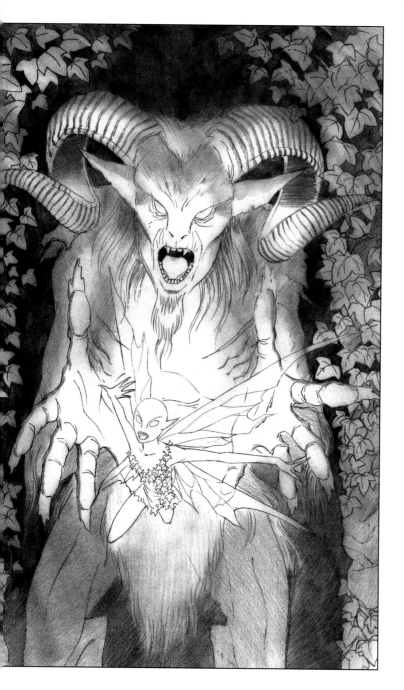

STEP 9

You can now carefully blend the shaded areas of the faun. You may prefer to use a blending stump for the smaller areas.

STEP 8

Using a blending stump or tissue paper, blend the mid-range pencil work. I purposely went over the ivy while blending to give the leaves some tone. I find this is achieved more successfully using tissue paper rather than a blending stump, though you may prefer the effect provided by the stump. Leave plenty of light around the central area where the fairy is positioned, as this will be the main light source.

STEP 10

Apply a dark shadow to the ivy. The shadow would be cast by the central light source, so the direction of the shadow will change depending on where the ivy is in relation to the light. The ivy leaves at the top left of the page will cast a shadow to the far top left, whereas those at the bottom left will cast a shadow to the far bottom left.

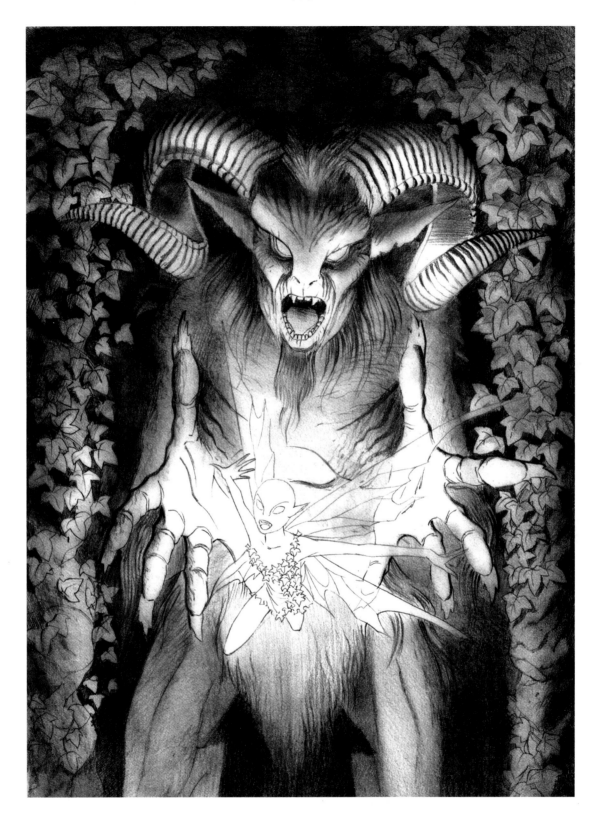

STEP 11

Here you can see that the shadow lifts the ivy away from the stone.
You should check the shading at this stage, before adding highlights.

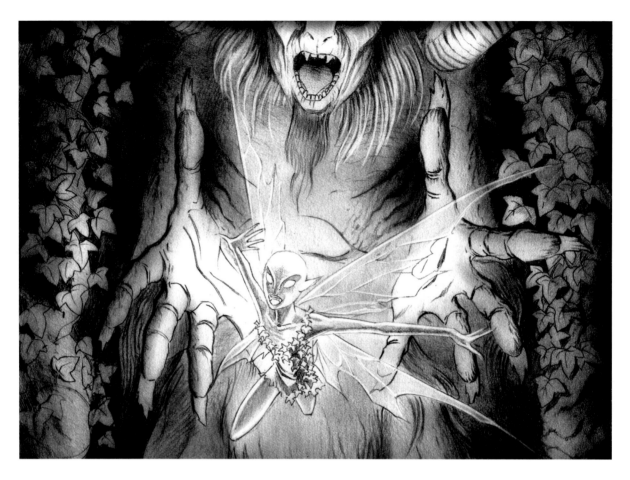

STEP 12

It is now time to apply highlights to the areas that are nearest the light source, including the faun's face, hair (Figure 11) and hands; the ivy nearest the light source (Figure 12); and the veins in the fairy's wings. This not only brightens up the drawing but also creates a sense of depth.

Figure 11

Figure 12

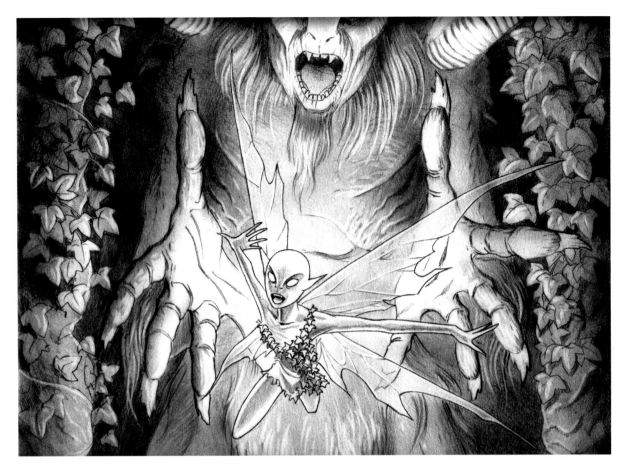

STEP 13

After applying the highlights, the drawing needs to be tidied up. Draw a thin, crisp line around the body of the faun and the fairy (Figure 13), paying particular attention to the wings (Figure 14). Notice how the thin line work adds strength and clarity to the drawing.

Figure 13

Figure 14

STEP 14

The final step is to add rays of light shooting from between the hands of the faun, creating a fantastical light source for the image. This was achieved using the round-edged stump of a plastic eraser. A putty rubber can also be used.

The final drawing can be seen on the opposite page.

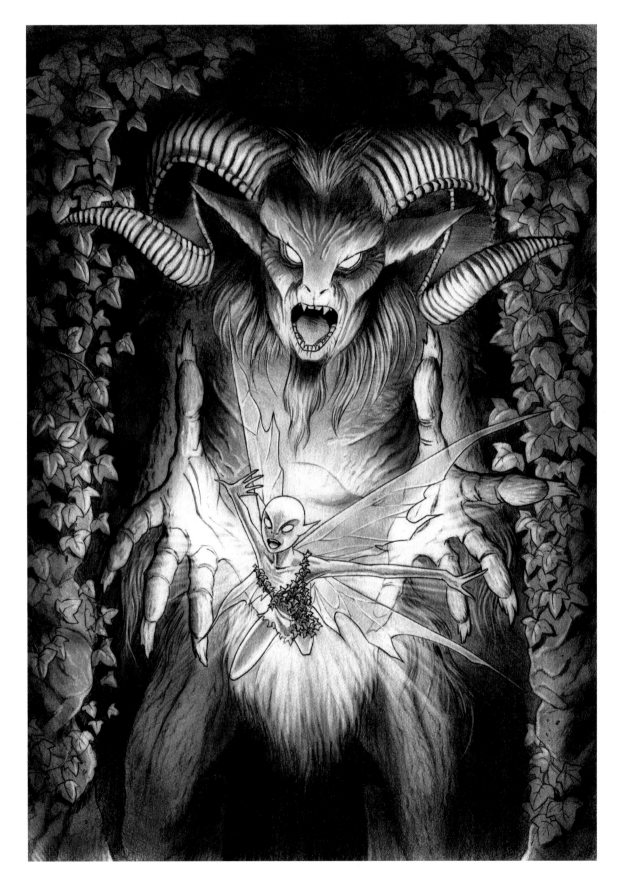

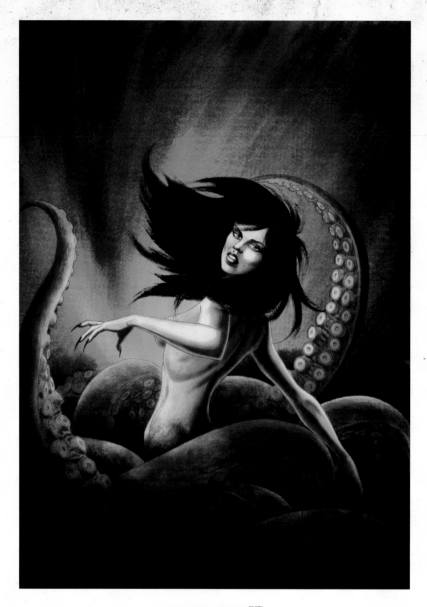

PROJECT 15

— ◦ ❦ ◦ —

SEA CREATURE

I have always been fascinated by the female villains in classic Walt Disney animated feature films. In my opinion, they steal the show. *Snow White and the Seven Dwarfs* has the fantastically cruel Queen, *Sleeping Beauty* has the magnificent Maleficent, *101 Dalmations* has Cruella de Ville and *The Little Mermaid* has Ursula. I think Ursula is a great character and she is the inspiration for this exercise. I produced the pencil drawing with a Staedtler HB pencil on Winsor & Newton hot-press 300gsm watercolour paper, with a Lamp Black gouache wash for the background.

This strong, eye-catching character was created as a book cover as well as for this exercise. The rough thumbnails (Figures 1–3) on this page give you an idea of the creative process. Figure 1 was one of the first thumbnail sketches I produced, but I was not happy with it so I drew Figure 2, scanned it and imported it into Photoshop and produced some quick colour schemes. Eventually I arrived at the approved image, Figure 3. When drawing for a client, it is very important to go through these planning stages and to produce colour roughs as well as pencil sketches, but this is not usually necessary if the artwork is just for yourself.

Figure 1

Figure 2

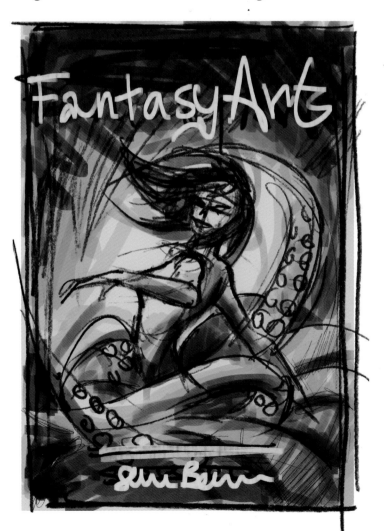

Figure 3

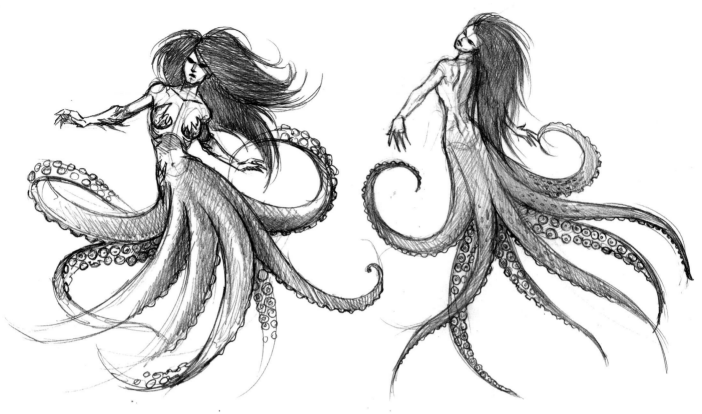

Figure 4

Figure 5

Sometimes, before getting to work on the final drawing, I will spend some time sketching figures and designs to see if the process leads to any new ideas. In the past, I have often produced a drawing and then, after its completion, had some ideas that would have improved it.

I am always learning from studying work by other artists whom I admire. One artist in particular, Claire Wendling, has produced incredible fantasy creations that merge humans and animals which I find greatly inspiring. What makes even her loose sketches so believable is that she watches and studies her subject matter until she knows it so well that drawing it becomes (or so it appears) an effortless task.

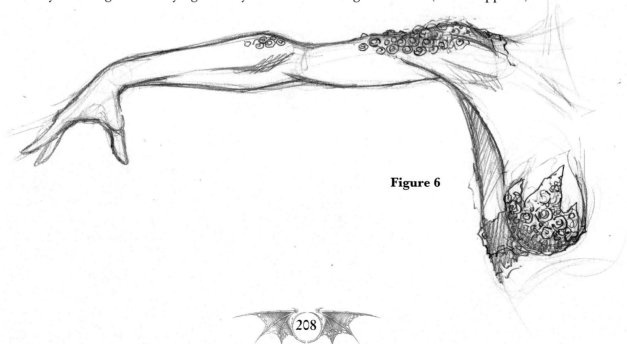

Figure 6

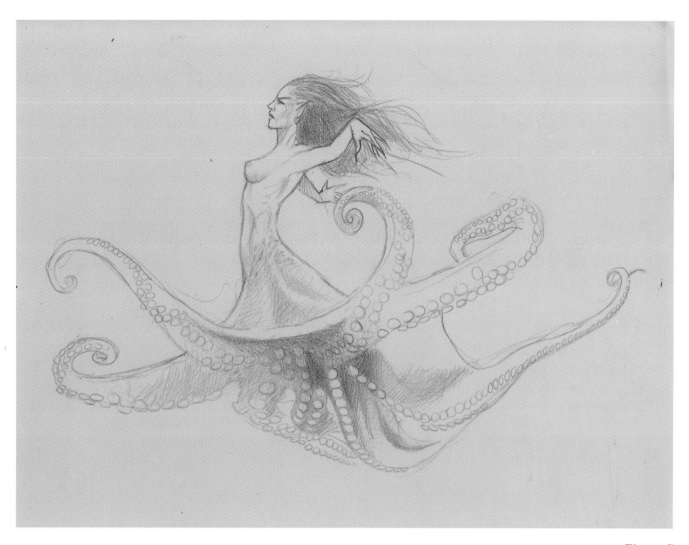

Figure 7

So, following Wendling's example, in order to gain a greater insight into the subject of this piece, I took a trip to an aquarium and watched and sketched an octopus swimming. Upon returning to my studio I then adapted the sketches into some rough concept work (Figures 4–7).

Pictures from the internet and television documentaries (Figure 8) are also good references when studying wildlife, especially if you do not live near a place where you can study your subject matter at first hand. If you have pets – whether it be a cat, dog, reptile or fish – spend some time drawing them. It is fun to do and will develop your observational skills as well as improving your drawing abilities.

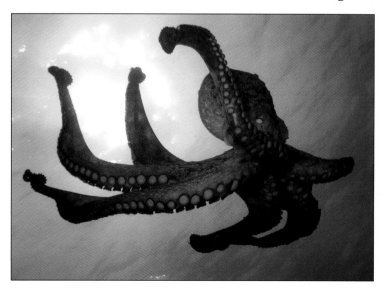

Figure 8

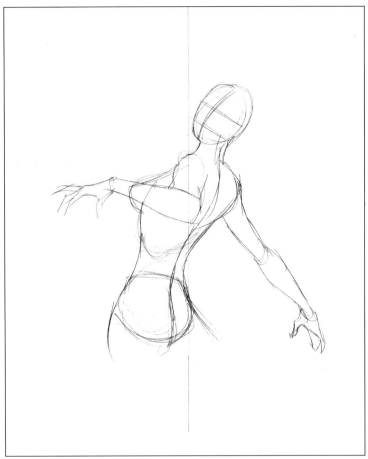

STEP 1

Since the figure is situated in the middle of the composition, draw a faint centre line as a guide. Draw in some construction shapes to help proportion the figure correctly. If you are less confident, take the time to break down the figure completely and draw all the construction shapes, as shown in Figure 9. As you become more confident you will find that you may be able to produce the drawing from a looser, sketchier outline, as shown in Figure 10.

Once you are happy with the outline, lightly sketch out the figure, using curves and shapes that capture a swaying, flowing motion.

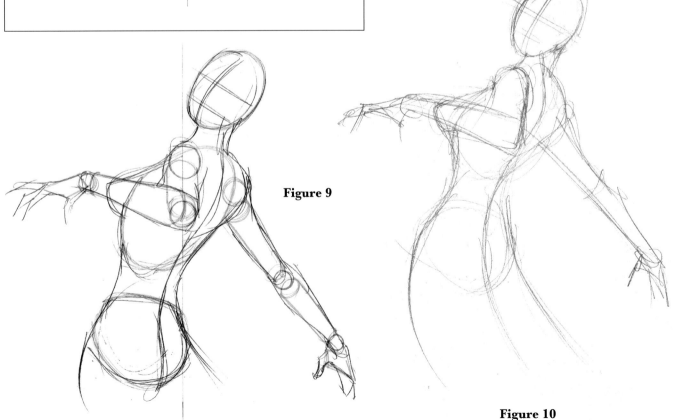

Figure 9

Figure 10

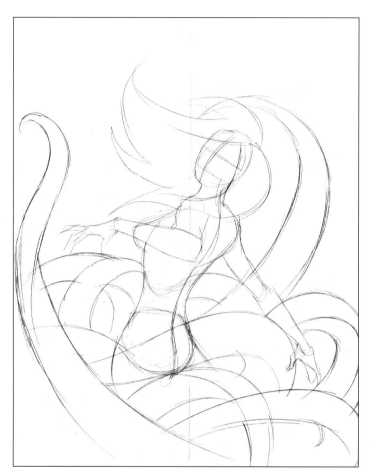

STEP 2

I wanted to create a menacing, writhing mass of tentacles. To do this I stopped trying to accurately depict how real-life tentacles would flow and instead used some artistic licence, positioning them so that they looked right for this piece and created the desired impact.

The arrangement of tentacles may look a bit complex at first glance, so in Figure 11 I have added some colour to identify the shapes more clearly.

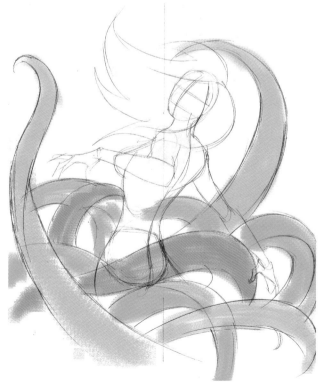

Figure 11

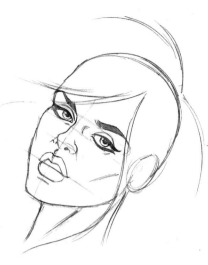

STEP 3

One of the best ways to draw an attractive, young-looking female face is to keep the line work soft, and by that I mean use curves instead of hard edges. Keep the cheekbones rounded and soft. Do the same with the eyes and lips. Avoid drawing too many lines around the eyes as this can make the face look old.

I tend to stylize the eyebrows and eyelashes into solid shapes (Figure 12). This keeps things simple and saves time, since not every single hair needs to be drawn. If you look at someone's face from a distance, you do not really see every hair anyway – just a collective shape.

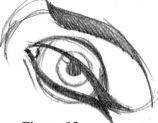

Figure 12

STEP 4

When it comes to drawing hair, keep things simple at first. I based the shape of the hair here on the style used by Disney artists. If you want to add some detail, remember that hair strands all flow from the scalp, so group the line work accordingly (Figure 13).

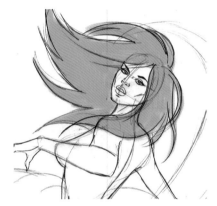

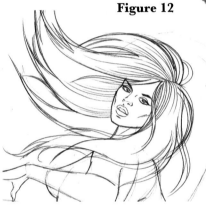

Figure 13

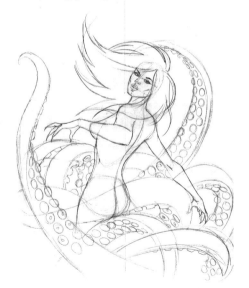

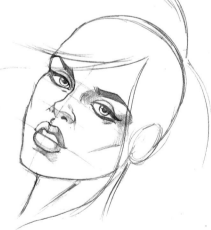

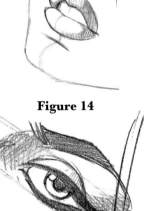

Figure 14

Figure 15

STEP 5

Having established the hair and face, add the details to the tentacles, returning to pictures of octopuses and other references, if required.

STEP 6

Once you are happy with the outline of the figure, add the shading. Notice the simple shape of the lips and nose (Figure 14) and the light, uncomplicated shading around these areas and around the eyes (Figure 15).

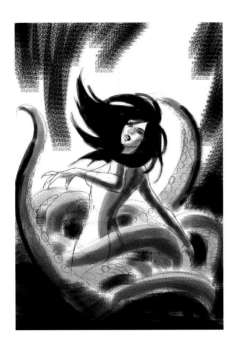

STEP 7

Before you begin adding the final solids and shading, scan the working drawing and import it into Photoshop. You could also take a photocopy of your drawing and work on the copy, or trace your working drawing on to a clean sheet of paper. In this instance, I used Photoshop. I chose to use three layers of tone and spent some time working out the strengths of each and where they would be placed. I decided in the end to position the main light source in the background in order to isolate the main figure. This means that all the heavy shadows will be at the back of the figure, as shown.

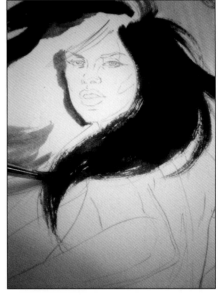

STEP 8

Once you have established the placement of the solids and tones on the computer image, return to the pencil drawing and add the final pencil work. I began by applying solid black gouache to the hair. If you are drawing on cartridge paper and not planning to use paint or ink, use a soft lead pencil for the hair and make it as dense as possible. If you are using watercolour paper then it is a good idea to stretch it and tape it down with masking tape before applying paint (see page 102), or you could risk warping the paper.

If you study someone with long dark hair swimming underwater, you will notice that the hair becomes one dark flowing mass. Unlike lighter or blonde hair, it is difficult to see individual strands of dark hair. Try to re-create this in the drawing.

STEP 9

Build up the skin tones on the body by applying softer, lighter shades at first, then add darker, heavier pencil work over the top.

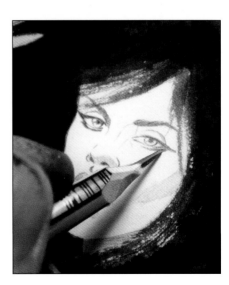

STEP 10

Check the shading on the face and strengthen the eyes and mouth with heavier pencil work, taking care not to press too hard.

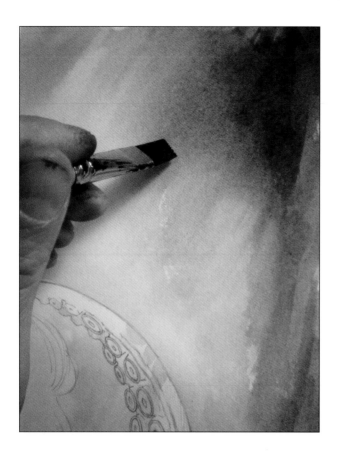

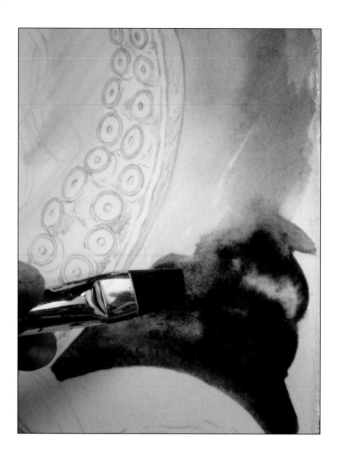

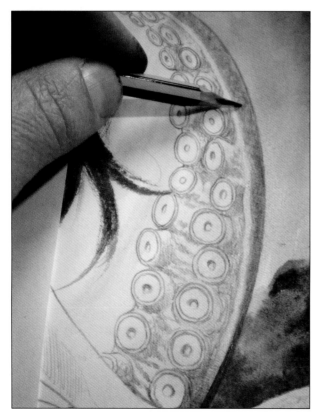

STEP 11

Apply a wash of Lamp Black gouache to create the background effect. As with any watercolour, gouache or ink wash, the result can be random and a little unpredictable. How the wash dries will vary each time and will create different patterns, so don't try to create an identical background to mine – see what develops with your own wash.

STEP 12

Add texture to the tentacles by using the flat edge of the pencil and light pressure to create a random swirling pattern. Blend the texture. I used some tissue paper rather than a blending stump, as I wanted just a subtle blend. Repeat the process, adding texture over the top of the blended work to create a denser finish.

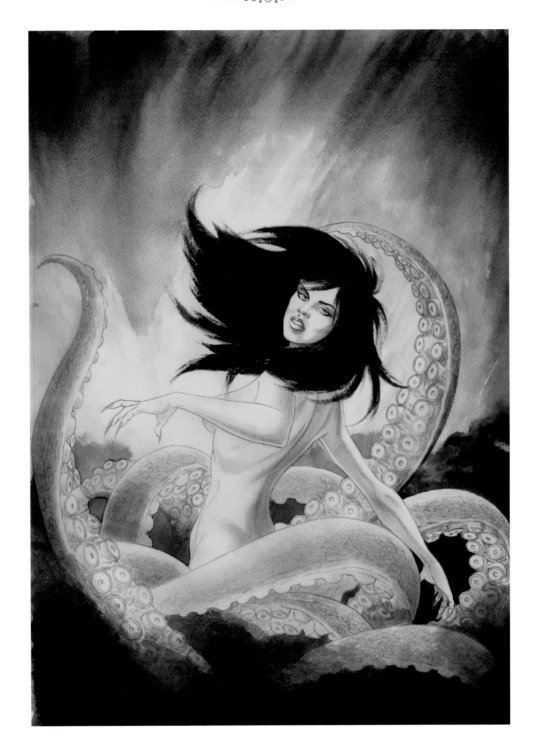

STEP 13

Once the pencil-and-wash drawing is complete and dry, scan the artwork and import it into Photoshop. If you do not have Photoshop or any kind of graphics package, but want to colour your drawing, you should be able to follow a similar procedure using watercolours: start with light, pale colours first and gradually build up darker tones by applying multiple layers of colour.

 I applied a base layer of cold, pale green, set on Multiply. Regard the colours shown here merely as a guide and choose your own colour palette. You may find shades and combinations that are more pleasing to your eye.

STEP 14

Usually I colour the backgrounds first, but in this case I began with the figure in the foreground. You can work the other way round if you prefer. Start to build up the skin tones using darker greens by selecting a textured brush. The one I used for the skin here is a scan of pencil marks I created by rubbing a pencil across a piece of paper placed over a rough surface (Figure 16).
I initially focused on building up the darker areas along the figure's back and arms and on other features in shadow, furthest from the light, then I created a new layer and used a lighter green for the rest of the skin tone, set to Multiply.

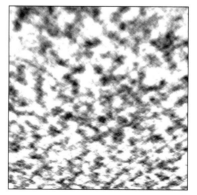

Figure 16

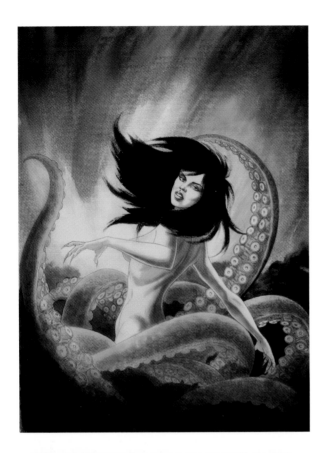

STEP 15

Introduce transparent shades of pale blue over the green to create subtle blends of colour tone. These are simply rough, broad strokes initially, but they will appear less coarse when more layers are applied over the top. All layers should be set to Multiply.

STEP 16

Apply darker tones of green and warm greys. Here you can see the greys around the eyes, the underside of the nose and on the lips.

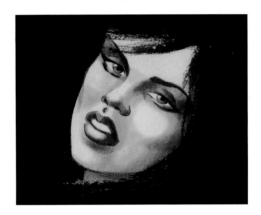

STEP 17

Add darker, denser tones of blue round the outer edges of the image, as these will draw your eye to the lighter centre, where the character appears. Apply the same blue tones to the tentacles, on another layer, on Multiply, with the opacity set at 50%.

STEP 18

Add a scaly texture to the lower part of the body using tones of grey and blue. I used a brush I had created by scanning some paper on which a marker had been randomly blotched (Figure 17).

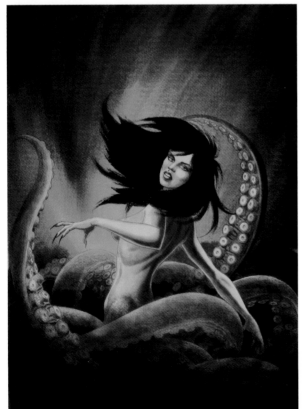

Figure 17

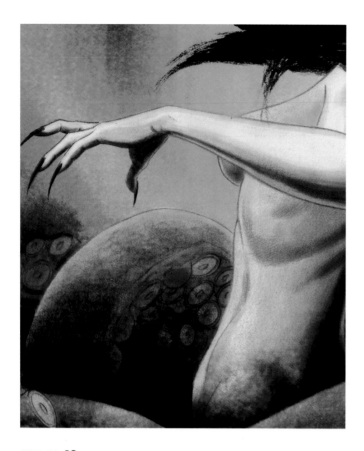

Figure 18

STEP 19

Add tones of yellow to the background to further separate the figure in the foreground from the background. Apply highlights of yellow, set to Normal rather than Multiply, to the figure and the tentacles (Figure 18).

I used the brush I had employed for the scales, but set to a wider diameter, to create a murky, cloudy effect that suggests a disturbance of the sea floor (Figure 19). I started with a low opacity setting and a mid-strength grey and built up the effect by increasing the opacity.

Figure 19

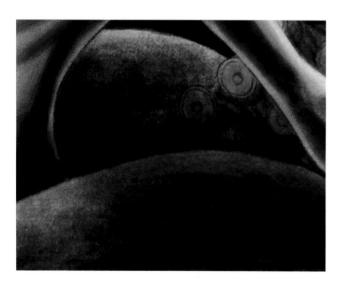

STEP 20

Finally, add some darker reflected shadows to the rear tentacles using blue-grey tones. I used a brush pattern I created by dabbing ink on to paper with a coarse sponge (Figure 20).

Figure 20

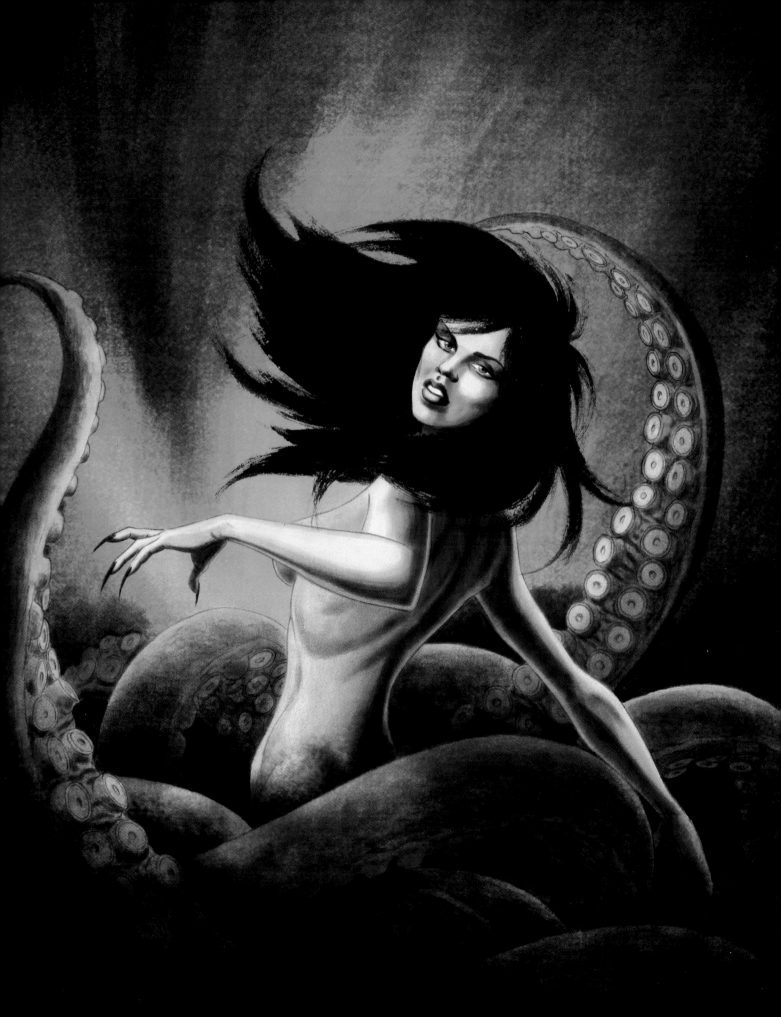

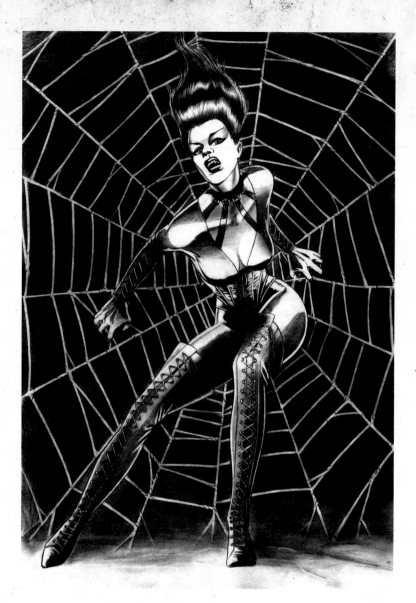

PROJECT 16

◦•◦ ⟡⟡ ◦•◦

BLACK WIDOW

◦•◦ ⟡⟡ ◦•◦

This drawing was inspired by James Whale's 1935 horror movie *Bride of Frankenstein*, and 1950s sci-fi movies and glamour pin-ups. Just as with Exercises 2 and 4, the objective is to turn what would normally be considered a repulsive creature into something strangely attractive.

 The female black widow spider is the most poisonous spider in North America and is recognizable by the hourglass shape underneath the abdomen. The body is shiny and black. In this drawing the corset represents the hourglass shape, the PVC clothing mimics the shiny coating of the spider and the fangs make the character appear predatory.

As usual, I produced a set of rough thumbnail sketches to arrive at the desired composition (Figure 1).

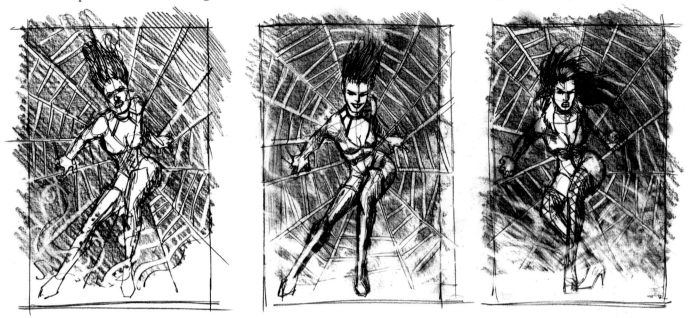

Figure 1

STEP 1

Lightly sketch the figure, paying attention to the balance of the pose. Most of her bodyweight is on her left leg (her right as we are looking at her) and the right leg is positioned to balance her. Notice the position of her upper body and how it is situated above the legs.

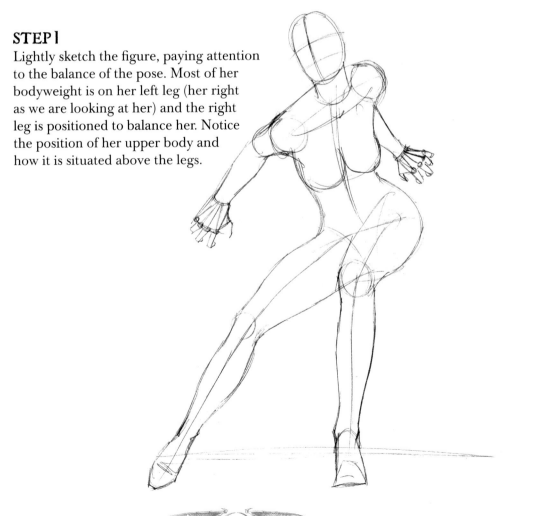

STEP 2

Roughly sketch in the web strands. Notice how the strands stem from the centre of the picture, behind the figure. This will act as a visual aid and will draw attention to the character, while the outline of the web forms a circle that frames the whole picture. You can also now draw the face and hair. Here, the head is tilted back slightly but her eyes are looking directly at you. The hairstyle is a reference to Elsa Lanchester as the *Bride of Frankenstein*.

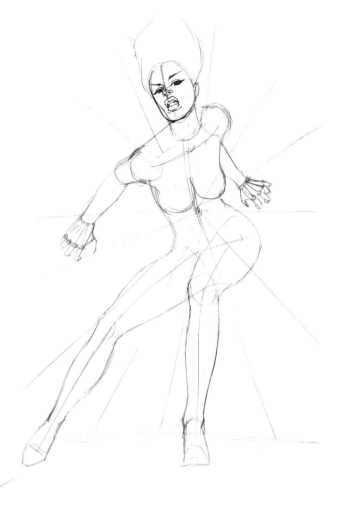

STEP 3

The clothing can now be sketched out. The style of clothing I chose is gothic dominatrix. Reference for this type of clothing can be found in gothic clothing catalogues, which are available online, as well as on the high street. Movies such as Len Wiseman's vampire trilogy *Underworld* are another good point of reference.

STEP 4

Next come the finer details of the clothing. The intricacy of the lacing of the boots and corset are intended to continue the web theme. The straps attached to the dog collar/choker also stem outwards like the webbing.

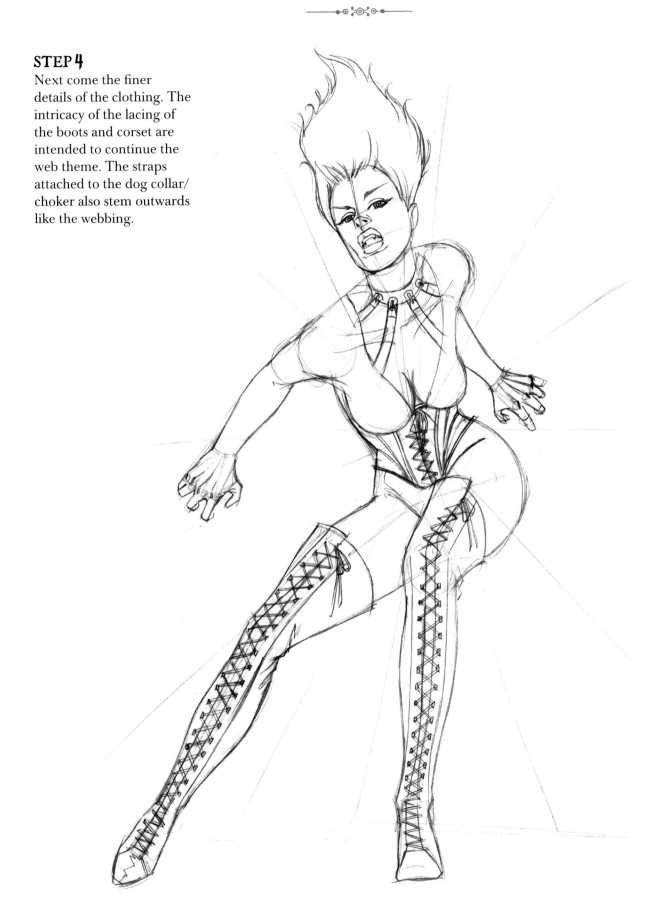

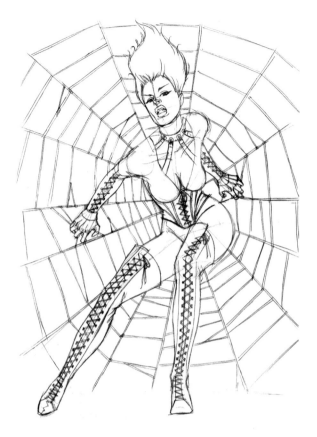

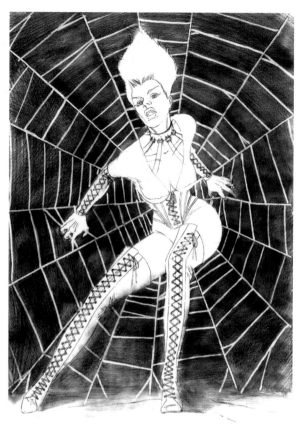

STEP 5

Add more detail to define the webbing. Keep the strands fine; the web should look delicate yet strong.

STEP 6

I decided on a simple, dark background tone to help isolate and strengthen the delicate strands of the web. I used an HB pencil and gently blended it with tissue paper, going over parts of the web to give the strands a very light tone. I carefully applied a further darker tone to the background, between the strands of the web, and this time blended with a blending stump so I could be more precise.

STEP 7

Shade the PVC clothing with a dark tone using an HB pencil, leaving white highlighted areas, then blend the shaded areas with a blending stump. Study the photo reference (Figure 2) for guidance. You can accentuate the web by going over the strands of the webbing with a Derwent battery-operated eraser, which gives a good, clean line.

Figure 2

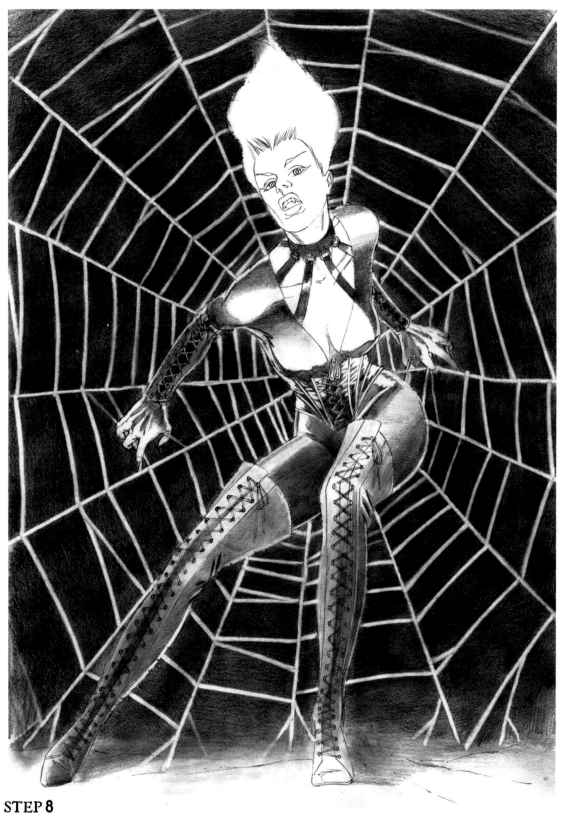

STEP **8**

Sit back and observe the overall effect.
Add any extra shading or highlights as required.

STEP 9

You can now add details and shading to the face and the hair. I decided to match the sheen of her lips and hair with the sheen of her clothing, emulating the overall glossiness of the black widow spider. The face has been created using hard contrasts. There are hardly any subtle tones present, apart from around the eyes and on the left-hand side of her face (as we are looking at her), which is in shadow.

The hair was created using an HB pencil, applying varying pressures to create light and dark tones.

STEP 10

Use a blending stump to blend the highlights, then follow with a few more defining strokes with an HB pencil to create hair strand detail. You can see the completed head on the opposite page: notice how the inside of the mouth is completely black, to highlight the white fangs (canines).

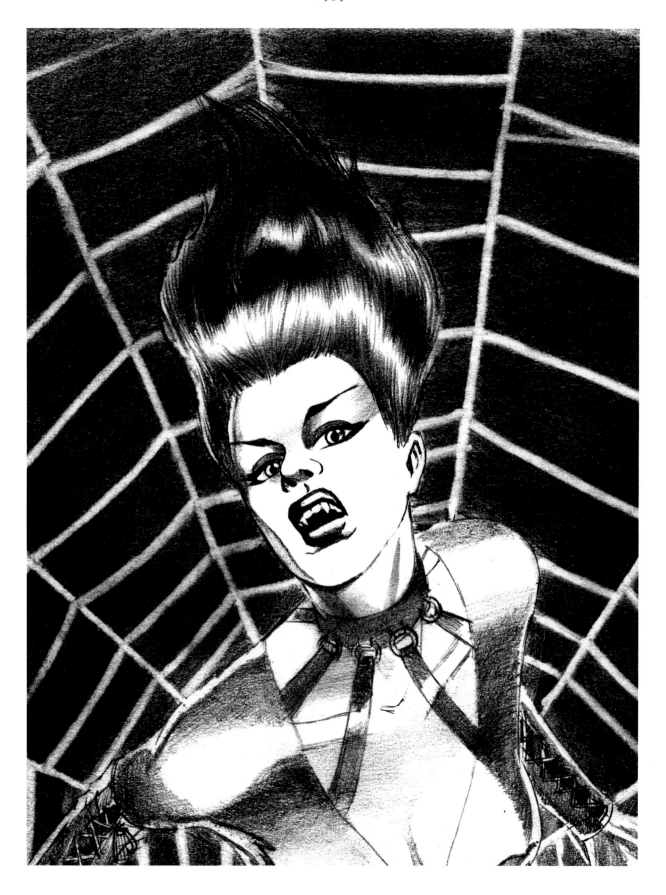

STEP 11

When all the shading and tone work is finished, you can add hard, fine highlights to the outer areas of the figure to lift her away from the dark background. The best way to do this is to use a finely chiselled eraser and the finely moulded point of a putty rubber or, as shown in the photograph, the edge of a battery-operated eraser where the eraser has been cut to form a sharp edge.

STEP 12

Once the highlights have been applied, go over the drawing with an HB pencil, drawing a fine, crisp line around the entire figure. This helps to accentuate the highlights and also lifts the figure away from the background.

STEP 13

You may want to pick out the detail of the lacing on the boots and corset. An eraser will not be suitable for highlighting this level of fine detail, but you can paint in the highlights with Permanent White gouache using a No. 0 brush. On the opposite page you can see the final image, which I converted to a sepia tone using Photoshop.

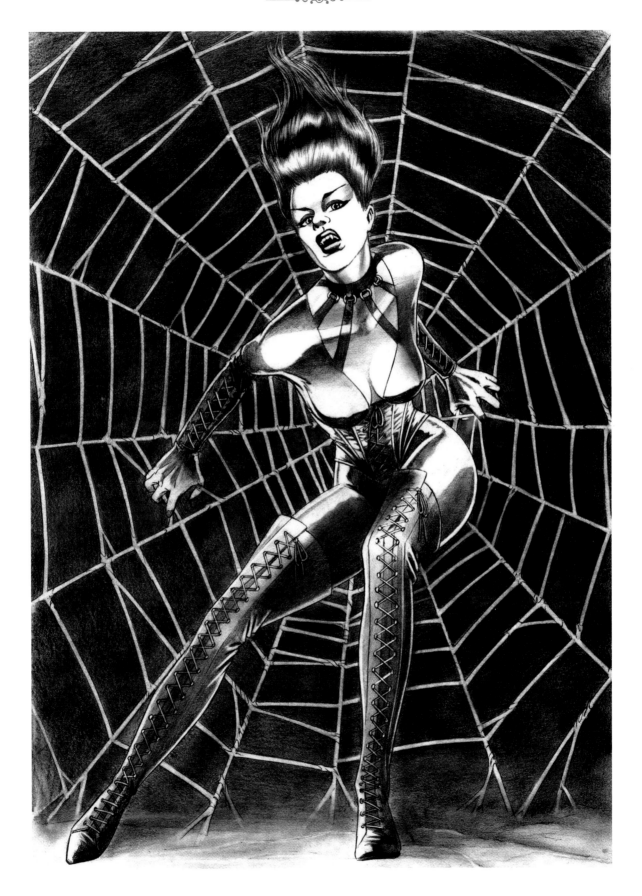

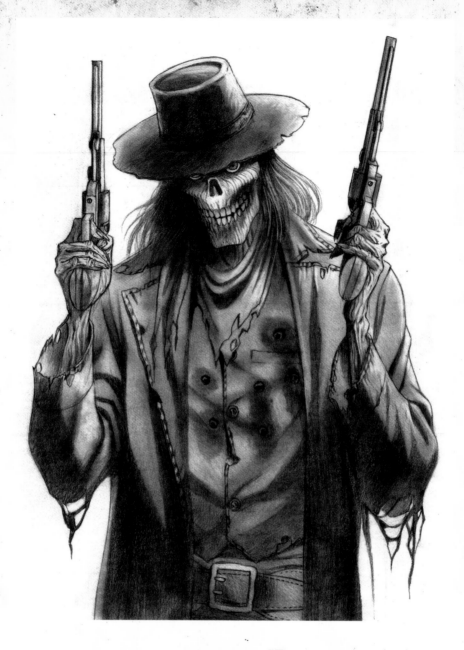

PROJECT 17

GUNSLINGER

I'm a big fan of both westerns and Sam Raimi's movies. Sam Raimi has made movies about the undead (*The Evil Dead* trilogy) and about gunslingers (*The Quick and the Dead*) but, to my knowledge, he has never mixed the two genres. I thought it would be interesting to combine the undead and gunslinger themes and create an *Evil Dead*-style cowboy, back from the grave to seek vengeance.

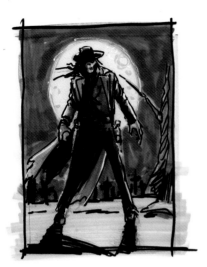

Figure 1

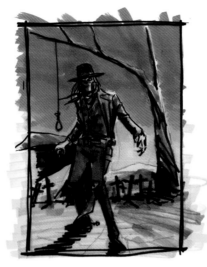

Figure 2

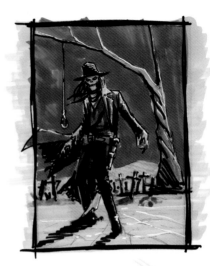

Figure 3

While producing the thumbnails for this picture, I considered a few wide shots showing a full pose (Figure 1, Figure 2 and Figure 3), and I thought about whether to colour it or not. In the end I decided to go for a close-up black and white image (Figure 4) as I thought it would be more fun developing the face than drawing a distant, less detailed view.

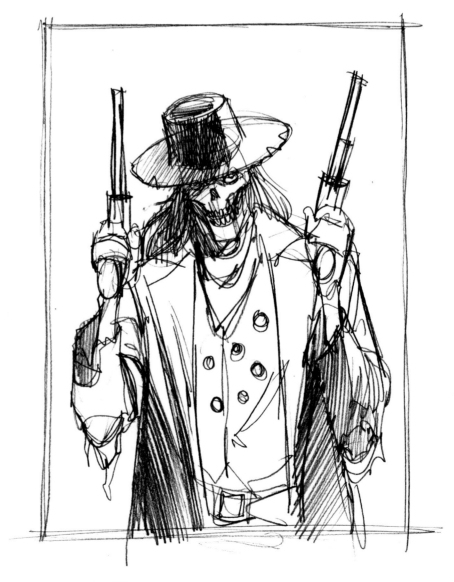

Figure 4

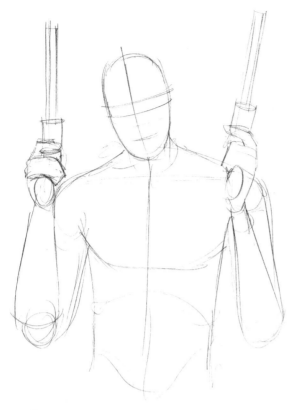

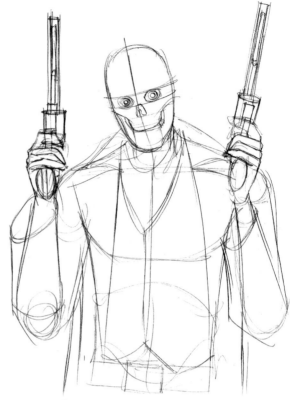

STEP 1

Map out the figure in rough. You may not need to start with a skeletal figure for this exercise – just gauge the proportions of the arms in relation to the torso. Mark out the dividing lines for the face, which will help you place the eyes, nose and mouth correctly.

STEP 2

Map out the clothing and the skull. When drawing the skull, refer back to page 182 or use the photo reference below (Figure 5), although in the drawing the skull will have withered skin stretched over it. The clothing is based on the long coats worn in movies such as *Once Upon a Time in the West, The Good, The Bad, and The Ugly* and *Long Riders* (Figure 6).

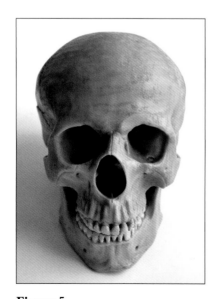

Figure 5

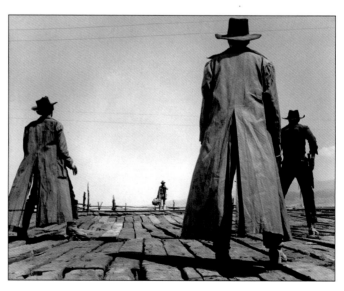

Figure 6

DRAWING THE GUN: PRACTICE

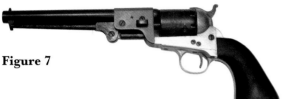

Figure 7

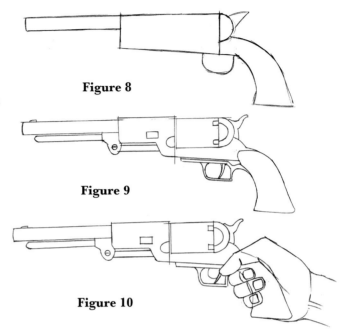

Figure 8

Figure 9

Figure 10

To draw guns successfully it is best to do some research first. Handguns come in all shapes and sizes, from revolvers to automatics, and each has its own characteristics. The gun in this drawing is a Colt Model 1848 Percussion Revolver (Figure 7). As with drawing anything for the first time, I recommend breaking the object down into manageable shapes. This helps you become familiar with the item, making it easier to draw it well.

First establish the basic shape (Figure 8), then add a little more detail to the gun (Figure 9).

Once you are happy with the gun, work out how the hand fits around the handle and trigger (Figure 10).

STEP 3

Once you are familiar with the shape of the gun, go through the stages again with the gun shown in the correct position for the final drawing. Start with the basic shape, then add the leading lever and cylinder pin. Draw in the shape of the hand as it holds the gun, then refine and develop it and add the nails.

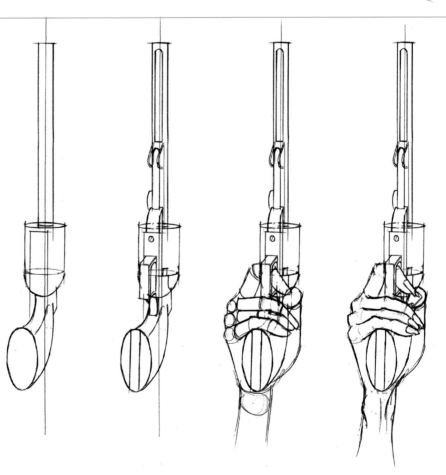

STEP 4

Sketch out the position of the hat, using reference material for a guide to its look (Figure 11), and work out how it sits on the head. Incorrect positioning can look awkward and lopsided, so it is good practice to draw the head and hat as transparent shapes, which can easily be deleted, to get the correct fit. The clothes can also now be developed further.

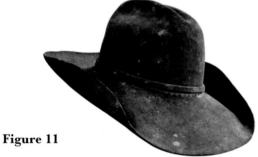

Figure 11

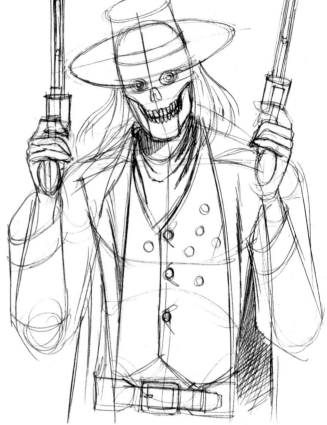

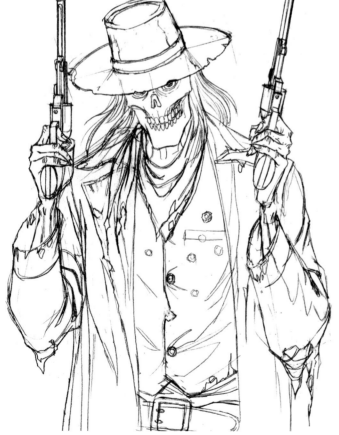

STEP 5

Remove any development sketch lines with an eraser. Do not worry about making the drawing too clean, as most of the line work will be covered by the shading. Define the features with clean line work, making sure all the details are present for the face, clothing and guns before you commence on the shading.

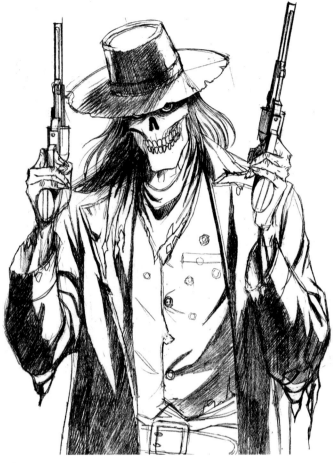

STEP 6

The first stage of shading is to identify the main solid areas of shadow created by the light source, which in this instance comes from an area to the figure's right as we are looking at him. Block these in using an HB pencil.

STEP 7

Add the mid-range tones with an HB pencil, then softly blend between the dark and mid-range tones with tissue paper (Figure 12). I also used a blending stump around the face. The bullet holes can be strengthened with darker shading.

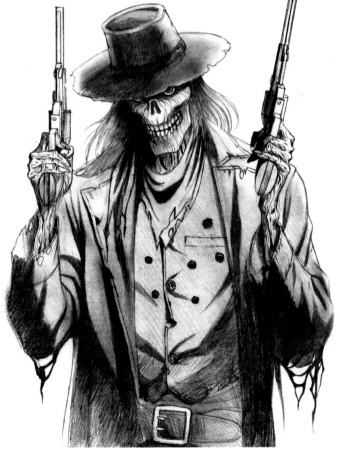

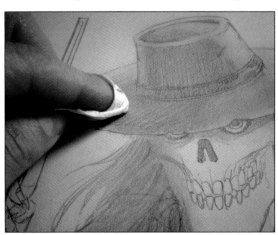

Figure 12

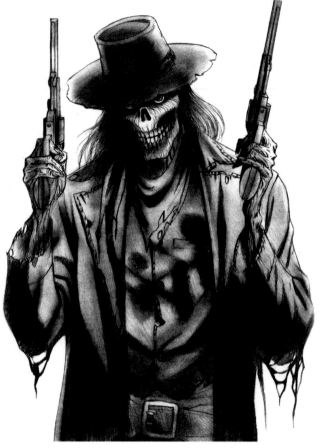

STEP 8

Bloodstains can be created around the bullet holes by adding a heavy tone with a B pencil, then blending with a blending stump.

STEP 9

The withered skin can now be applied to the skull. It needs to look dried, stretched and drained of all fluids. Wrinkles should be added using the fine point of an HB pencil, which can then be blended with a stump before a further layer of fine detail is applied over the top.

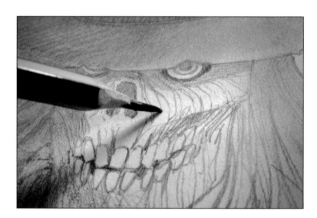

STEP 10

The same process is used for the hands and hair. Using an eraser, create highlights on the hair (below) face (Figure 13) and hand (Figure 14). Carefully apply a few sparing highlights to the rim of the hat, and to the left edges of the gun barrel, cylinder and trigger guard. Finally, apply a crisp, thin, hard line with a sharp HB pencil to add definition. The completed Gunslinger is on the opposite page.

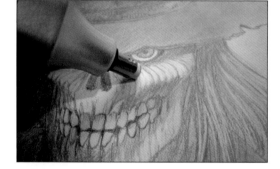

Figure 13

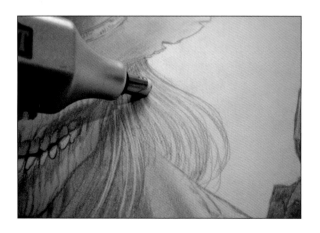

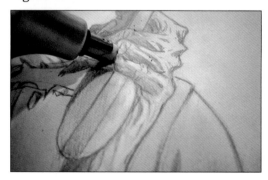

Figure 14

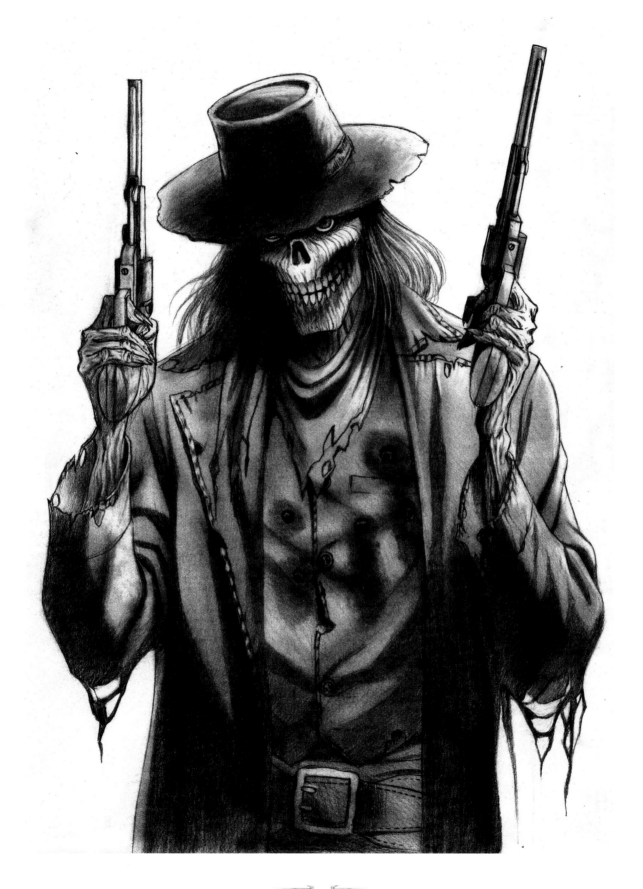

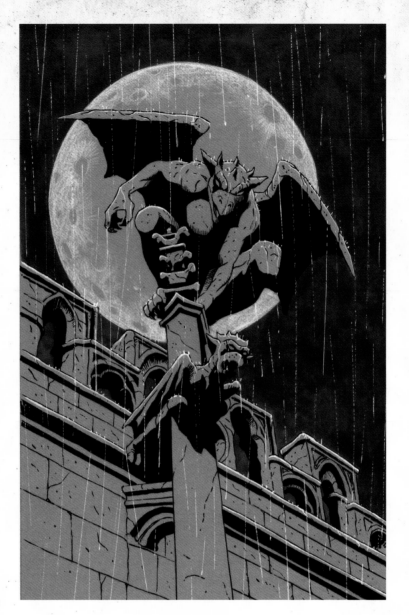

PROJECT 18

—◦❖◦—

GARGOYLE

—◦❖◦—

This last exercise is typical of a quick sketch session, during which I take a class through a sketch from beginning to end in one and a half hours. The purpose of the exercise is to show how easily and effectively a drawing can be achieved in a short space of time. Often these are produced on coloured paper and inked with a Faber-Castell Pitt Artist pen and a coloured marker that complements the choice of paper.

Figure 1

Figure 2

Figure 3

Figure 4

Figure 5

Figure 6

The materials you will need for this exercise are: grey or stone-coloured paper (Figure 1); Permanent White or Zinc White gouache (Figure 2); No. 0 or No. 2 watercolour brush (Figure 3) or a Pentel correction pen (Figure 4); Faber-Castell Pitt Artist pen (Figure 5); B26 Cobalt Blue or a B29 Ultramarine Copic marker (Figure 6).

To get a feel for the look of the gargoyle, source some photo reference, as shown in Figures 7 and 8. On my travels, I often take photographs of any architecture that I think is interesting or that will possibly come in useful for reference on a future project. For this drawing, I used photographs of St Martin's Church in York, one of northern England's most architecturally interesting cities (Figures 9 and 10).

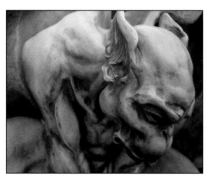

Figure 7

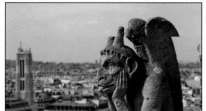

Figure 8

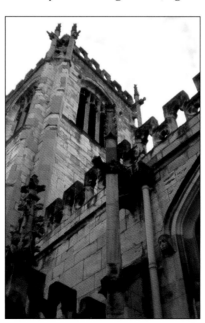

Figure 9

Figure 10

PERSPECTIVE

The main things to consider when working from a photograph are the angles and perspectives inherent in the shot. Some settings can provide striking backdrops for additional imagery that you may wish to superimpose. In this exercise, the Gothic building and upward-looking perspective lend themselves well to a winged figure, and a gargoyle seemed an apt subject.

In order to draw both the setting and the gargoyle correctly you will require some knowledge of perspective drawing, so the aim of this section is to outline the basic rules. Figure 11 shows a railway track disappearing into the distance. Notice how the rails get closer together the further away they are from the foreground. The point at which they meet is called a point of perspective or a vanishing point. The horizontal line that crosses the point of perspective is called the horizon line. It is always at your eye level.

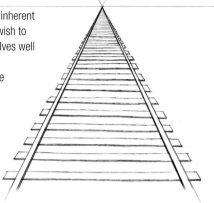

Figure 11

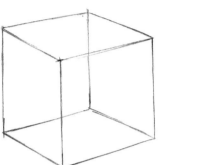

Figure 12

Figure 13

We shall use a basic cube (Figure 12) to show how the rules of perspective work. If we turn the cube so we are looking at it straight on (Figure 13) you will notice that the two sides on the top of the cube appear to draw closer together, or converge, towards the back. If these lines are extended, they will eventually meet (Figure 14). The point at which they meet determines the horizon line. This is called single or one-point perspective because the perspective lines meet at a single point.

When the cube is turned so that the corner point faces the front, we get two-point perspective below the horizon line (Figure 15). If the viewpoint changes, so does the horizon line (Figure 16).

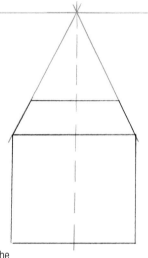

Figure 14

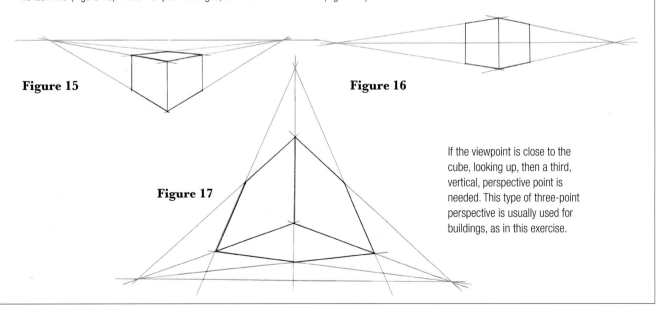

Figure 15

Figure 16

Figure 17

If the viewpoint is close to the cube, looking up, then a third, vertical, perspective point is needed. This type of three-point perspective is usually used for buildings, as in this exercise.

STEP 1

Start by plotting the layout. I have used white paper for this exercise to make the steps clearer, but you can draw directly on to coloured paper. The vanishing points for this drawing go right off the page, so roughly gauge the perspective or tape extra paper loosely to the main sheet and work out your vanishing points in full.

Draw a vanishing point above the figure and converge the lines that demarcate the outline of the figure at that point (A). You can then gauge the angle of the castellations on the top of the wall, drawing diagonal downward lines from left to right (B) towards an imagined vanishing point off the paper. To create a three-dimensional effect and give the castellations depth you need to add a further set of diagonal lines travelling in the opposite direction (C) towards another imagined vanishing point off the paper, creating three-point perspective. Figure 18 is a cleaned-up version so that you can see how the different components in the image work once they have been correctly positioned.

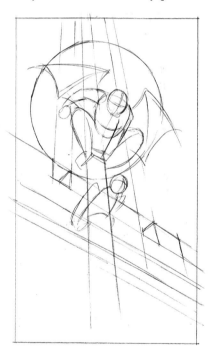

Figure 18

STEP 2

Once you have plotted the layout and are happy with the perspective, apply some detail to the architecture, defining the stonework and the gargoyle. Note the use of the full moon, which will create a framing device for the gargoyle.

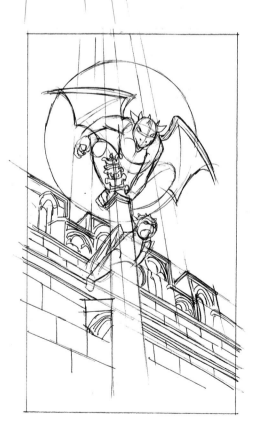

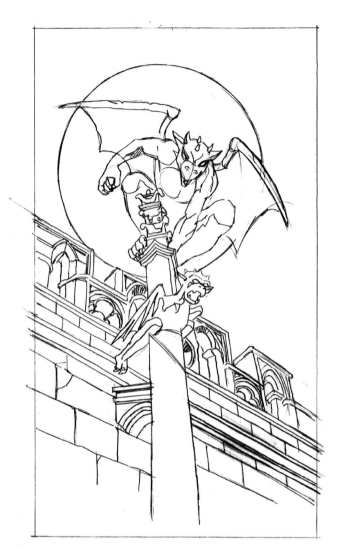

STEP 3
Develop the detail of the gargoyle's character, taking pointers from the photo references you have collated. The face here is almost like that of a small dragon.

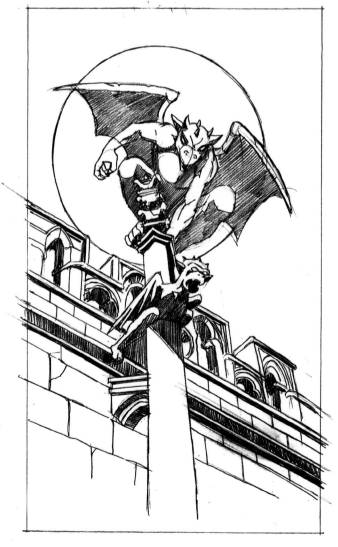

STEP 4
Shading can now be applied to the areas that will be mostly solid black. In reality, if a full moon this size were directly behind the gargoyle you would mostly see a silhouette, so to make the drawing more interesting I have used artistic licence and inserted some additional off-frame light sources.

STEP 5

Once all the pencil work is complete, apply the ink. I used a brush pen for this drawing as it enabled me to create some bold line work as well as to pick out delicate lines from the stonework details. First, I went over all the line work with ink, then I filled in the solid areas. I purposely created an uneven line with the pen to give the impression of old, worn and weathered stone (Figure 19). The brush pen is perfect for this kind of line work.

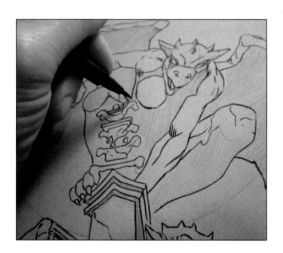

Figure 19

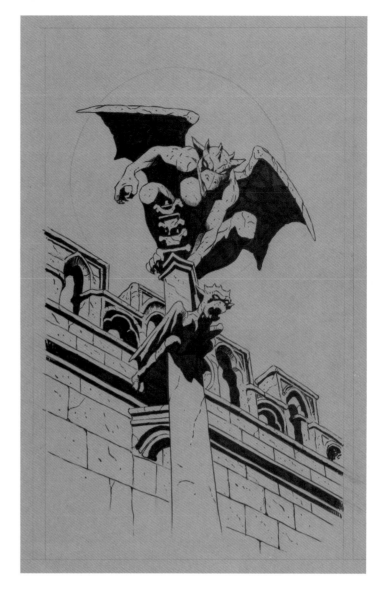

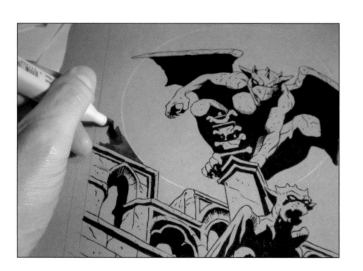

STEP 6

Once the inking is completed it is time to add colour. I used a B26 (Cobalt Blue) Copic marker for the sky. When attempting to colour a large area with a marker, always study the drawing first and decide the best position to begin from. Never start in the middle of an area or in a place that will lead you in two different directions. The important thing to remember is to keep the ink flowing until you have covered the required area. I started at the left-hand side of the drawing as it allowed me to put down a continuous flow of ink all the way round to the other side.

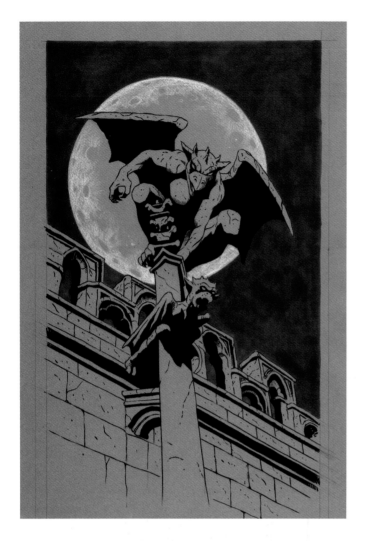

STEP 7

The gargoyle is looking a bit flat against the moon, so use a white pencil (I used a chinagraph pencil, Figure 20), chalk pastel or Permanent White gouache to add some detail to the moon. Use a photo (Figure 21) to help you re-create a realistic texture. This will give a sense of depth between the moon and the gargoyle.

Figure 20

Figure 21

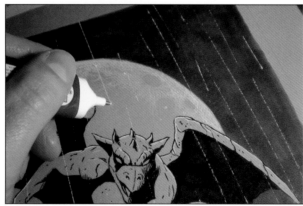

STEP 8

The moon in the background would cast light on the form of the gargoyle. To create these highlights, apply a thin line of gouache to the wings and outer areas of the creature using a No. 2 sable brush.

STEP 9

Finally, add the rain using a Pentel correction pen, which gives a solid white line with one stroke. Alternatively, try gouache and a brush, but I would advise you to practise this technique on some scrap paper before applying it to your final piece of artwork.

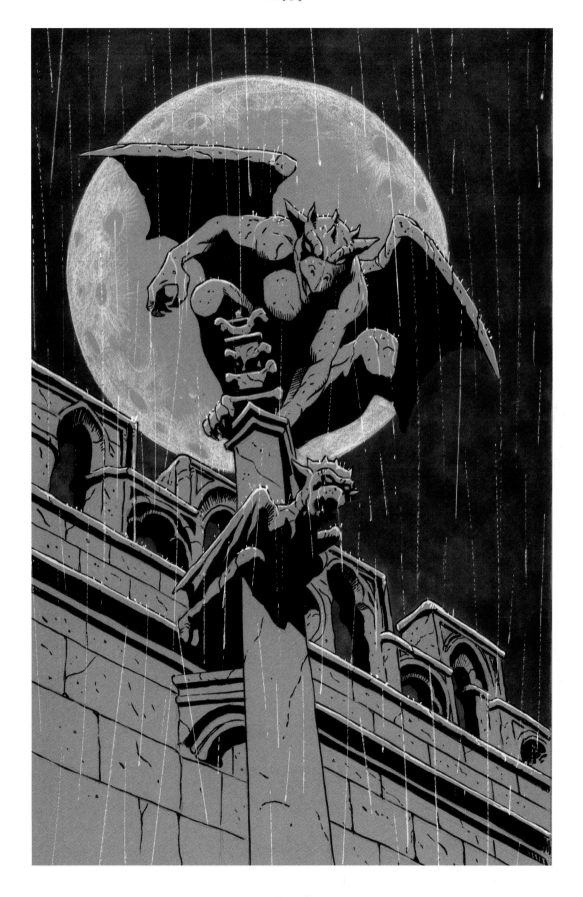

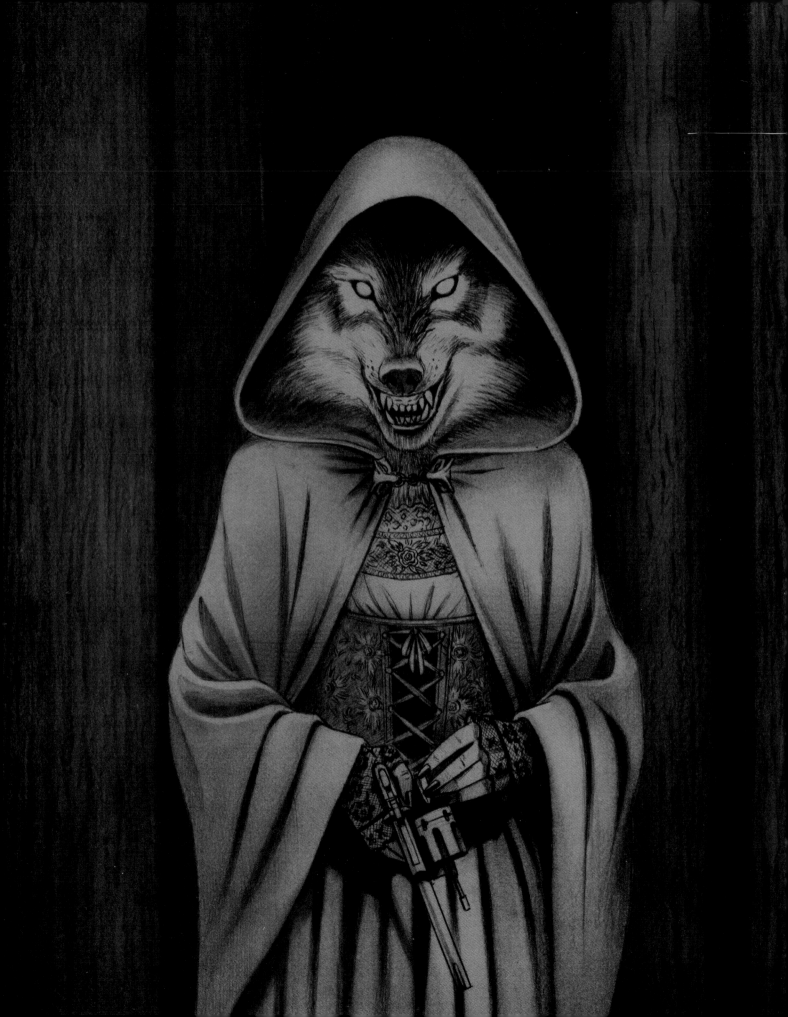

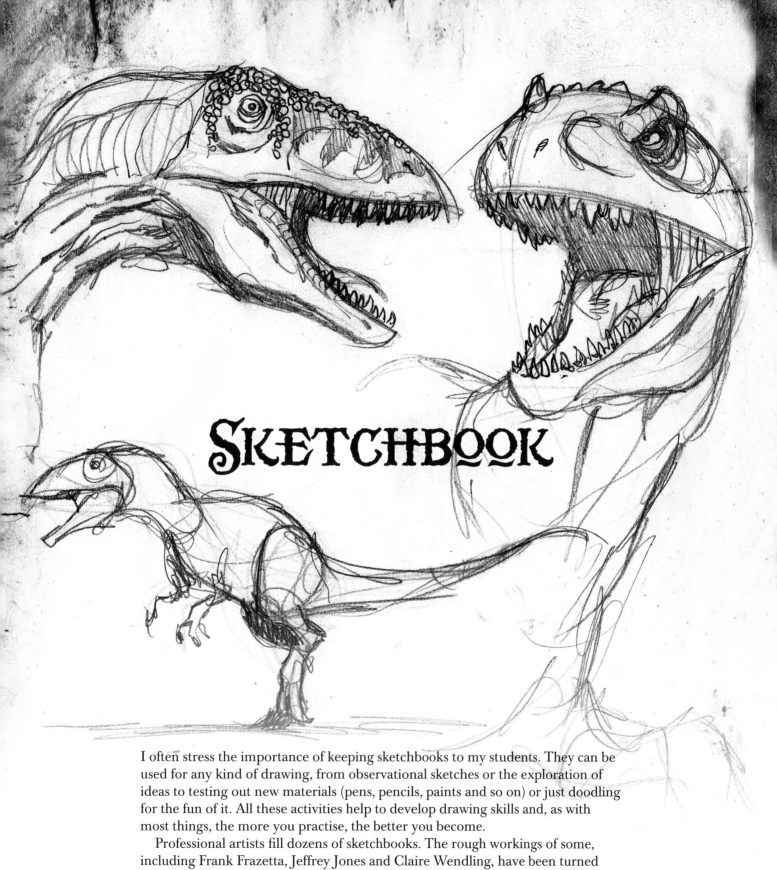

Sketchbook

I often stress the importance of keeping sketchbooks to my students. They can be used for any kind of drawing, from observational sketches or the exploration of ideas to testing out new materials (pens, pencils, paints and so on) or just doodling for the fun of it. All these activities help to develop drawing skills and, as with most things, the more you practise, the better you become.

Professional artists fill dozens of sketchbooks. The rough workings of some, including Frank Frazetta, Jeffrey Jones and Claire Wendling, have been turned into high-end art books that showcase their creative processes. The seeds of some of your best ideas may be doodled in a sketchbook. Ideas flow uninhibited when you are not feeling too precious about your drawing and you may often experience a breakthrough in this way.

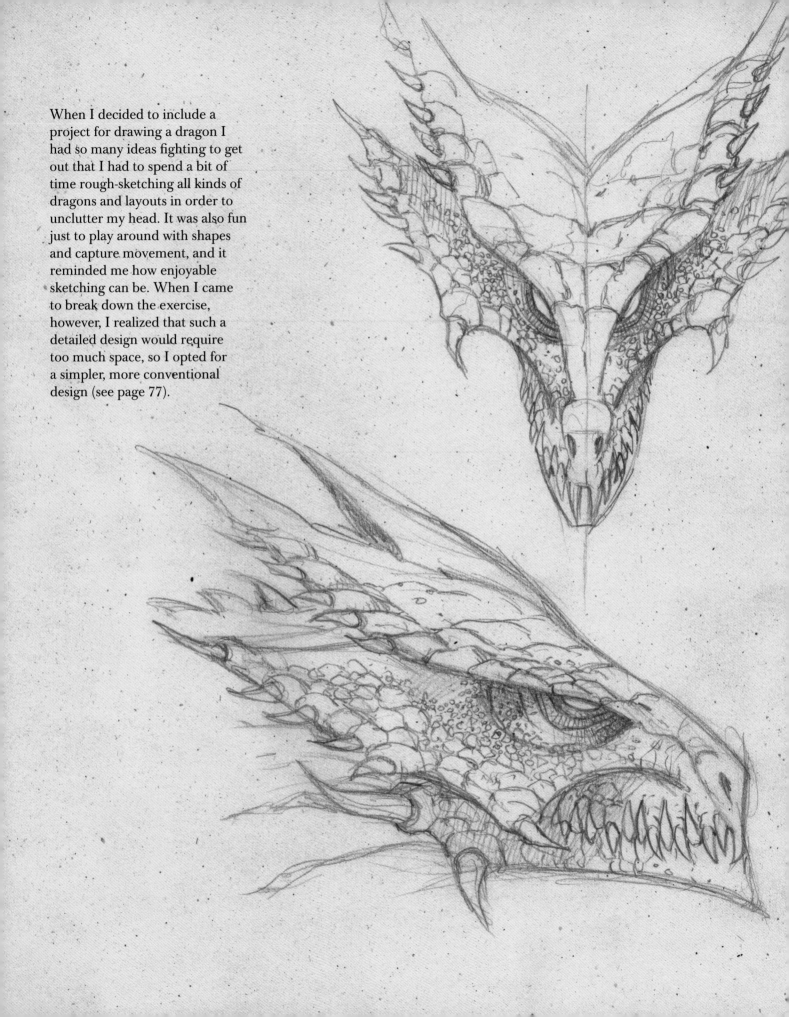

When I decided to include a
project for drawing a dragon I
had so many ideas fighting to get
out that I had to spend a bit of
time rough-sketching all kinds of
dragons and layouts in order to
unclutter my head. It was also fun
just to play around with shapes
and capture movement, and it
reminded me how enjoyable
sketching can be. When I came
to break down the exercise,
however, I realized that such a
detailed design would require
too much space, so I opted for
a simpler, more conventional
design (see page 77).

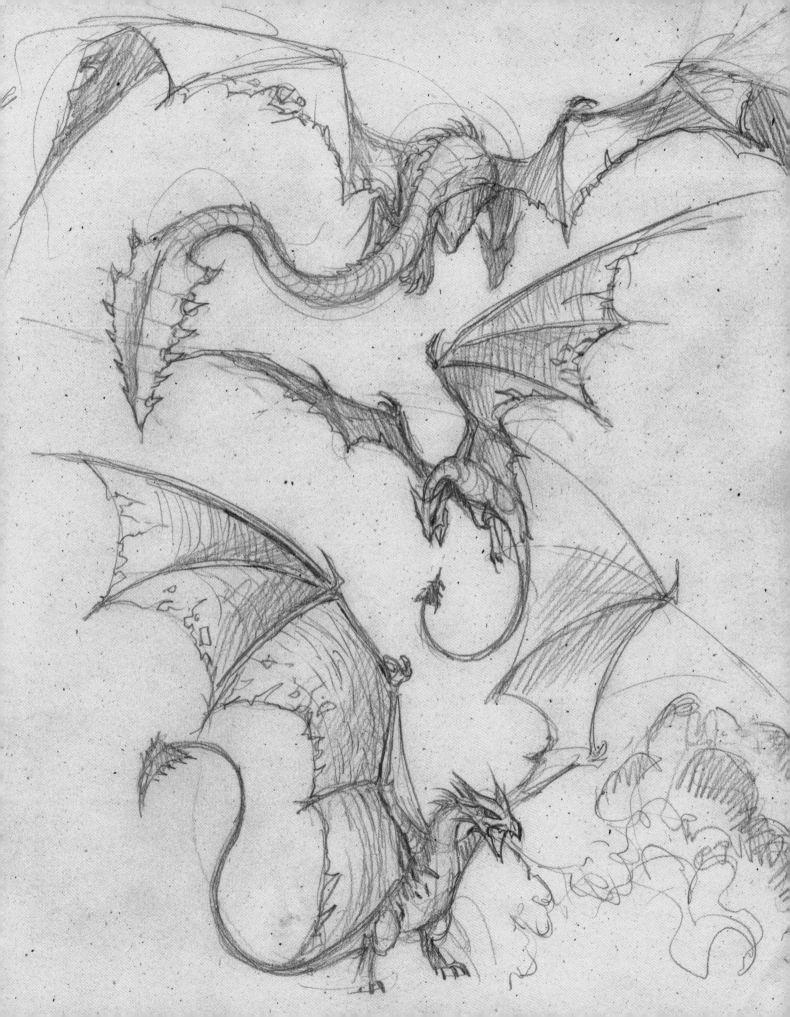

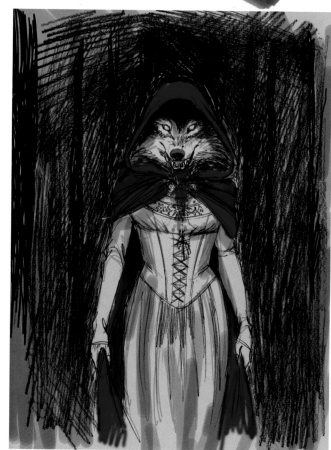

I wanted to play with the imagery of the story of Little Red Riding Hood, subverting the idea of an innocent little girl and replacing it with something altogether more predatory. I have long been a fan of Neil Jordan's 1984 gothic fantasy-horror film *The Company of Wolves*, a resonant portrayal of a young girl's immersion in fantasies where sexuality is both scary and seductive, and I guess the images shown here are the result of this influence.

First, I drew the images on paper using pencil, then scanned and imported them into Photoshop so that I could play around with the colour schemes. Computers are great for exploring and developing ideas using the same image as a template.

I produced the large image shown opposite in charcoal on a piece of blue textured paper; this was taken from a promotional sample pack of paper manufactured for packaging that I happened to have. It is not always necessary to use specific types of paper or certain materials, and some of the best and most creative results occur when you are inventive with materials and use whatever is to hand.

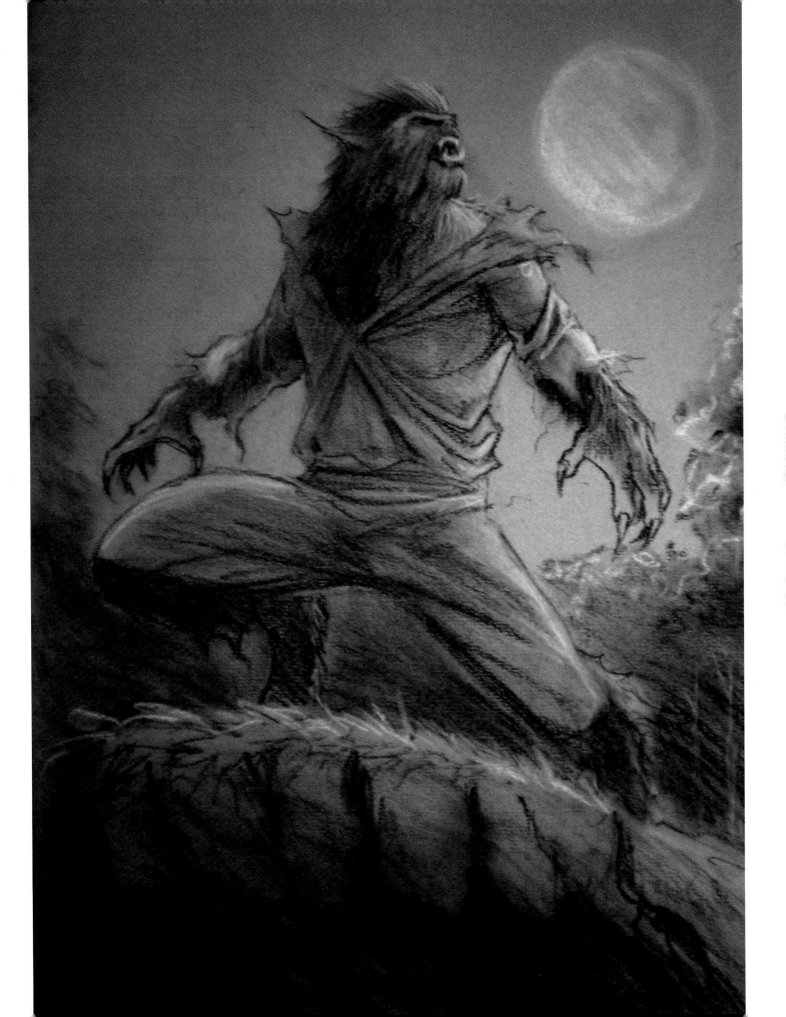

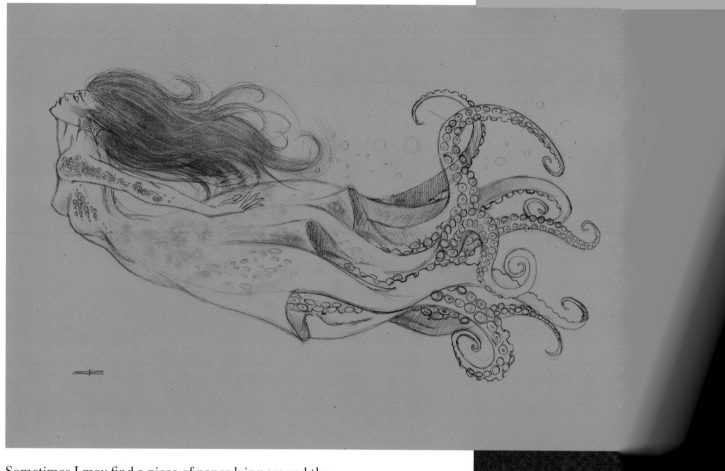

Sometimes I may find a piece of paper lying around the
studio and the texture or colour might inspire an idea
and prompt me to explore it using different materials.
The large image shown here was produced using Caran
d'Ache coloured pencils on green textured paper
(about 200gsm). The smaller inset picture above was
drawn in HB pencil on green card.

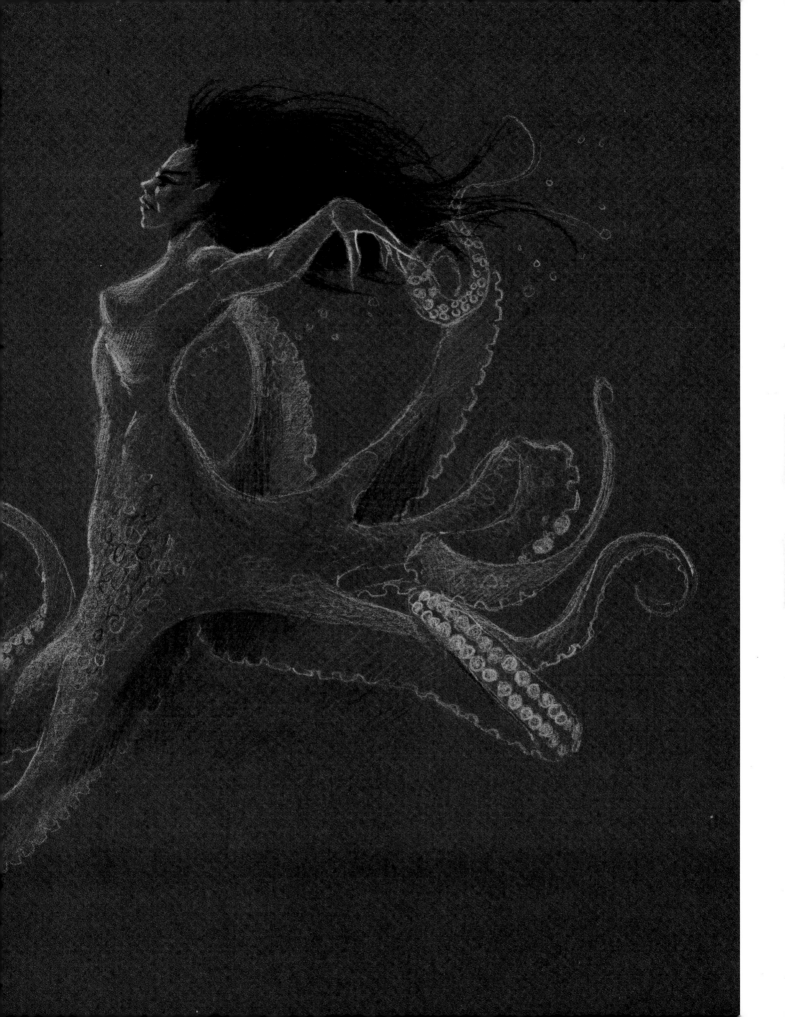

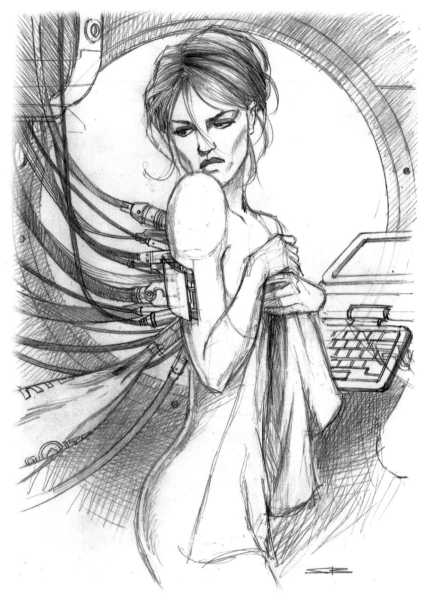

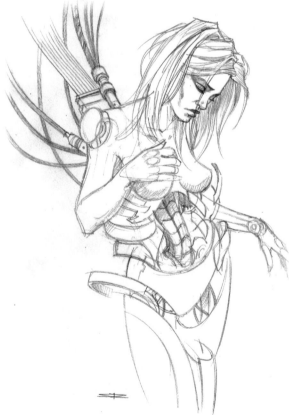

In 2009 I was asked to create a female android for an advertising campaign. It was a great project to work on and I thought it would be fun to revisit some of the ideas that were discussed and develop them further. I like the idea of the android appearing to have emotions and, as in this rough sketch, seeming to display a knowledge that she is naked. Her need to cover herself with a robe suggests that she is more human than machine.

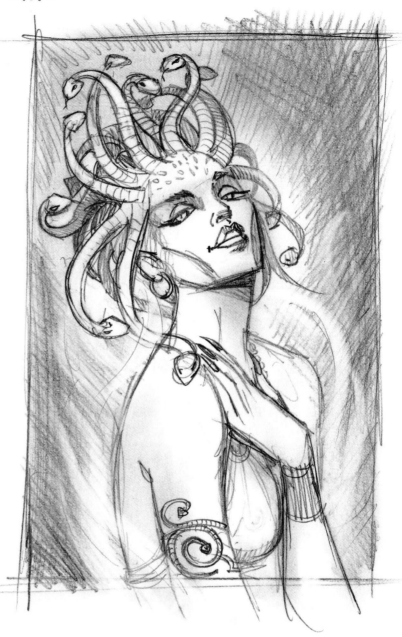

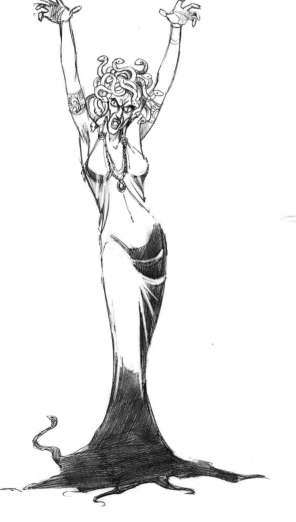

Medusa, according to Greek mythology the most beautiful of Phorcys' three daughters, is often portrayed as a visually repulsive monster. However, although she is part-reptile, I prefer to think of her as alluring and seductive. In the 1964 Hammer Horror movie *The Gorgon* (directed by the legendary Terence Fisher), a female monster called Megaera takes on human form and terrorizes a village. She is depicted with hair of writhing snakes, as in the Medusa legend, but she is without a serpent's tail. It is this representation that in part inspired the images on this page.